Homage to Frank O'Hara

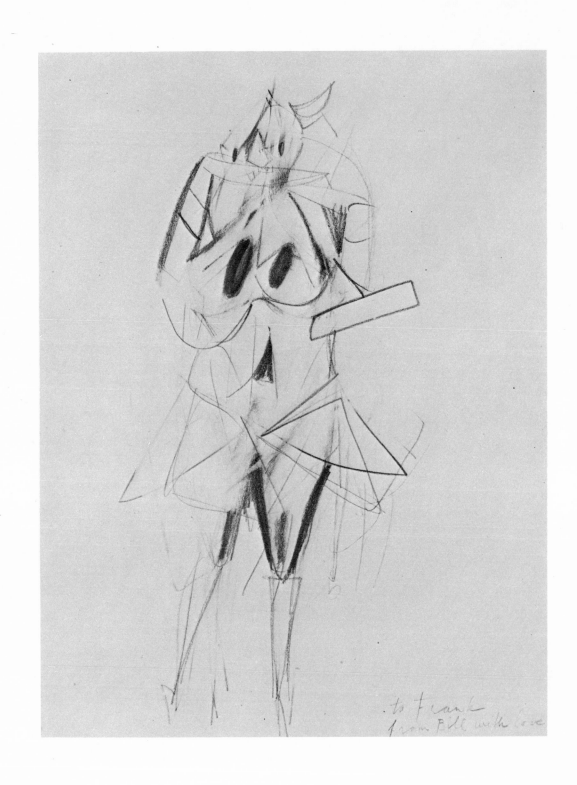

to Frank
from Bill with love

HOMAGE
TO FRANK O'HARA

Edited by Bill Berkson & Joe LeSueur

Creative Arts Book Company
Berkeley • 1980

Originally published as *Big Sky 11/12* in April, 1978.

Typeset by Barrett Watten. Half-tone photography by
Tim Hildebrand and Dale Samoker. Paste-up by Dave Bullen.

Text has been revised and corrected by the editors for this new edition.

Thanks to the Literature Program of the National Endowment for the
Arts for their assistance in supporting the publication of this book.

CREATIVE ARTS BOOKS
ARE PUBLISHED BY
DONALD S. ELLIS

Published by CREATIVE ARTS BOOK COMPANY
833 Bancroft Way
Berkeley, California 94710

Library of Congress Catalog Card Number 80-68015
ISBN 0-916870-29-4

EDITOR'S NOTE

You in others—this is your soul.
Boris Pasternak

Frank O'Hara in others—that is what this book is about. As editors, we have collected the messages, long and short, from many of the people who knew Frank or who otherwise feel some close connection with him through either hearsay or his work or both, and whom we approached, asking them to contribute in the forms of their choice: "How would you like to write something about Frank—a memoir perhaps, any anecdotes you'd care to tell, or an essay or notes on poems, or any poems you have written or want to write directly related...?" Our requests darted back and forth across the USA and elsewhere, for photographs, for information as to the whereabouts of portraits, art collaborations, documents. All sorts of little oddities popped out of dresser drawers, stacks of drawings, warehouse nooks. The file marked "FO'H" got opened. At times our editorial thoroughness astounded (and even dismayed) us—but far more astounding, and constantly, was the realization of how much interesting and previously uncollected material exists that properly belongs here, in this book, with Frank O'Hara as its unifying figure, or force: How central he remains in how many lives, how many new poets keep appearing to acknowledge how open and powerful and inspiring his poetry really is, how right Edwin Denby was when (at Frank's funeral) he said Frank's reputation would surely grow and keep on growing, how expressively photogenic he was and (like Picasso!) how glamorous, how many different words could be used to describe him accurately. In fact, one thing that struck us while rereading these texts is how the words each person uses when writing about Frank tend to be completely different from the ones the next person uses in writing about him—and all of those words are true, to Frank *and* to those people. Each one's character stands the more revealed in that one specific relation.

Most of the people we contacted for memoirs et cetera came thru with flying colors. A few demurred. (It *is* hard to write about Frank O'Hara, especially if you knew him, and it is even harder to explain exactly why that is.) Anyhow, we received plenty of material to fill the book we originally had in mind, and then some! Within less than a year, we had enough for two or three such books or anyway something massive (and, alas, beyond our means). It was time to sit down and "edit", in the sense of to tighten up. For one thing, we ruled out reprinting any lengthy memoirs or essays that are still widely available in books in print. (Poems were exempted from this stricture; just about all the poems written to and about Frank since his death are included.) For another thing, we cut some pieces that seemed too generalized or redundant and did not zero in precisely on specific qualities or stories about the subject. For yet another, we reduced the size of the typeface to slightly smaller than we (or you, the gentle reader) would normally have liked.

As for the title of this book, "Homage" was an assumption *a priori*, a right one. And it was Ron Padgett who convinced us finally that "homage" was the word we wanted, and not any of the other words, fortuitously erased from memory at this writing, which we had considered as possibly appropriate.

Plans for this book, or one like it, go back ten years. The two of us began discussing it in 1968. However, the rather bumpy history of false starts, hiatuses, distraction, and shifts of attitude towards the likelihood or validity of the project, which preceded this present editing, now seems hardly pertinent.

We are extremely grateful to Donald Allen for giving us the full benefit of his editorial expertise and his memory, and again to him and to Alex Smith for their useful suggestions as to what should be in this book and for copies of some of the items in it. We are likewise very grateful to Maureen Granville-Smith for her approval and encouragement, and for letting us publish several lovely photographs from her family archives. Also, to George Butterick, David Kermani, Walt Silver, JJ Mitchell, Grace Hartigan, and Gordon Craig of The American Poetry Archives at San Francisco State University for their various kindnesses, our thanks.

Photographers who generously made prints of their photographs available to us include: Jacob Burckhardt, O.E. Nelson, Camille McGrath, William T. Wood, Wim Van Der Linden, Lorenz Gude, Dale R. Laster, John Button, Geoffrey Clements, Fred W. McDarrah, Eeva-Inkeri, Walter Silver, Robert E. Mates, Eric Pollitzer, John D. Schiff, Kenward Elmslie, John Gruen, Mario Schifano, Hans Namuth, John Ashbery, George Montgomery, Richard Simpson, Dale Samoker, Arthur Swoger. Thanks to The Museum of Modern Art, Marlborough Gallery Inc., Graham Gallery, Allan Frumkin Gallery, Leo Castelli, Fischbach Gallery, Hirshl & Adler Galleries, Meredith Chutter, Muriel Newman, and Jack Larson for sending photographs upon request.

Acknowledgment is hereby made to the following publishers of books, some contents of which are reprinted in this book: The Yellow Press (*Red Wagon* by Ted Berrigan), Bobbs Merrill (*Another World* edited by Anne Waldman), George Braziller, Inc. (*The Final Diary* by Ned Rorem), Harcourt, Brace & World (*On Bear's Head* by Philip Whalen), Doubleday & Company, Inc. (*Freely Espousing* by James Schuyler), Random House (*Hymn to Life* by James Schuyler), McGraw-Hill (*Allen Verbatim* by Allen Ginsberg, edited by Gordon Ball), City Lights Books (*Planet News* by Allen Ginsberg), Harper & Row (*The Poetry Room* by Lewis MacAdams), The Bookstore Press (*The Street* by Aram Saroyan), Columbia University Press (*North* by Tony Towle), Big Sky (*Blues of the Egyptian Kings* by Jim Brodey), North Atlantic Books (*Selected Poems* by Diane di Prima), London Magazine (*Seven Years of Winter* by Erje Ayden), Corinth Books (*Many Happy Returns* by Ted Berrigan), Pick Pocket Poets (*One or Two Love Poems From the White World* by Stephen Rodefer).

And acknowledgment likewise to the editors of the following magazines in which some of these writings first appeared: *The World, Paris Review, Location, Audit, Chicago, Art In America, Art News, Evergreen Review, The Village Voice, Gay Sunshine, Best & Company, Art & Literature, New Republic*; and special thanks to Dennis Koran and Bruce Boone for permission to reprint material from the Special Frank O'Hara Supplement of *Panjandrum 2 & 3* (1973).

Bill Berkson & Joe LeSueur
Bolinas-New York, November 27, 1977

HOMAGE TO FRANK O'HARA

Table of Contents

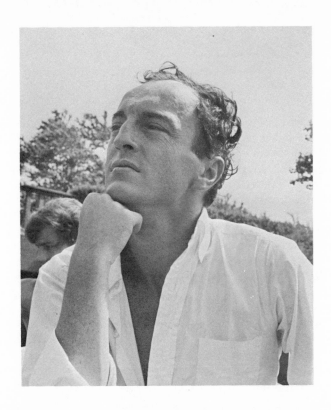

The summer of the photo, I shared a hilariously feminine bungalow with Kenneth Koch for the month of August, in Watermill—a highway on one side, inches away, a stream on the other—a stream that widened into a small pond, with a lawn and weeping willows by which Kenneth and I would sit on occasion as the moon rose, and talk of Li-Po, and Chinese-Freudian analyst-sages, ha-ha: we were both on vacation from our analysts. The bungalow was a hoot—every room decorated within an inch of its life—and ours: cocotte boudoir heaven, a comic-strip setting for Kenneth and I, big messy lugs bumping into tassels and fringes and marble-ized bathroom walls with dainty recesses for guest soap, and grandiose trompe l'oeil vistas to compensate for closet-size dimensions. Into which were stuffed the following weekend guests—Janice and Katherine Koch, and Frank O'Hara and Bill Berkson, a poet enclave of sorts, with the ladies on its fringe. Frank and Bill shared a fold-out sofa-bed in the living-room, and there was considerable prurience on my part—and others!—what this "meant." On Sunday afternoon, I got purposeful—perhaps because of a natural propensity to hype the sameness quotient of reality by freezing it (got up early, stared at them sleeping the morning away)—and then too, I was probably anxious about never-being-in-the-same-house-with-Frank ever again, and then too, it was a way of making someone feel welcome and important—anyway, it seemed terribly urgent to take Frank's picture. Bill rowed us about the pond, and I sat in the back-seat and crouched and displayed acrobat prowess: Frank was fun to take pictures of, rising to the occasion, much too pro to be modest. At one point, the boat brushed against spiderwebs at one end of the pond: dark recessed place. It seemed right to catch Bill coming out of Frank's shoulder, angelic familiar. Later that afternoon, Frank typed up a poem (or something) (I don't think he handed it about)—and at some point, a poem arrived in the mail (back in NYC) from him, subsequently lost, so it may or may not have been POEM IN FORM DE SAW.

Kenward Elmslie
July 2, '77
Calais, Vt.

Anne Waldman

APRIL DREAM

I'm with Frank O'Hara, Kenward Elmslie & Kenneth Koch visiting Donald Hall's studio or lab (like ivy league fraternity digs) in "Old Ann Arbor." Lots of drink and chit chat about latest long poems & how do we all rate with Shakespeare. Don is taking himself very seriously & nervously as grand host conducting us about the place. It's sort of class reunion atmosphere, campus history (Harvard) & business to be discussed. German mugs, wooden knick knacks, prints, postcards decorate the room, Kenward making snappy cracks to me about every little detail. We notice huge panels of Frank O'Hara poems on several walls and Kenneth reads aloud: "a child means BONG" from Biotherm. We notice more panels with O'Hara works, white on red—very prettily shellacked—translated by Ted Berrigan. Slogan-like lines; "THERE'S NOBODY AT THE CONTROLS!" "NO MORE DYING." Frank is very modest about this and not altogether present (ghost). Then Don unveils a huge series of panels again printed on wood that he's collecting for a huge anthology for which Frank O'Hara is writing the catalogue. Seems to be copies of Old Masters, plus Cubists, Abstract Expressionists, Joe Brainards & George Schnee-man nudes. Frank has already compiled the list or "key" but we're all supposed to guess what the "source" of each one is like a parlour game. The panels are hinged & like a scroll covered with soft copper which peels back.

I wonder what I am doing with this crowd of older men playing a guessing game! None of us are guessing properly the "sources," Kenneth the most agitated about this.

Then the "key" is revealed and the first 2 on it are:

I. Du Boucheron

II. Jean du Jeanne Jeanne le 🍷 (wine glass)

"I knew it! I knew it!" shouts Kenneth.

We are abruptly distracted from the game by children chorusing "da da da du DA LA" over & over again, very guileless & sweet. We all go to a large bay window which looks over a gradeschool courtyard. Frank says "Our youth."

April 17, 1977

FRANK O'HARA

Winter in the country, Southampton, pale horse
as the soot rises, then settles, over the pictures
The birds that were singing this morning have shut up
I thought I saw a couple, kissing, but Larry said no
It's a strange bird. He should know. & I think now
"Grandmother divided by monkey equals outer space." Ron
put me in that picture. In another picture, a good-
looking poet is thinking it over; nevertheless, he will
never speak of that it. But, his face is open, his eyes
are clear, and, leaning lightly on an elbow, fist below
his ear, he will never be less than perfectly frank,
listening, completely interested in whatever there may
be to hear. Attentive to me alone here. Between friends,
nothing would seem stranger to me than true intimacy.
What seems genuine, truly real, is thinking of you, how
that makes me feel. You are dead. And you'll never
write again about the country, that's true.
But the people in the sky really love
to have dinner & to take a walk with you.

Ted Berrigan

Morton Feldman

LOST TIMES AND FUTURE HOPES

The day Jackson Pollock died I called a certain man I knew—a very great painter—and told him the news. After a long pause he said, in a voice so low it was barely a whisper, "That son of a bitch—he did it." I understood. With this supreme gesture Pollock had wrapped up an era and walked away with it.

It was big stakes we were after in those times. Through the years we have watched each others' deaths like the final stock quotations of the day. To die early—before one's time—was to make the biggest coup of all, for in such a case the work perpetuated not only itself, but also the pain of everyone's loss. In a certain sense the artist makes that pain immortal when he dies young. Even the widows of these men don't behave like other widows. There is a kind of exaltation, as though they know there can never be an end to the period of mourning.

Looking at Mondrian's total output, we see a man who has completed a consummate journey. What regrets can we have? But do we ever hear a melody of Schubert's without that sense of a life cut short, of genius cut short?

As a very young man, my brother once approached George Gershwin at Lewisohn Stadium, and asked for his autograph. He never could explain to me what it was that had made that brief contact so unforgettable. What he did communicate was his sense of extraordinary luck to have had that one moment of Gershwin's presence.

That's a little the way I think of Frank O'Hara. Not in terms of artistic insight or of personal reminiscence, but just in terms of that all-pervasive presence that seems to grow larger and larger as he moves away in time.

Trying to write about that is like trying to write about F.D.R. What memoir can have the impact of that room in Hyde Park where his cape is still hanging? What revelation can equal that hat, that photograph, that profile?

I suppose it would have been fitting if Frank and I had met on the train coming to New York, like in a Russian novel. Actually I'm not certain when my personal memories of him begin. Let's just say he was there, waiting for us all.

What I remember is mostly what he said about myself or one of the others. He never talked about his own work; at least, not to me. If ever I complimented him on something he had done he would answer, all smiles, "well—thank you." That was the end of it. As if he were saying, "Now, you don't have to congratulate me about a thing. Naturally, everything I do is first rate, but it's you who needs looking after."

He admired my music because its methodology was hidden. Yet he admired other music too, whose method was unashamedly exposed. Though he understood and appreciated my particular position in regard to virtuosity, he did not share it. Frank loved virtuosity, loved the pyrotechnics of it. He was, in fact, able to love and accept more difficult kinds of work than one would have thought possible. It is interesting that in a circle that demanded partisanship above all, he was so totally accepted. I suppose we recognized that his wisdom came from his own "system"—the dialectic of the heart. This was his secret. That was what made it possible for him, without ever being merely eclectic, to write so beautifully about both Pollock and Pasternak, to dedicate a poem to Larry Rivers one day and to Philip Guston the next. Nobody I knew resented Frank's love for an irrelevant genius like Rachmaninoff. We all know it was not Rachmaninoff who was our enemy, but the second-rate artist who dictates what art should be.

His intense involvement with so many different levels of work, so many

different kinds of artist, naturally created great demands on his personal loyalties. But it was part of O'Hara's genius to be oblivious to these demands, to treat the whole thing as if it were some big, frantic, glamorous movie set. To us he seemed to dance from canvas to canvas, from party to party, from poem to poem—a Fred Astaire with the whole art community as his Ginger Rogers. Yet I know if Frank could give me one message from the grave as I write this remembrance he would say, "Don't tell them the kind of man I was, Morty. *Did I do it.* Never mind the rest."

It is only now that one sees the truth about this intellectual's intellectual—this Noel Coward's Noel Coward—only now one realizes it was his capacity for work, his stamina, his passion for work, that was the energy going through his life.

As a literary artist he was a sort of latter-day Chekhov on the New York scene. When we read O'Hara we are going along and everything seems very casual, but as we come to the end of the poem we hear the gun-shot of the Sea Gull. There is no time to analyse, to evaluate. We are faced with something as definite and real and finite as a sudden death.

Unlike greatness, talent is an elusive thing, hard to pin down. Can anyone question, for instance, that Stravinsky is great? He certainly fits the fantasy bill of culture, gives off all the "greatness" culture demands. Yet he relies on so much beside his actual gifts that one wonders whether he is really to the medium born. The fame of a Mondrian, on the other hand, had to be propagated by a sort of word-of-mouth from artist to artist. How can culture admit he is as great as Della Francesca, when he brought nothing to the work but his gifts?

Unlike Auden or Eliot, who never stopped writing for the undergraduate, Frank O'Hara dispenses with everything in his work but his feelings. This kind of modesty always disappoints culture, which time after time has mistaken coldness for Olympian objectivity.

Let us remember, however, that while culture has the initial say, it is the artist who has the last word. Somebody once said the unconscious was a "subtle fox." History, too, has an unconscious that plays its tricks on us. Throughout the first half of the twentieth century everyone was sure it was Picasso; we are only now beginning to see it was Mondrian. How could anyone have known or guessed? The work seemed so limited, so simplistic, so unambitious. And all the time, nobody was reading it, nobody was seeing the touch, nobody was looking at the handwriting on the wall.

Not that I am comparing Frank O'Hara with an austere artist like Mondrian. What I am saying is, it may be Frank O'Hara's poems that survive when all we now consider "epic" is shot full of holes, nothing remaining of it but its propaganda.

When you begin to work, until that unlucky day when you are no longer involved with just a handful of friends, admirers, complainers, there is no separation between what you do and who you are. I don't mean that what you are doing is necessarily real, or right. Rather, you work. In some cases the work leads to a concept of music or of art that draws attention, and you find yourself in the world. Maybe not for the right reasons, but you find yourself in the world.

Yet there was that other "world." Of conversation, of anonymity, of seeing paintings in the intimacy of a studio instead of a museum, of playing a new piece on the piano in your home instead of a concert hall. Because of this it isn't easy for me to talk to young composers these days. I always feel what I am telling them is so incomplete. What I really want to do at times is stop talking about all ideas, and just tell them about Frank O'Hara, tell them what really matters is to have someone like Frank standing behind you. That's what keeps you going. Without that your life is not worth a damn.

In an extraordinary poem Frank O'Hara describes his love for the poet, Maya-kovsky. After an outburst of feeling, he writes, "*but I'm turning to my verses / and my heart is closing / like a fist.*"

What he is telling us is something unbelievably painful. Secreted in O'Hara's thought is the possibility that we create only as dead men. Who but the dead know what it is to be alive? Death seems the only metaphor distant enough to truly measure our existence. Frank understood this. That is why these poems, so colloquial, so conversational, nevertheless seem to be reaching us from some other, infinitely distant place. Bad artists throughout history have always tried to make their art like life. Only the artist who is close to his own life gives us an art that is like death.

I remember so little out of all those endless conversations. Are his words going so slow or so fast over the eighteen years I cannot catch them? What did he leave us? A few poems, a few drinks, a few rooms around town, a few friends. He was our Stendhal. No one came anywhere near him.

"The thin tunes, holding lost times and future hopes in liaison," wrote F. Scott Fitzgerald. Note how we say his full name. The same is true of Frank O'Hara. It is his full name that conveys the complete meaning of this poet. This could be the subject of a game. How easily the last name of Joyce or Valéry falls on our lips. But we always say, "Gertrude Stein"—we always say, "E.M. Forster." We need that extra sweep to distinguish those who typified an era from those who thrust themselves above it.

I hope I will be lucky as Frank O'Hara, and be remembered by my full name. No last name for me, sitting shivve over history.

(1967; in *Art In America*, 1972)

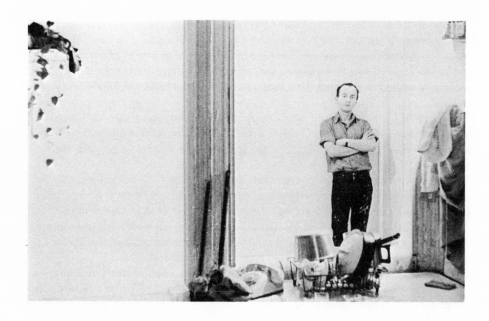

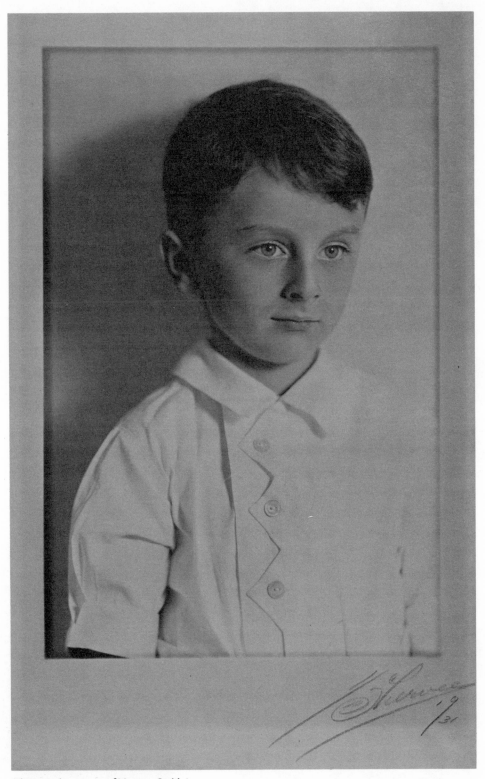

(Photographs courtesy of Maureen Smith.)

Left: Francis Russell O'Hara, ca. 1929.
Below left: With a cousin (Mary O'Hara).
Below right: Frank at bat, with friends.

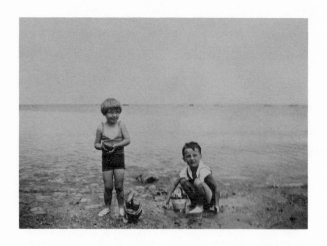

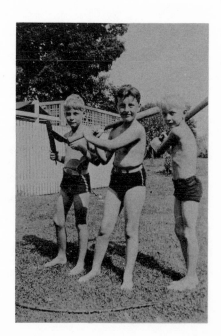

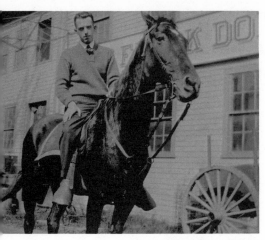

Russell J. O'Hara.

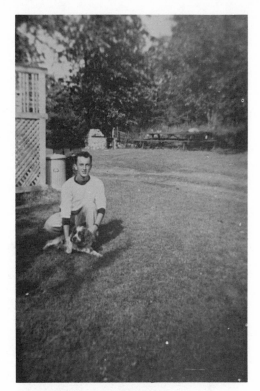

Frank O'Hara, aged about 18,
in Grafton, Mass. with "Freckles."

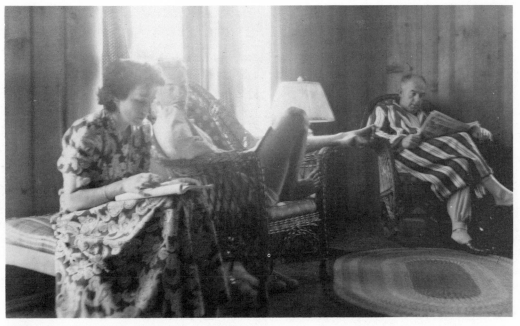

Katherine Broderick O'Hara, FO'H, Russell J. O'Hara,
August, 1943, West Dennis, Mass.

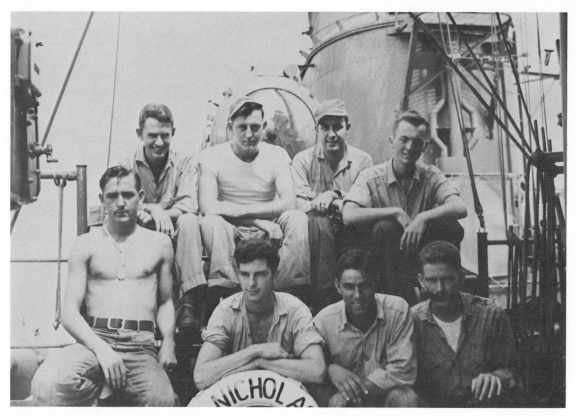

With shipmates aboard the destroyer USS Nicholas, ca. 1945.

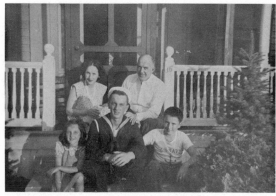

Katherine, Russell, Maureen, Frank, Philip,
16 North Street, Grafton, Mass.

from a Letter to Donald Allen

The years blur. Frank took my Freshman English course at Harvard in either '46 or '47, then signed up for various writers' workshops I buzzed at for the rest of his time at Harvard. It was I who steered him to Michigan to compete in the Hopwoods. He was certain, I told him, to win, and so to be launched. It was for that reason, I suspect, that he dedicated his Noh Play to my wife and me.

I never saw him again, even when I was in and of NYC though I was glad to learn from Larry Rivers that he remembered me warmly, as I did him.

His talent was obvious, even when he was a Freshman. He also had a lovely sardonic sense of fun. When my wife and I were fixing an attic apartment in Medford, Frank and Ted Gorey (Edward St. John Gorey)—they were inseparable in college and took all my courses together—and George Rinehart (who showed high promise in his short stories but who left Harvard in disgust at the end of his junior yr and who never went on to write)—these three, as students needing some extra money made a crew to steam the wierd wall paper from the apartment. They were at it for days as they played a game of killing insults. They were beautiful and bright and I have never come on three students as a group who seemed to have such unlimited prospects.

Yet the fact is—aside from a sensed and very active flow of sympathy between us—I knew very little about Frank. His homosexuality was not a barrier but it was not a subject we discussed. And aside from picking and probing at his papers (I could teach him nothing but only hope to stir him a little closer to his own questions) his wit was a sort of wall around him. He showed his brilliance rather than his feelings. —That was a point I often made in talking about his writing. I think, in fact, it was when he learned to use his brilliance to *convey* rather than to *hide behind* that he found his power.

John Ciardi
May 27, 1975

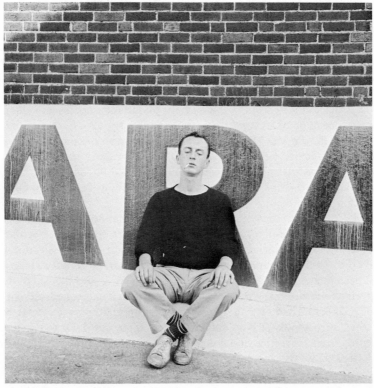

Cambridge, ca. 1950.

A REMINISCENCE

I first met Frank at a cocktail party at the Mandrake Book Shop in Cambridge in the spring of 1949. I believe the occasion for the party was an exhibition of water-colors by Edward Gorey, who at that time was Frank's roommate. I had known who Frank was for some time—he had submitted poems and stories to the *Advocate*, of which I was an editor, and we had published some. I had thought several times of introducing myself when we passed each other on the street, but each time I held back. Frank's normal expression—the one into which his face settled when he was thinking about something—was a tough, aggressive one which I later found out did not necessarily reflect his mood (though it certainly *could* on occasion!) So it was rather a surprise when I overheard a ridiculous remark such as I liked to make uttered in a ridiculous voice that sounded to me like my own, and to realize that the speaker was Frank. He said: "Let's face it, *Les Sécheresses* is greater than *Tristan*." I know that *Les Sécheresses* was a vocal work by Poulenc which had been performed recently at Harvard; I also know, back in those dull and snobbish days, that nobody at Harvard took Poulenc or any other modern composer (except Hindemith, Piston, and Stravinsky), seriously, and that this assertion was in the way of a pleasant provo-cation. Also, I was somehow aware, it summed up a kind of aesthetic attitude which was very close to my own. I knew instinctively that Frank didn't really believe that *Les Sécheresses* was greater than *Tristan*, and that he wanted people to understand this, but at the same time he felt it important to make that statement, possibly because he felt that art is already serious enough; there is no point in making it seem even more serious by taking it too seriously.

But I was struck, as I said, not only by his remark but also by the voice in which it was uttered. Though we grew up in widely separate regions of the east, he in Massachusetts and I in western New York state, we both inherited the same flat, nasal twang, a hick accent so out of keeping with the roles we were trying to play that it seems to me we probably exaggerated it, later on, in hopes of making it seem intentional. I don't know what the significance of this was, but it fascinated us and was doubtless one reason why we became friends so quickly after our first meeting. On the telephone, I was told, we were all but indistinguishable. Once when I was at Frank's apartment in New York I picked up the phone and impersonated Frank to Joe LeSueur, one of Frank's closest friends, pretending to pick a quarrel with him for several minutes during which he was entirely taken in. Another time when Frank came to visit my parents' farm in upstate New York he walked into the kitchen one evening when my mother was washing dishes and asked if he could help; without turning round from the sink my mother said, "No, John, go back in and talk with your friends."

Having determined that Frank's somewhat intimidating punk-angel look was an anomaly, partly the result of a broken nose which gave him the look of a scrappy boxer, I decided to try to spend as much time as possible in his company during the few weeks that remained before my graduation from Harvard. (Frank, whose college days had been interrupted by a two-year stint in the navy toward the end of the War, stayed on another year after I left.) Not since I had met Kenneth Koch a couple of years before had I encountered anyone so stimulating, with such a power-fully personal way of looking at art and poetry and at the world. He was an insatiable reader with a knack for discovering unknown writers who, later on, came into their own. Shortly after we first met I ran into him in Widener Library carrying a stack of books by various writers I had never heard of, including Samuel Beckett, Jean Rhys and Flann O'Brien, who were in fact all but unknown in 1949. He also introduced

me to the work of Ronald Firbank, whom I had avoided reading up until then because everybody said he was frivolous and silly. Frank corrected this misconception and somehow allowed me to see what a major writer Firbank was. I was interested in modern music but hadn't really heard very much; recordings of it in that early LP era were relatively few. Frank played the piano quite well, albeit somewhat percussively as was the fashion then, and we used sometimes to go to a music room in Eliot House, where he lived, and I got to hear for the first time works by Satie, Krenek, Sessions, Schonberg, and others, as well as some of Frank's own compositions (including a "sonatina that lasts about three seconds"), which have apparently disappeared. I think he was rather careless with his work; he had a tremendous energy and zest for it while he was working on it, and then seemed to rather lose interest once it was done. One work that seems to have been lost was a play called "Dig My Grave with a Golden Spoon," of which I remember only that the action was to take place behind a fishnet curtain, and that one character said to another, "I don't think we're ever going to get out of here," to which the latter replied, "Why not? I don't see any 'No Exit' signs anywhere." So much for Sartre.

We were serious but we were also a little unintentionally funny in our aesthetes' pose, and a little pathetic. Nobody but ourselves and a handful of adepts knew or cared about our poetry, or seemed likely to in the future. Though Cambridge teemed with poets who would later become celebrated (Bly, Creeley, Donald Hall, Adrienne Rich, Richard Wilbur) we did not know them well, if at all, except for Koch who had already graduated the year before, and V.R. Lang whose close friendship with Frank had only just begun. And despite their presence, Cambridge seemed to me then a place where anything adventurous in poetry or the arts was subtly discouraged: I mentioned in my preface to Frank's *Collected Poems* how some friends of his in the music department had made fun of him for attending the premiere of a work by Schonberg. Later on, in the more encouraging climate of New York, we could begin to be ourselves, but much of the poetry we both wrote as undergraduates now seems marred by a certain nervous preciosity, in part a reaction to the cultivated blandness around us which also impelled us to callow aesthetic pronouncements.

Nevertheless I look back on that remote period as an almost idyllic one for a number of reasons. One was that I had discovered a wonderful new friend and we gave each other attention and encouragement. Another was that we didn't know so many people and could often be alone together—later on, when Frank moved to New York it was difficult to see him alone. New York discovered him and his radiant magnetism almost as soon as he moved there. Everybody wanted to be with him, so that it was difficult to get a private audience. If one made a date for dinner with him there would usually be six or seven other close friends along, all secretly resentful of each other's being there. And after a few years I left for France on a Fulbright and ended up staying there for ten years, during which I saw him only on the rare occasions when I came home or he went to Europe. By the time I moved back to New York, he had only a few months left to live. And during those months, alas, we seldom had or took the opportunity to see each other. Frank's job at the museum had become more time-consuming; he was busy with the Nakian retrospective which opened just a few weeks before his death; his circle of business and personal acquaintances seemed to be constantly expanding at a geometrical rate. I was having problems of my own readjusting to New York and my new job at *Art News* after a decade abroad, finding and furnishing an apartment, picking up the threads of interrupted friendships, re-learning the New York *patois*. Our moments together were few and far between. One that sticks with me was a bleak Sunday afternoon in the spring of 1966; Frank had just returned from a business trip to Holland with a mysterious ailment. He was lying in bed surrounded by the unread Sunday *Times*. I had never seen him so "down," or at any rate, never for reasons of his own health: more often his moments of depression grew out of empathy with

other people's misfortunes. I tried, not too successfully, to cheer him up, and left after an hour or so. Probably his mood was short-lived; Frank was too curious about what was going on around him to remember his depressions or anxieties for very long. I have often envied this quality of his.

Unfortunately, this rather sad occasion is one of the last memories I have of him, except for the gala opening of the Nakian show shortly afterwards, where I kept catching sight of him (in black tie) at a distance, moving from group to group with the purposeful but effortless grace of a Balanchine dancer. The last time we spoke was, I believe, the Friday he left for the fatal weekend at Fire Island. He suggested that we have lunch at Larré's as we often did. I was trying to clear up my desk before going to Maine for a few days and suggested another day the week after the following one. Shortly afterward, eternity intersected time. How could I have known it was our last chance to gossip in the bar of that hectic but pleasant restaurant (the setting of so many "lunch poems"), where the French waiters don't mind replying in French to one's French, where the paté (as Jimmy Schuyler once wrote in a poem) is really meat loaf and where Frank usually had a Ricard and the *oeuf à la russe*. I can never go there now without imagining him across the dinky table for two, responding to some gambit of mine with a favorite rejoinder like "Oh, so *that's* the way it is, is it?" At which we both burst into laughter, not because anything funny was said, but from the special happiness that comes with being with an old friend in a familiar place and making the same remarks that have warmed and mildly amused us so many times before—the *olim meminisse juvabit* syndrome. How cruel and unjust it seems that we cannot do it again.

John Ashbery & Frank O'Hara reading at Egan Gallery, April, 1955.

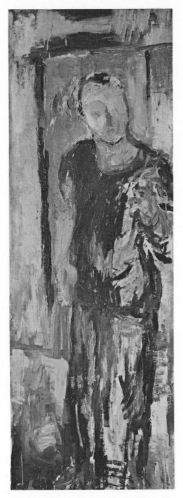

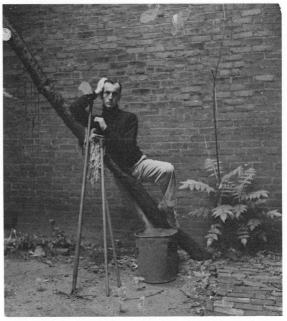

Jane Freilicher: ''Frank O'Hara,''
1951. Collection: J. Philip O'Hara.
(Photo: Lorenz Gude.)

Cambridge, ca. 1950 (Courtesy of Jane Freilicher).

''It is really a sketch painted from memory as he appeared characteristically in those days (1950, or 51) with his dark fuzzy shetland sweater, no shirt, chino pants & tennis shoes— Ivy League but rather exotic & chic in the N.Y. art world in those days. Frank was very well put together physically, the scale of his body, the delicate but irregular features of his face remind somewhat of the drawings of ideal male proportions by Dürer. He was very pleasing to look at & I sometimes wonder if this attractiveness was one of the reasons so many painters enjoyed knowing him.

However, my painting was just an attempt to capture a fleeting sense of his physical presence as he seemed, often, to be standing in the doorway of a room, one arm bent up at the elbow, his weight poised on the balls of his feet, maybe saying something funny or charming, proffering a drink or listening attentively, alert & delightful.''

Jane Freilicher

FRANK'S PHYSIQUE (A Selective Inventory)

His Nose

Or, as Bunny Lang calls it in her poem to Frank's guardian angel, "his Three Noses" (which she asks the angel to let him keep), capitalizing them as if they were the title to a Grimm fairy tale. Broken twice in childhood, Frank's nose rose above these early disasters to resolve itself into a mature hump of bone that divided his face into its two profiles like a mountain ridge. In shape and formation, though, it was an Adirondack, not an Alp—it was an old nose. Frank sometimes used it for firing small explosive snorts into the air. One of these snorts would start somewhere under the roof of his mouth toward the back of that cavity and, passing through his nasal passages like an express train through a tunnel, would shoot out of his nostrils like a judgment bursting on the world. It was a thoroughly animal sound, and it seemed to clear his whole head as well as his sinuses, for it often heralded a remark of more than usual incisiveness and always was a signal that something was about to happen. When Frank snorted, ears pricked up. I'm convinced Frank never snorted on purpose or was even aware that he ever snorted; it was instinctive.

His Lips

The lower lip unfurled itself from his mouth with a sensual languor; the upper lip, no less full, curved away from its center toward its corners like an archer's longbow. (It was a bow from the arsenal of Vercingetorix, not Cupid.) Where upper and lower lips met, the line was as firm and as straight and as sure as a carpenter's level. Frank's lips fit together like two halves of a true but improbably statement, and their fullness seemed to expose to the elements, with a cocky asking for it, more than just their own flesh. His lips were pushing into the future to taste what it was like there. René Crevel had similar lips. Frank's kisses were soft and fierce.

His Breath

Beer, gin, and Camel cigarettes—a musky mixture. But there was another odor to be caught that was as distinctive as a whiff of ground rhinoceros horn. (But was it on Frank's breath, or did it come, like the effluvium of an essential oil, from his pale Irish skin, so vulnerably freckled around the collarbones?) It was an odor like dried grass hanging in a damp barn, a potpourri of glandular secretions as intimate and arresting as the touch of his fingertips. For years, I could summon it into my nostrils at will.

His Hands

They were surprisingly pudgy.

His Clothes

Clothes liked Frank. Whatever he wore, it fit him as if it enjoyed doing the job. A tan corduroy jacket from Filene's basement buttoned itself exactly at his waist and clung to the slight sway in his back as if it were proud of his posture. His jeans fit him as if they wanted to go to bed with him. ("How did you get into those:" a man once asked him in the Silver Dollar Bar. "With a shoe-horn?" "You bet," said Frank.) He had a way, probably learned in the Navy, of making two pleats in a shirt before tucking it into his trousers that drew the cloth taut around his torso and kept it like that no matter how much he moved around. When he walked down the street, Frank held his head tipped up as if he had perfect confidence in the clothes underneath his chin, knew that they were friendly, was aware they enjoyed each other's company but felt he needn't acknowledge the fact, they being on such good terms already. I never saw him glance at himself in a store window.

His Voice

I still sometimes hear Frank's voice. I hear no words, only a rise and fall of pitch ringing with great clarity in some chamber of my inner ear. But no words are needed for me to tell what his voice is saying. It twangs jauntily along, then bubbles into a laugh, suddenly jumps forward like a motorcycle revving up a hill, and finally swoops down like a Rachmaninoff glissando in a delighted pounce of a final, unintelligible word. The sound says that life is exciting, that honesty is joyous and pretension silly, that all discoveries are good, and that energy is all.

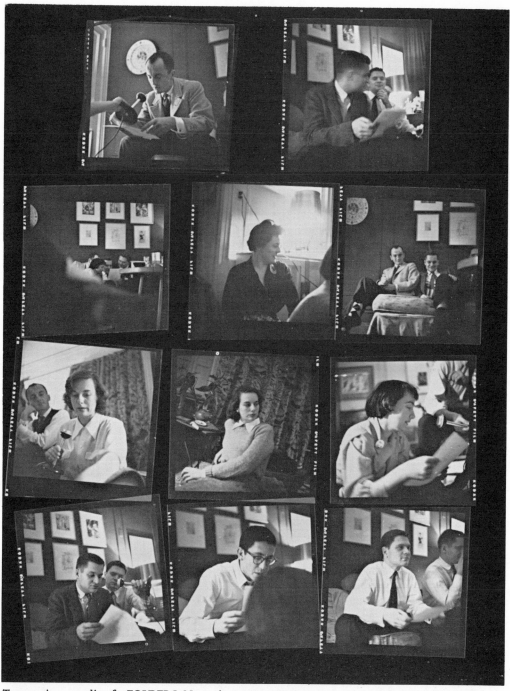

Tape session—reading for FOLDER I, November, 1953: FO'H, Ashbery, Schuyler, Aldan, Hartigan, Koch.

A NOTE ON FRANK O'HARA IN THE EARLY FIFTIES

The first thing of Frank O'Hara's I ever read was a story in the Harvard *Advocate* in 1948. It was about some people drunkenly going up stairs. During the next year, when I was living in New York, John Ashbery told me that Frank had started to write poems and that they were very good. I forget if I met Frank before or after John told me he had started writing poems. Actually, as I later found out, Frank had started writing poetry a long time before, and prose was only a temporary deviation for him. In any case, the first time I read some of Frank's poems was in the summer of 1950, just before I left for France on a Fulbright grant. John Ashbery had mailed them to me and had described them enthusiastically. I didn't like them very much. I wrote back to John that Frank was not as good as we were, and gave a few reasons why. These poems by Frank were somehow packed in one of my suitcases when I went abroad, and I happened to read them again when I was in Aix-en-Provence. This time they seemed to me marvellous; I was very excited about them. Also very intimidated. I believe I liked them for the same reasons I had not liked them before—i.e. because they were sassy, colloquial, and full of realistic detail.

It was not till the summer of 1952 (after coming back from Europe, I had gone to California for a year) that I got to know Frank well. *Know* is not really the right word, since it suggests something fairly calm and intellectual. This was something much more emotional and wild. Frank in his first two years in New York was having this kind of explosive effect on a lot of people that he met. Larry Rivers later said that Frank had a way of making you feel you were terribly important and that this was very inspiring, which is true, but it was more than that. His presence and his poetry made things go on around him which could not have happened in the same way if he hadn't been there. I know this is true of my poetry; and I would guess it was true also of the poetry of James Schuyler and John Ashbery, and of the painting of Jane Freilicher, Larry Rivers, Mike Goldberg, Grace Hartigan and other painters too.

One of the most startling things about Frank in the period when I first knew him was his ability to write a poem when other people were talking, or even to get up in the middle of a conversation, get his typewriter, and write a poem, sometimes participating in the conversation while doing so. This may sound affected when I describe it, but it wasn't so at all. The poems he wrote in this way were usually very good poems. I was electrified by his ability to do this and at once tried to do it myself—(with considerably less success).

Frank and I collaborated on a birthday poem for Nina Castelli (summer, 1952), a sestina. This was the first time I had written a poem with somebody else and also the first time I had been able to write a good sestina (my earlier attempts had always bogged down in mystery and symbolism). Artistic collaboration, like writing a poem in a crowded room, is something that seemed to be a natural part of Frank's talent. I put this in the past tense not because these things are not part of Frank's talent now, but for the sake of history—since I believe that, as far as American poetry is concerned, he started something. Something about Frank that impressed me during the composition of the sestina was his feeling that the silliest idea actually in his head was better than the most profound idea actually in somebody else's head—which

seems obvious once you know it, but how many poets have lived how many total years without ever finding it out?

This Nina Sestina collaboration occurred during one of the weekends in the summer of 1952 when Frank and I, Jane Freilicher, Larry Rivers, and various other writers and painters were in Easthampton. Jane and Frank were sporadically engaged in being in a movie which was being made out there by John Latouche.

Frank's most famous poem during that summer was "Hatred," a rather long poem which he had typed up on a very long piece of paper which had been part of a roll. Another of his works which burst on us all like a bomb then was "Easter," a wonderful, energetic, and rather obscene poem of four or five pages, which consisted mainly of a procession of various bodily parts and other objects across a vast landscape. It was like Lorca and Whitman in some ways, but very original. I remember two things about it which were new: one was the phrase "the roses of Pennsylvania," and the other was the line in the middle of the poem which began "It is Easter!" (Easter, though it was the title, had not been mentioned before in the poem and apparently had nothing to do with it.) What I saw in these lines was 1) inspired irrelevance which turns out to be relevant (once Frank had said "It is Easter!" the whole poem was obviously about death and resurrection); 2) the use of movie techniques in poetry (in this case coming down hard on the title in the middle of a work); 3) the detachment of beautiful words from traditional contexts and putting them in curious new American ones ("roses of Pennsylvania").

He also mentioned a lot of things just because he liked them—for example, jujubes. Some of these things had not appeared before in poetry. His poetry contained aspirin tablets, Good Teeth buttons, and water pistols. His poems were full of passion and life; they weren't trivial because small things were called in them by name.

Frank and I both wrote long poems in 1953 (*Second Avenue* and *When the Sun Tries to Go On*). I had no clear intention of writing a 2400-line poem (which it turned out to be) before Frank said to me, on seeing the first 72 lines—which I regarded as a poem by itself—"Why don't you go on with it as long as you can?" Frank at this time decided to write a long poem too; I can't remember how much his decision to write such a poem had to do with his suggestion to me to write mine. While we were writing our long poems, we would read each other the results daily over the telephone. This seemed to inspire us a good deal.

Frank was very polite and also very competitive. Sometimes he gave other people his own best ideas, but he was quick and resourceful enough to use them himself as well. It was almost as though he wanted to give his friends a head start and was competitive partly to make up for this generosity. One day I told Frank I wanted to write a play, and he suggested that I, like no other writer living, could write a great drama about the conquest of Mexico. I thought about this, but not for too long, since within 3 or 4 days Frank had written his play *Awake in Spain*, which seemed to me to cover the subject rather thoroughly.

Something Frank had that none of the other artists and writers I know had to the same degree was a way of feeling and acting as though being an artist were the most natural thing in the world. Compared to him everyone else seemed a little self-conscious, abashed, or megalomaniacal. This naturalness I think was really quite strange in New York in 1952. Frank's poetry had and has this same kind of ease about the fact that it exists and that it is so astonishing.

April, 1964 (*Audit*)

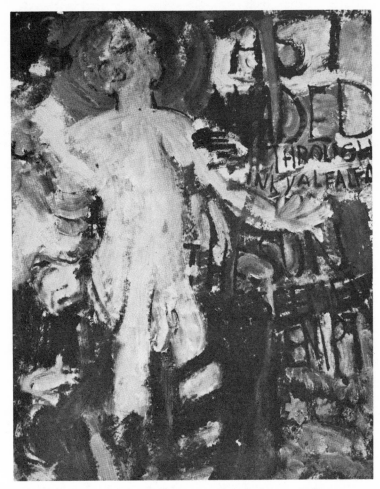

"As I waded through inky alfalfa the sun seemed empty..." Grace
Hartigan. Oil on paper from *Oranges*, 1952.

Frank O'Hara, 1954.

Photographs 1952-54
by Walter Silver

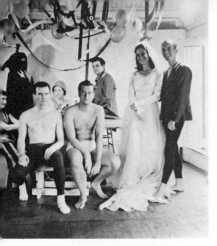

Posing for "Masquerade."

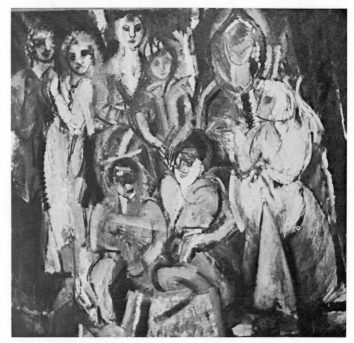

"Masquerade," 1954. Art Institute of Chicago.

Paintings by Grace Hartigan

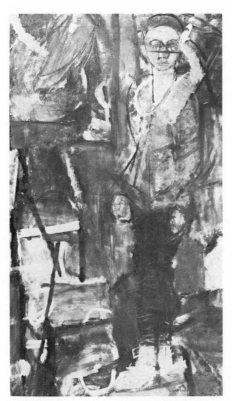

"The Masker" in progress.

"The Masker." 1954. Vassar College.

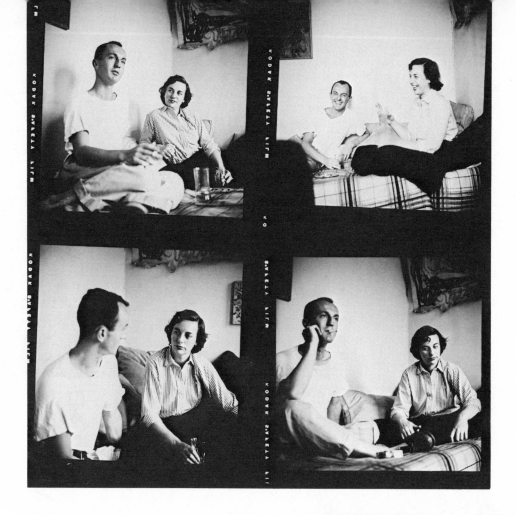

''He is 'Frank O'Hara and the Demons' as well as 'The Masker.' He is the front image in 'Ocean Bathers'...In 'Masquerade' the images come from friends (and myself) posing in costumes I found in a thrift shop. The 'models' were Frank, Jane Freilicher, John Ashbery, Richard Miller, Daisy Aldan and Floriano Vecchi. I wore a long black cloak, Frank the same embroidered 'Persian'? jacket he wore in ''The Masker.''' Grace Hartigan.

''Frank O'Hara and the Demons,'' 1952.

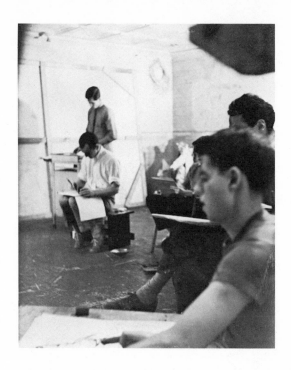

Above: Sketch class at Hartigan's studio, 1954, with (front to back) Wolf Kahn, Larry Rivers, FO'H, Allen Kaprow. Below: With Grace Hartigan at Fairfield Porter's house, Southampton, ca. 1952.

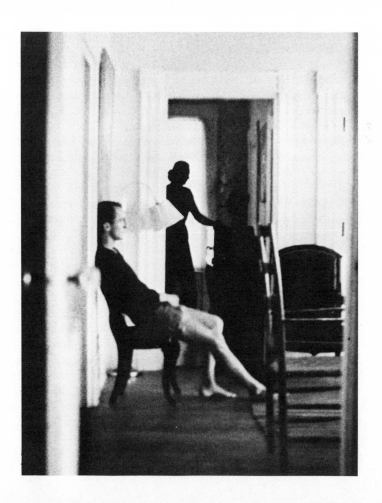

Anne Waldman

PARAPHRASE OF EDWIN DENBY
SPEAKING ON THE "NEW YORK SCHOOL"

"Met these four boys Frank O'Hara, John Ashbery, Kenneth Koch, and Jimmy Schuyler (who I had met first abroad) at the Cedar Bar in '52 or '53. Met them through Bill (deKooning) who was a friend of their and they admired Kline and all those people. The painters who went to the Cedar had more or less coined the phrase "New York School" in opposition to the School of Paris (which also originated as a joke in opposition to the School of Florence and the School of Venice). Great things started to happen in the Fifties—the point was the great effort in the Eighth Street Club and the Eighth Street lectures (going on when I was away in Europe)—the brilliant discussions among painters which had broken through the provincialism of American Painting (people don't think of it that way now, of course, they say "previous generation" because it's American now, but was European then). So the poets adopted the expression "New York School" out of homage to the people who had de-provincialized American painting. It's a complicated double-joke. It wasn't a question of New York subject matter but just as Paris broke through in opposition to, say, the School of Florence, New York was where it was happening and it was these people living in New York who said "That's what we want to do." The title *An Anthology of New York Poets* (edited by David Shapiro and Ron Padgett) falsifies (though not intentionally, obviously) the whole joke and it's been further falsified and there's no way of saving it. The point was New York *School*, not poets of New York. Later, everybody's forgotten all that—the whole original joke. So the New York School was a cluster of poets and it was through Frank O'Hara that the uptown poets and the downtown poets got together and eventually the West Coast too, plus the painters and Frank was at the center and joined them all together. After his death there was no center for that group. He had started giving big parties at his loft on Broadway after he started making enough money working very hard at the Museum of Modern Art. No one was grateful for it. He was writing less and working hard. He really wanted to establish the painters he liked. The Museum of Modern Art had always had a hard time making up its mind, but Pollock and deKooning and Gorky had all been in the Venice Biennale. Bill called Pollock the "ice breaker" (of the 300-400 year old ice). He and Bill had different ideas and Pollock made the big impression at the time. He insisted on painting without knowing what you were doing (so-called "improvisation"). But there was fighting about whether it was Abstract Expression-ism or Action Painting (Clement Greenberg wrote in the Nation about his theories on it—but I didn't know much about it, I was away and wasn't paying any attention —I don't know if he ever used the term "New York School"). Then along came Pop Art. Philip Pearlstein and his wife were friendly with Andy Warhol—they were all from Pittsburgh and they took him in in New York. Andy was a clever draftsman —then working in advertising. Then there were painters like Jane Freilicher and Fairfield Porter, painters who in the middle Fifties were picking up on first generation and got swamped by Pop Art. Alex Katz was always a realistic painter but carried on the values the New York School had established but never in relation to the descriptive-representational. At any rate, that's what Alex did in his mind. When he was an art student he was overcome by shows of Kline and deKooning but didn't want to imitate them. The color-field people were a different story. Stella was a very brilliant man. I have never belonged to any of these groups. Frank accepted me and Rudy too. Bill liked us so much—we were friends at that time and the poets got to know Rudy and of course liked him and Dance criticism was o.k. too. Then of

course Frank and others started looking for *In Public, In Private* and saying nice things about it. Frank was so wonderful about the book and wrote a review in *Poetry* and had the marvelous gift of saying nice things. He would make compliments and then quote lines from the poems and in some instinctive way he managed to prepare the ear for what was interesting about the quotations. So that's my story on the School of New York—about the painters and about the joke among jokes. Then it became a journalists'-dealers' expression, but then came Pop Art and that was a much better phrase as far as news is concerned.''

1974
(*The World*)

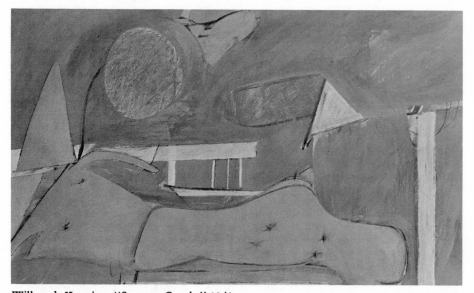

Willem de Kooning: "Summer Couch," 1943.

Well, I have my beautiful de Kooning
to aspire to. I think it has an orange
bed in it, more than the ear can hold.

FRANK O'HARA: A MEMOIR

That Year, I believe it was 1951, "all the young men were twenty." (Gertrude Stein remembered that in one particular year "all the young men were twenty-six...") They were coming down from Harvard College. It was like thinking about Isherwood, Auden, and Spender coming down to London, except that in this case it was Ashbery, Koch, and O'Hara. No one but Larry Rivers seemed to meet them all at once. In my case, it was John Ashbery whom I met first because he had a Harvard friend called Peter Grey who had invited him to come to Sneden's Landing on the Palisades to watch a marionette show. The marionettes were mine and Peter and his wife, Ty, were members of my puppet company. Peter's mother lived at the Landing where our performance was being given to raise money for a community project. I was told that Ashbery wrote verses, and I expected to meet the usual (the usual for me, at least) untidy, poetic-type American. No one could have been less poetical or less untidy. It was a hot summer, but Ashbery looked as fresh as laundry and as couth as they come. Reserved though he was (and Ashbery could be vaguely distant), he was pleased with the performance of the Pueblo Indian fairy tale called *Fire Boy* and said so warmly.

I mention this first meeting at Sneden's Landing because a few years later the two-piano team of Arthur Gold and Robert Fizdale took a house there. Frank O'Hara and James Schuyler became regular weekend visitors. Since they were all "special friends" others in the O'Hara-Schuyler conclave also found themselves invited.

O'Hara would have arrived in New York sooner were it not for the fact that he won a scholarship to do graduate work at the University of Michigan. Kenneth Koch left Cincinnati as soon as he could. I believe he arrived before O'Hara, and, of course, his presence was felt immediately.

In Manhattan the sybil who seemed to draw poets around her was the painter, Jane Freilicher. It is easy to understand why. She was (and is) very attractive, intensely intelligent, and, unusual for a painter, sensitive to literary work, especially the poetry of her friends. Kenneth Koch liked her wit and since she had a sense of humor as wild as his own, their appreciation was mutual. The same thing could be said of John Ashbery and Jane. At any rate, many of the poems mention her or are dedicated to her. And when Frank O'Hara finally ensconced himself in New York, he, too, became a part of the little band. However, it was not at Jane's miniscule studio that people gathered so much as at Larry Rivers'. I know that this was not the first time poets have allied themselves with painters; there has been a long tradition for such friendships. But what seems to me unique was the extent and depth of this alliance, which was to prove to be a very fruitful one.

How do I describe the physical effect of Frank O'Hara when I first met him? The long neck, the high cheek bones, the bridged nose and flaring nostrils reminded me of an over-bred polo pony. Or did he bring to mind Robert de Saint-Loup, that reddish-golden aristocrat leaping over the tabletops in Proust's novel? His supple, finely shaped body moving swiftly along the beach as he would rush headlong into the highest waves again recalls the image of a sleek animal. At any rate, it always gave me pleasure to see him, and, luckily, because he liked coming to my gallery, I saw him a good deal.

O'Hara adored art, loved looking at it, and had an uncanny knack of becoming every artist's Best Friend.

My gallery at that time was in East 53rd Street near Third Avenue about five doors from the El station. It occupied the first floor of an old brownstone, a "cold

water flat'' as one used to say. But a clever young architect from Milano named Roberto Mango stripped and tailored the moulding walls, painted the ceiling blue, and under it made a web of black wire on which were placed spot lights. The floor was black linoleum, and for the time it seemed the right ambiance to show new works of what quickly became known as the Second Generation. The artists included Larry Rivers, Alfred Leslie, Grace Hartigan, Helen Frankenthaler, Robert Goodnough, Fairfield Porter, Jane Freilicher, Nellie Blaine, and several others. Frank became friendly with most of them. Many were ''abstract expressionists'' which bothered Frank not the least; he seemed to have no prejudices about what people painted either then or later.

However, his most favorite artist in the early 1950's was Larry Rivers. At first I was pleased, but as the year 1952 closed, I found myself becoming intensely jealous.[1] I felt that Rivers was my territory and that it was all right for O'Hara to pay homage but not to take over. Did I not telephone and write to Larry constantly? Did I not pose for picture after picture, *The Agony in the Garden*, the series of drawings called *The Disturbed*? Did I not stand naked while he executed his parody of Rodin's *Balzac*? And who got him to read *War and Peace*? Not Frank. Luckily, just as my high feelings were about to turn into a first class obsession, I met the theatre director, Herbert Machiz, who seemed to me to be far more thrilling than Larry Rivers, perhaps even a greater artist.

It must be said for Frank that he was aware of my unhappiness and, great tease though he could be, he did not exploit the situation or allow me to hate him. In fact, it could be said that our feelings about Rivers brought us closer together. By 1953 the dust was quite settled and Frank and I never had any problems again.

That was the same year in which Herbert Machiz decided that poets, painters, composers, actors, and director come together to create theater pieces in collaboration. A theatre audience would be recruited by subscriptions and the organization would be called The Artists' Theatre. We rented the Theatre De Lys which had just been remodeled. Formerly a movie house, it was located at the far we end of Christopher Street in Greenwich Village and eventually became one of the most successful of the Off-Broadway theatres.

Our first program consisted of *Red Riding Hood* by Kenneth Koch with décor by Grace Hartigan, *Presenting Jane* by James Schuyler with décor by Elaine DeKooning, and *Try! Try!* by Frank O'Hara with décor by Larry Rivers. Of the three playwright-poets, Frank was the most involved and cooperative. He was patient about explaining the exact meaning of any line in the verse which might be difficult for the director or the actors. When asked for a few revisions or clarifications, Frank was happy to help if he felt that the objections were valid. Rivers' décor was handsome; it consisted of a large suspended mural of strange, large-eyed figures placed in a city scape that suggested Istanbul. At stage right a pipe sculpture stood as though to serve as a coat rack. Anne Mecham and Jack Cannon acted their roles with great feeling and style. Frank was so pleased with Herbert Machiz' directing that he promised to write more plays for the Artists' Theatre.

Alas, the two plays that he did write never saw the light of day. The first, called *The House of Falling Hanging*, was set in an ultra-modern villa perched on the edge of a cliff. The play came about as a result of the entire Fizdale-Gold circle attending a party in Sneden's Landing which was given by a Mr. Katzenbach, a man who manufactured wall paper and enjoyed living on the edge of a cliff. The terrace which overlooked a precipitous ravine had no railing and the party guests had to hug the wall or clutch their chairs while sipping martinis and burning their fingers on the scalding hors d'oeuvres. It was a terribly funny play, pure Theatre of the Absurd and certainly ahead of its time. However, Frank had but one copy which he kept meaning to get duplicated. One weekend he left the play in a suitcase which he checked at a Grand Central Station locker. Upon returning he found the locker rifled and the suitcase gone.

Herbert Machiz introduced Frank to Lotte Lenya some time after that, and Frank was so excited by her personality that he wrote a play which would feature her in the central role. He was star struck and knew Lenya's recordings almost by heart. It was his wish to bring out her glamour and her extraordinary quality with language which would express her bright, particular genius. However, instead of giving the play directly to the Artists' Theatre, Frank allowed Julian Beck of the Living Theatre to see it. Months passed and he received no word as to what would happen to his script. After almost a year Julian sadly admitted that he had lost it. Again there was only one copy. It was never recovered and all we can know of it is its title: *The Thirties.*

O'Hara, who was so scrupulous when it came to writing a catalogue or installing an exhibition at the Museum of Modern Art where he was employed, was often careless and casual about his own work. Poetry flowed out of him as easily as breath, but it might be written on scraps of paper forever awaiting final editing, typing, and copying. When Don Allen essayed to edit the COLLECTED POEMS, he must have been sorely vexed in attempting to pick and choose which versions of which poems to include; the manuscripts were in such disarray. When my gallery decided to publish a poets' newsletter called SEMI-COLON, Frank was marvelously helpful in correcting proof and selling copies. One issue consisted of a series of chain-poems by Koch and O'Hara. It was the ephemeral quality of SEMI-COLON which most delighted him. After twelve issues I decided that it would be interesting to publish a series of poetry pamphlets and include pictures by artists of the poet's choice. The first one was A CITY WINTER with drawings by Larry Rivers. We made twenty *editions de luxe*, each containing an original pencil drawing which sold for five dollars each. A few were sold; the rest were swiped off my desk.[2]

In 1956 I gave up the gallery in East 53rd Street and moved to a rather grand, old-fashioned building on the corner of East 67th Street and Madison Avenue. Frank was seeing a good deal of the painter Grace Hartigan who then had a studio on Essex Street. I suggested one day after a group of us had spent a funny evening at Grace's that the two of them get together and do picture-poems. They did. Writing and images were combined for a series of large gouaches, enough of them to make an exhibition. I felt the poems should have been published properly, but since the gallery was short on funds they had to be mimeographed. Grace painted plates of oranges on the covers. I think we put together about thirty copies and sold them for around a dollar each. The title was ORANGES. Frank continued to do picture-poems, elegantly collaborating with Larry Rivers on a series called STONES, but perhaps the best edition was a suite-of poem-paintings done with the painter Norman Bluhm. Delightfully, other poets took to making picture-poems, too. For instance, Barbara Guest, James Schuyler, Kenneth Koch and John Ashbery collaborated with such artists as Michael Goldberg, Mary Abbott, Ilsa Getz, Helen Frankenthaler, Alfred Leslie, and Nell Blaine.

Many years later (I think it was 1961) and after constant urging, I finally persuaded Frank to give me a suite of poems for another gallery edition. The manuscript pages were not numbered so that the sequence of the poems was not clear. I asked him for a title and he said he couldn't think of one. I said, "Well, for now let's call it LOVE POEMS (TENTATIVE TITLE)." "What a wonderful idea!" he replied, "Let's call it that."[3] So we did. I then set about arranging the order of the poems since I found that they dealt with the lovely beginning, middling middle, and sad ending of a love affair. Frank was surprised and pleased that quite by accident this suite of poems had a kind of scenario.

What was there about Frank O'Hara that prevented him from taking the full stance of "Poet?" Was it his incredible empathy for all sorts of people towards whom he extended his sympathy? Even when, in my opinion, they were using him for their own opportunistic ends? He couldn't say no to almost anyone asking him for a loan, and he spent enormous amounts of time reading and correcting the

so called "poetry" of hopelessly untalented versifiers. He seemed prone to establish friendships with people who can only be described as horrible.

It is little wonder that O'Hara did not have sufficient time to give to his true vocation. That necessary quietness was his only intermittently.[4] As the 1960's advanced, more and more claims were made upon his life. That his inner life remained undisturbed was remarkable.

My last collaboration with Frank took place in 1965 when I asked him to write a poem for a benefit exhibition that I was arranging for Spanish Refugee Relief. He was particularly sympathetic to the many painters and sculptors he had known in Madrid and he well understood their difficulties under Franco. The poem he wrote was entitled *A Little Elegy for Antonio Machado* and in it Frank expressed his concern for the plight of the Spanish people living in the their world of pain and alienation, as had the poet Machado. It was printed as part of the catalogue. I wish I still had a copy.

(June, 1977)

NOTES

1) My sometimes quoted, "There they are, all covered with blood and semen," was noted by Rivers in one of his journals: "John Myers thinking he was being funny screamed out for general use . . . " This was Madame Verlaine's spiteful remark. It was at the Opera where their semen was observed; the blood was the result of Verlaine's nearly fatal shooting of Rimbaud. Frank knew perfectly well whom I was quoting (one doesn't scream a vaguely malicious bonmot) and was amused. Larry's reaction was more complex probably because he didn't know I was quoting Verlaine's wife and because he still felt more comfortable in the closet. Needless to say, he remembered the scene at the ballet, as did Frank. And in their collaboration called STONES, there they are—Rimbaud and Verlaine—with several bullets shaped like penises.

"Good heavens," said my friend Herbert Machiz. "Larry's drawing of Rimbaud looks more like you than Rimbaud," an observation I found quite unsettling. But what Herbert had in mind was Rivers' portrait of me painted in 1953. I fail to see the likeness except for the stray locks of hair on the forehead.

2) A CITY WINTER, O'Hara's first published collection of poems was printed in late 1952 and distributed gradually over a period of a year or so. When I suggested to him that my gallery would like to do this edition, I was, as usual, up against the problem of limited funds and I knew I could only print a certain number of pages. I was given far more poems than I could include. The poems I selected from this batch represented my taste at the time; I suspect I would have tried to include others had I known Frank's work better. It is to be remembered that in 1952 poetry like Frank's was considered bizarre, a bit cuckoo. It was hard for me to decide which ones were better than others; I knew that I liked the work and thought it extremely original and fresh. I probably chose verses that I "understood" better than some I didn't quite follow. What delighted me most was the language; it seemed to be bubbling with a life of its own. And what a relief from the boring poesie which was considered classy! Getting other people to agree with my taste was not easy. My friends at *Partisan Review, Poetry, The New Republic* and other "high brow" publications thought I was getting soft in the head to admire such stuff. On the other hand, Wystan Auden, Alan Ansen, James Merrill, Allen Ginsberg and other such literary people were interested. I particularly worked on Barney Rosset of Grove Press (cold shoulder from Bob McGregor at New Directions) until finally Rosset gave in a few years later and published MEDITATIONS IN AN EMERGENCY. But the best supporters of Frank's poetry were always artists who liked to purchase a poetry pamphlet while visiting my gallery.

3) Marjorie Perloff's recent *Poet Among Painters* refers to LOVE POEMS (TENTATIVE TITLE) as the "Vincent Warren" poems. At the time I received the manuscript I asked Frank if he wished to be explicit about Warren. He said it was of no consequence and urged

me to go ahead with my editorial arrangement of the poems. What he meant was that it mattered as little who Warren might be as Shakespeare's ''W.H.'' If the poems continue to be touching and beautiful after all these years, Frank must have been aware that biographical particulars are only incidentally interesting. I believe Don Allen was correct in arranging the COLLECTED POEMS in chronological order since this method offered a structure by which so many and varied works could be held together; it is useful to the reader in locating particular poems. On the other hand, O'Hara corrected and approved the final page proofs of LOVE POEMS (TENTATIVE TITLE), hence the definitive arrangement was his.

4) Joe LeSueur's claim that O'Hara needed the constant excitement of being surrounded by friends as well as to hold down a regular job seems well-founded. Since Joe shared O'Hara's apartment for several years and was his close friend, his opinion must be respected. But do we not all know each other differently? In the years (1945-1956) that I knew Jackson Pollock, for instance, I only saw him intoxicated twice. The rest of the many times I was with him he was not drinking; he was a person of great gentleness and sharp intelligence. The novels and essays about Pollock often impose a different myth. Most of the times that I met with Frank he was usually quite pulled together and serious. Of course, he was still full of fun and a great tease, but he always knew what he thought and would say so clearly. Our best conversations had to do with painting and poetry about which we had few disagreements. He was not a complainer, self-pity was not a part of him, but I do clearly recall several occasions when he expressed a wish for more time to write, read, and think. The purpose behind the Ingram Merrill grant he received was to gain time. It probably was a mistake for him to go to Cambridge and become totally embroiled in the Poets' Theatre activities. His work for the Museum of Modern Art was admirable, but like other people who have worked for that institution, it became an all-absorbing, life-taking machine, a round-the-clock, never-ending occupation. Even the Museum's director, Alfred Barr, a fine historian of art, completed only a small portion of the books he wanted very much to write.

J.B.M.

With Jane Freilicher (left) & Grace Hartigan (right), hanging Freilicher's show at Tibor de Nagy, 1952 (Photos: Walter Silver)

From THE FINAL DIARY

We met on John Latouche's floor, December 1952, toward the end of my first trip back to America. Sonia Orwell was then new in New York, and John gave her a party. Vast carpet, Manhattan-type wit I'd forgotten, of course piano tinkling to support divine Anita Ellis whom I'd never met either, who clutched her red satin hem and threw those closed eyes to heaven screaming *Porgy!* while the room exploded with applause that only Streisand, second hand, commands today. Today, when half those guests of John Latouche, and John Latouche, are dead.

Pushed by John Myers, Frank edged toward me, and placing the ashtray among our feet, exclaimed in that now-famous and mourned Brooklyn-Irish Ashberian whine I didn't at first take to: "You're from Paris and I think Boulez is gorgeous." He meant, as they say, well; and I was surprised that a poet then already knew Boulez' sound over here; but gorgeous seemed hardly the word, even from that poet, for that composer.

Snow, and the year was closing. I sailed to France where Bobby Fizdale suggested I write something for two voices and two pianos. What words? Why, those of his friend Frank O'Hara. So a friendship was planted over the ocean which blossomed into our "Four Dialogues," originally titled "The Quarrel Sonata."

*

Here I'd hoped to quote whole letters. It can't be done in diaries—that's for grandiose epitaphs and homages he's everywhere receiving, more than his more famous peers, Jarrell and Delmore Schwartz. Nevertheless, from May of 1955, plucked from their generous context, come concerns about opera after witnessing my *Childhood Miracle* on Elliott Stein's libretto:

> Surely we must do an opera together. Something terribly sweet and painful, maybe? . . . In the final trio I felt you lifted the work onto a new height where the music was inspired; before that, one felt admiration for your gifts and an awareness for the facility of the setting, but was more impressed than moved. . . . The libretto worked very easily on stage, but it is not up to Elliott's other work which I admire tremendously. Not that a libretto should necessarily be a major literary production. But there are qualities of peculiar insight in his other work which would not be at all foreign to the stage and which he seems to have consciously avoided in favor of a non-dramatic gentle whimsy. . . . I feel that the audience cannot be given enough, particularly in a medium where the writer is confined by the greater importance of the musical expression. . . . Bringing your own extraordinarily sophisticated talent to bear on this subject, dealt with as sparingly as it is (it is almost a "least common denominator" of the situation), is like getting a cannon on stage and not firing it. . . . I am prejudiced by my longing to have you write the significant modern opera I feel about to happen in music. There is no social, dramatic or sensational contemporary situation you couldn't deal within your characteristically beautiful fashion, I think, and that is true of virtually no other composer now, saving perhaps Marc [Blitzstein] who has other ideas and other gifts from the ones I'm thinking of. . . . When you think of yourself in relation to the work I imagine hearing from you (and remember this is because I love what we already have and don't mean to be overbearing or overstep the bounds of discretion between one artist and another), think of Manon

and Louise and 3 Penny and Lulu. Why deal with a melting snowman when a cocktail party would be a great opportunity for great music? I don't mean to harp on modern subject matter; of course the subject counts for little or nothing sometimes. But it doesn't hurt a great gift to have a significant subject either, whether it is the liberation of Flanders or love à la Onegin. And I really believe that an artist cannot be in his best work more mild than the time. It harms the work's conviction. . . .

<div align="center">*</div>

More mild than the times. . . . I do not, like Styron or Blitzstein, pretend to deal with the time's Big Issues. Yet by definition my prose and music are of, and hence concern, our day. Who can say that narcissism or the forgotten themes of romantic love are less timely, less indigenous to our health or malady?

But when Stravinsky states that "artists and 'intellectuals' can be as dangerous and foolish as professional politicians . . . about matters beyond their competence," smart Mary McCarthy concurs, but points out that artists do possess a higher intuition and are good at smelling rats.

Frank O'Hara smelled rats. And from the common rats about the house he made his poetry, as Auden had a generation earlier.

<div align="right">(August 13, 1966)</div>

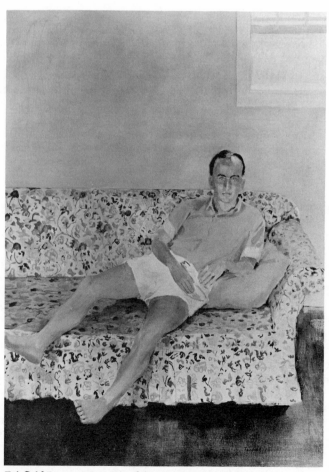

Fairfield Porter: "Portrait of Frank O'Hara," 1957.

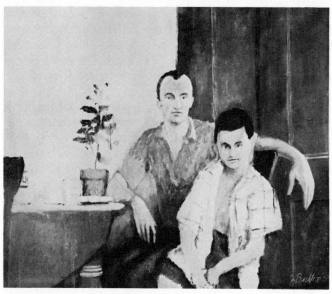

John Button: "Frank O'Hara and Steven Rivers," 1956.
Oil on canvas. Collection: Howard Griffin.

John Button

FRANK'S GRACE

Frank O'Hara was different from other non-establishment but influential post-war American poets. He never sought to influence the young as did, say Jack Spicer, Allen Ginsberg, or Paul Goodman in their various ways. As often as not, Frank sought out people older than himself. He did and does influence large numbers of younger poets and painters, but his celebrity among the young always seemed to surprise him. He did not publish or appear publicly very much during his life; he wasn't particularly interested in his career. When asked by a publisher-friend for a book, Frank might have trouble even finding the poems stuffed into kitchen drawers or packed in boxes that had not been unpacked since his last move. Frank's fame came to him unlooked-for.

Frank was a gentleman. He was civilized. He could be courtly. Furthermore he was proud of it. He never really liked the kind of manners that would permit a host to allow a newcomer to a party to introduce himself or to make his own drink. This New England habit of good manners extended to the young as well. Frank made no distinction among his friends, whether they were older and accomplished or younger and lacking in accomplishments. He often gave help, and he had the faculty of making even beginners feel like "somebody." He could praise in a way that left no doubt in the minds of the young that they belonged to a venerable and important tradition. Even his put-downs were based on his desire to see his friends do more and do it better.

His manners were not those of an aristocratic elite. They sprung from his sense of Nobility . . . perhaps the strongest sense in Frank's character. He wanted everything to be noble: poetry, art, friends, and life, as well as himself. His graceful style was tailored to that end.

But he was never stuffy. Rather he was wild. His responses to life were total

41

responses, often involving his sexuality. It would be proper to imagine Frank physically attracted to Willem de Kooning, for example, because he admired Bill's painting and his mind, and his beautiful presence. The fact that de Kooning's orientation is heterosexual would have been irrelevant to Frank. Frank's orientation was undoubtedly irrelevant to de Kooning, too, because he always greeted Frank with a juicy kiss on the mouth. This was never ''gay'' or condescending. It was the appropriate greeting of two wonderful people.

Frank plunged into bed with a number of handsome young men. He had moving affairs with some. But three of his profoundly engaged love affairs were platonic and with men who did not share Frank's erotic interests. If, in these cases, there was little or no sex, there surely was all the passion of love. Frank was unable to compartmentalize his feelings in the way ordinary mortals do, feeling this way about ''A'' and that way about ''B.'' Frank's respect, his admiration, his judgment, and his love seemed inseparable.

After seeing Judy Garland's first big show at the Palace Theater, Frank said, ''Well, I guess she's *better* than Picasso.'' This was not a Pop-Art response. It wasn't even campy. It was serious. Serious in the way that great comedy is serious. Frank could relate his admiration for Mayakovsky to his admiration for ''William Powell's stunning urbanity.''

> *...you find a card with violets*
> *which says ''a perfect friend'' and means*
> *''I love you'' but the customer is forced to by shy.*

This is from a poem Frank wrote to me. The sentiment is extravagant but polite, and the commitment to friendship is total. It involves *all* that Frank felt when he wrote it.

This kind of complete response sometimes led to bizarre situations. Frank might lecture a European artist who was far too exclusively *moderne* on the virtues of listening to grand opera five minutes after he had complained to a conservative American artist that he wasn't enough with-it.

Frank's civility and wildness as well as his comprehensive knowledge of post-war art and artists were indispensible to the Museum of Modern Art. I worked there much of the time Frank did, and I could see that they had curators who were good scholars, curators who could shake the hands of patrons, and curators who could be snooty at parties. But they had no one who was at home among the newly emerging artists and was also ''presentable.'' Frank needed a job. The Museum needed Frank. So he entered the establishment art world and brought to it his own non-establishment style.

I've often thought that in the long run this arrangement was less than happy for either party. Frank was several times called upon to organize shows that were not completely to his liking. Frank once said that the museum was far too beguiling. (How he loved to let words like ''beguiling'' roll of his tongue!) He was asked to do a great deal of traveling. (Surprisingly, Frank had done very little traveling previously.) The job gave him less and less leisure at precisely the time he could have been writing his best poetry. It interfered with the free flow of his friendships. He was sometimes lionized by aspiring artists, but could never use his position in the way they might have expected. On the other hand he could never be aloof from those who only aspired. For the Museum he may unwittingly have helped to create a precedent for a curatorial manner that artists may learn to regret, especially if that manner is practiced by someone with less intelligence and integrity than Frank possessed. He was not an historian or a scholar. Although his knowledge of art was large and his spirit larger still, in the end he had to rely more on his own fine sensibility than on professional skills or a creative approach to the multiple problems posed by a rapidly changing art scene.

In the summer of 1966 I was in Paris. One afternoon I was to call a friend of

Frank's and mine to confirm our dinner date. I was in a phone booth in the Louvre. Our friend answered and told me to sit down because she had some very bad news. "Frank!" I thought, groping for a seat. Then I listened to the account of his being run over on a lonely beach at four-thirty in the morning. It was so strange that I couldn't absorb it. I learned that even after his body was broken and torn by that fearful accident, Frank's noble grace remained. He lived for two more days in a Long Island hospital room, his liver ruptured, his skin sutured in dozens of places and his blood saturated with pain-killing drugs. In that condition he had the courtesy to notice his nurse's accent, and he insisted on speaking to her in French. He even made jokes for her.

Shocked friends had gathered. Bill de Kooning rushed to the hospital and demanded to pay for anything that could be done. Other friends went to Frank's loft to secure his manuscripts. Legions came to the funeral to pay homage in remembrance of the generosity Frank had shown them. A center had gone out of our lives. I was in France, glad to be removed from the confusion of grief-stricken people.

But I have visited his grave more often than those of my own family. Frank's body is buried under a great hardwood tree in the rustic cemetery at Springs, far out on Long Island, in the heart of a pleasant countryside where he and his friends had spent so many memorable times together. Nearby Stuart Davis lies under a polished black stele. In a glade thirty yards away Jackson Pollock lies under a huge stone bearing his own signature.

Once in a testy mood some years before, Pollock had called Frank a fag in my presence. Today I imagine that, transfigured by death, Pollock would be proud to lie so near Frank O'Hara the poet, just as St. Jerome, who was so irascible in life, would be proud to see that artists have associated him with a very tame and civilized lion.

Frank's gravestone bears a supremely apt quotation from his work:

"Grace to be born and live as variously as possible."

(Panjandrum)

Frank O'Hara's grave in snow. (Photo: John Button.)

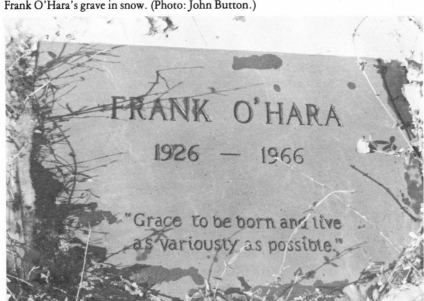

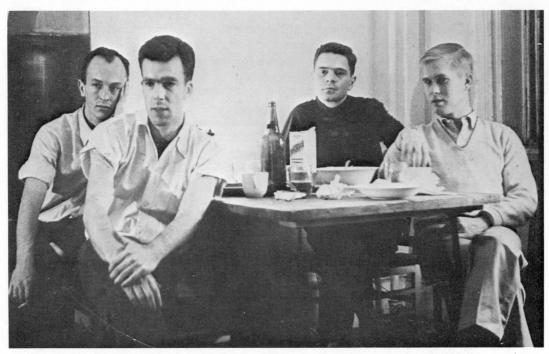

"Frank, John, Jimmy & Joe watching Footlight Parade on TV in 1955. It was the first TV set in our circle, so I had them over for dinner and to watch the movie. (Come to think of it—I *don't* think it was Footlight Parade—we're too serious. I think it was *Idiot's Delight*. I know I had everyone over for that, too.")

3 Photographs by John Button

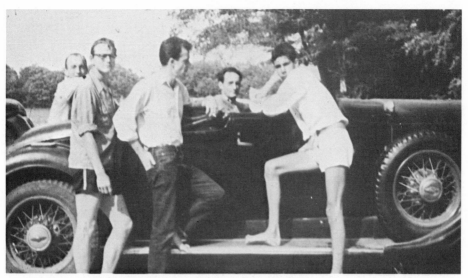

"Larry had just acquired Franz Kline's old Buick roadster. It was black with red trim. Frank in the rumble-seat, a friend of Joe Rivers, John, Larry at the wheel, and Joe Rivers, 1955. Larry later painted a nude of Joe in almost this exact pose."

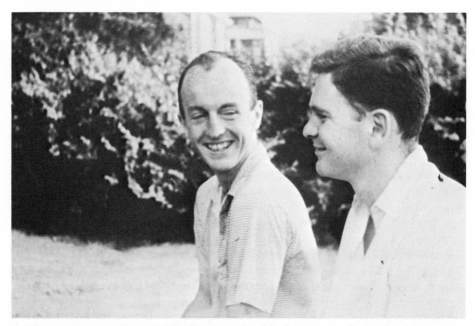

"Jimmy & I were staying at Fairfield's one weekend in the summer of 1956. Frank was at Larry's & he came over for lunch. Frank & Jimmy were in such a good mood, I snapped this picture in Fairfield's side yard in Southampton."

With Jean-Paul Riopelle, Norman Bluhm, Joe LeSueur in Bluhm's studio, 1960.

Joe LeSueur

FOUR APARTMENTS

We met on New Year's Eve, 1951, at a party John Ashbery gave in a one-room apartment in the Village. Paul Goodman said, ''There's a poet named Frank O'Hara I think you'll like,'' and led me across the room to him. Tchaikowsky's Third Piano Concerto was playing full-volume on John's portable phonograph, and almost immediately Frank and I began dreaming up a frivolous ballet scenario.

The rest of the party is a blur to me. I don't know what happened to Paul after he introduced us, and the Tchaikowsky is the only piece John played that sticks in my memory. Also, I don't remember anything else Frank and I talked about that evening. But before we parted we learned that we lived near each other, only a block apart in the East Forties. And very soon we began to see a lot of each other.

In June, 1955, when I moved back to New York after living out of town for a couple of years, Frank said he'd put me up until I found a place of my own. But come to think of it, I'm not at all sure that anything was said in a formal way. I often stayed with Frank on my weekends in town, and he always made me feel at home. So that was probably how we began living together, I just came for the weekend and stayed longer than I usually did.

On good days so much sunlight flooded the place that it woke you up in the morning, and when you got up you could look out and see the new U.N. building, a fair amount of blue sky, and pigeons on the next-door roof. Inside, the view wasn't so good. It was a perfectly decent tenement apartment, a sixth-floor walk-up spacious enough for the two of us. The trouble was, it never had a really thorough cleaning, and just about anything you can think of was strewn through its four rooms. Then there was the cockroach problem. But Frank said, "The cockroach and the ginkgo tree are the oldest things on earth," as though that made everything all right. And the place needed a paint job so badly that it was a good thing you could hardly notice the walls for the paintings. By the time I moved in with Frank—he'd previously shared the place with Hal Fondren, who actually had it first, and then with Jimmy Schuyler—he already had a number of things, by Joan Mitchell, Larry Rivers, Mike Goldberg, Grace Hartigan, Al Leslie, and other friends, as well as a very beautiful de Kooning from the mid-forties that really belonged to Fairfield Porter. Rudy Burckhardt said he wanted to photograph the place, it looked so great; but he never got around to it. Jane Freilicher, on the other hand, agreed with us that we needed somebody to clean up the place, and she put us on to Mildred, a blasé cleaning woman who chain-smoked while she worked. So once a week for about two months—she simply didn't show up one Tuesday and we never heard from her again—Mildred would drop by and leave a trail of ashes through the apartment that testified to her thoroughness. On one of her visits, just as she was leaving, she looked over at the rows of empty beer bottles that were accumulating in the kitchen and said, "Boys, you'll never have to worry about getting up carfare so long as you've got those bottles." But in those days we didn't worry about anything, not really.

I guess that's why this is the apartment I'm nostalgic about, because later on we didn't lead such easy-going, uncomplicated lives. Frank ran the information desk at the Museum of Modern Art and I worked at the Holliday Bookshop on East Fifty-fourth Street. We could walk to work and meet for lunch, and at the end of the day we could forget about our jobs. Most important of all, Frank—unknown as a poet and not yet officially involved in the art world—had no demands made on his time. Going to parties, movies, and the New York City Ballet; drinking at the San Remo and the Cedar; sitting around with friends at home—that was how we filled so many of our nights. And as far as I could tell, writing poetry was something Frank did in his spare time. He didn't make a big deal about it, he just sat down and wrote when the spirit moved him. For that reason, I didn't realize right away that if you took poetry as much for granted as you did breathing it might mean you felt it was as essential to your life. But I think Frank's attitude towards poetry, or towards art in general, was merely consistent with the way he lived his life. As important as art was to him, it was after all only part of life and not separate from it so that he had to shift into high gear to get ready for an esthetic experience. He was in high all the time, high on himself, and his every waking minute, regardless of what he was doing, was vital, super-charged, never boring if he could help it. Two weeks before his death, during a weekend at Larry Rivers' place in Southampton, a particularly exhausting all-night session of drinking, talking and listening to music prompted J.J. Mitchell to ask Frank, as dawn was breaking, "Don't you ever get tired and want to sleep?" Frank said, "If I had my way I'd go on and on and on and never go to sleep."

Maybe he didn't have his way, but he came awfully close. Sometimes he'd come home at three or four in the morning and charge into my bedroom. "Getting your beauty sleep?" he'd say caustically. Or: "Joe, would you mind getting up and having a drink with me? I have something I want to talk to you about." Other times, instead of waking me he'd write me a note, which he'd leave on the kitchen

table. One stands out in my memory: *Wake me up if you have to kill me. XXX F.*
And the next morning—I'm talking about the later years now—he'd cough his
lungs out, light a Camel, read a little Gertrude Stein, have a cup of coffee, sip an
orange juice laced with bourbon while he shaved, get on the phone for fifteen or
twenty minutes, then go off to the museum, where he'd work with extraordinary
efficiency for a couple of hours before going out for a two-hour lunch preceded by at
least one (but usually more than one) martini or negrone. If inspired, he'd also
manage to squeeze in enough time to knock off a poem after lunch. Back home at
six or seven, he was ready for whatever was on the agenda that night. Though he
loved parties, he was relieved if nothing was happening and he could stay home,
which meant watching Clint Walker in *Cheyenne*, talking on the phone with Bill
Berkson for an hour, having a late dinner after lots of drinks, reading anything from
Harlow to Pasternak for two or three hours, and ending up with a thirties movie on
The Late Late Show. He was seldom ill; when he was, he didn't complain or indulge
himself, and by the end of the day he'd be so restless that he'd drag himself out of
bed, have a stiff drink, and by sheer will get back into the swing of things. I couldn't
keep up with him, hardly anybody could. I think he exhausted everybody except
Patsy Southgate, Joan Mitchell, and Barbara Guest, who stayed up with him longer
than any of his men friends. Never the three or four of them together, of course; the
tête-à-tête until dawn was Frank's specialty.

Yet he always found time to write during the years we lived together, the last
year or so excepted. Not that he needed much time, because he usually got what he
was after in one draft, and he could type very fast, hunt-and-peck fashion. And
from the very beginning it seemed to me that he never tried to get a poem going,
never forced himself to write; he either had an idea or he didn't, and that was all
there was to it. Now of course it's possible that any number of his things were
written in that wonderful, generous hand of his, apart from his collaborations with
painters. But I know of only two non-typewriter works: his poem about James Dead
''written in the sand at Water Island and remembered'' and his ''Lana Turner has
collapsed'' poem, which he wrote on the Staten Island ferry on the way out to a
reading at Wagner College. (I might add that he opened his reading with the Lana
Turner poem, got a good laugh, and was followed by Robert Lowell, who wryly
apologized for not having written a poem for the occasion.) But ordinarily Frank was
lost without his typewriter. I remember his wanting to write something one weekend
at Morris Golde's Water Island beach house (not the same weekend as the James
Dean poem). He said he wished he'd brought his typewriter and I suggested that he
try writing without it. He took my suggestion, but what he wrote, or tried to write,
was by his own admission pretty bad, and I think he threw it away without showing
it to anyone.

The first time I observed Frank in action came early on, about a month after I
moved in with him. Over coffee one Saturday morning he said he had an idea for a
play. He began writing it a little before noon—and by cocktail-time, which rolled
around early on Saturdays, he'd finished it. What he wrote turned out to be a fairly
long one-act play. He called it *The Thirties*; and John Ashbery liked it so much that
Frank said he'd dedicate it to him. But like the play itself, this story has an unhappy
ending. A couple of weeks later, after spending a week or so in Maine with Fairfield
Porter and his family, Frank lost the original and only draft at Penn Station, along
with his suitcase and typewriter.[1] John Button took up a collection from a few of
Frank's friends and bought him a new Royal portable, but Frank said he couldn't
reconstruct what he'd written that day. And while the few of us who'd read the play
found its loss sad and distressing, Frank characteristically took what happened in his
stride and never talked about it. He had the same reaction when still another play,
The Houses at Falling Hanging,[2] was lost after he'd given the only copy to the
Living Theatre. He cared all right, but he couldn't waste time and energy fretting.

In January, 1956, Frank took a six-months' leave of absence from the museum

I was still up when I heard Frank come in. "How was it tonight?" I asked. Then I saw that he'd brought Joan Mitchell home for a nightcap; and while Frank made drinks, Joan sat down at my desk and proceeded to answer my question with a drawing of the scene at the Cedar Bar that night. If memory serves, this was the fall of 1957. From left to right: Grace Hartigan, Mike Goldberg, Marisol, Helen Frankenthaler, Clem Greenberg, and May Rosenberg. At the top, Landes Lewitin is standing to the left of Frank and Joan, who are sitting at the bar. —J.LeS.

Bunny Lang.

—the only one he had from 1955 on—when he accepted a grant from the Poets' Theatre in Cambridge, Mass., where he was presumably expected to write a play. But he hated being away from New York and all of his friends and returning to the scene of his college years, and while he was up there he wrote no play and only a few poems. When he could manage it he stormed back to New York, drank more than I ever saw him drink, and talked about how provincial and boring Cambridge was. The grant enabled him to see a lot of Bunny Lang and George Montgomery, his two great Cambridge friends, and he met and became friendly with John Wieners and Don Berry. Otherwise, the leave was sheer hell for him. Frank clearly wasn't cut out for grants, which he never applied for, or for places like Yaddo, where he never went; they created what I think he viewed as artificial writing situations. But the museum set-up worked for him, it seems to me. Not that he liked the routine and the paper work, which in fact frequently drove him to the point of despair; it was simply that he must have needed the reality and discipline of the workaday world. Renée Neu, who worked closely with him from 1960 on, helped him get through it. "I wouldn't be able to do it without her," he told me once when I asked him how he stood the routine. And finally, he believed in what he was doing. It wasn't just a job to him, it was a vital part of his life's work. And at the time of his death, with the Pollock and de Kooning shows on his agenda and a full curatorship in the offing, he was at last being put into a position that would draw upon his full resources.

90 University Place

This was a fair-sized loft-apartment, and we moved here in February, 1957, mainly because we wanted to live downtown. Its disadvantages were manifold: a thin partition between our two rooms that allowed no real privacy, a two-burner stove without an oven that made cooking a more exasperating chore than it already was, and a downstairs door that mysteriously stuck at night and forced us on more than one occasion to take refuge at Joan Mitchell's for the night. The apartment's one advantage, apart from good wall space for hanging pictures, was of course its location, which put us within walking distance of most of our friends' places and just down the street from the Cedar, where Frank could slip down for a talk with the painters he was so crazy about. Franz Kline was one of his favorites, and out of their Cedar-based friendship came the interview, "Franz Kline Talking," which Frank conducted in our apartment. But "one of his favorites" is perhaps a little misleading, because he seemed to be inspired and exhilarated by all his painter friends, from Bill de Kooning, whom he idolized, to certain painters who appeared in the sixties, such as Alan D'Arcangelo. He devoted so much time to looking at and thinking about their work you'd have thought he had a vested interest in their development as artists. But I don't entirely go along with the idea, as suggested by several of Frank's friends, that his generosity took him away from his own woark. That wasn't exactly what happened. He offered them encouragement, inspired them with his insights and his passion; they impinged upon and entered his poetry, which wouldn't have been the same and probably not as good without them. And if he was generous with his time, it naturally never occurred to him; he was too busy enjoying their company, too stimulated by them to stop and wonder what was in it for him. Besides, in the first place, Frank needed people—all kinds of people and not necessarily artists—and right to the end he always had room for someone new in his life.

All of this isn't to say that he wasn't generous to a fault. I remember his borrowing money from Larry Rivers so he could lend it to a friend, then paying back Larry and forgetting all about the money the friend owed him. And while he valued the art works his artist friends showered on him, he never kept one of his lithograph collaborations, with Larry, Jasper Johns, and Franz Kline, that had been presented to him in recompense for the part he played in the collaborations. They all became

gifts to friends. I guess his attitude towards those works wasn't any different from the way he felt about his only solo art effort, a charming collage featuring a photograph of Rimbaud he gave to Edwin Denby. Then there was the inordinate amount of time he devoted to helping friends who came to him with their troubles. It was while we were on University Place that he really came into his own as a sort of confidant-confessor—except Frank, unlike an analyst or priest, did most of the talking. He was a born talker to begin with, and he especially liked giving advice, which often came down to nothing more than encouragement: *you can do it, all you have to do is make up your mind; you've got lots of talent, so what's stopping you?* etc., etc. But it wasn't what he said that counted; it was his authority and passion, along with his marvelous understanding of a friend's needs, that made the difference. And there were times when I thought he was in love with at least half of his friends, for it was possible for him to get so emotionally involved with them that it wasn't unusual for him to end up in bed with one of them and then, with no apparent difficulty, to go right back to being friends again afterwards. That was always his way in the years I lived with him. He didn't make distinctions, he mixed everything up: life and art, friends and lovers—what was the difference between them?

I've probably given the impression that life with Frank was a bit chaotic—and I guess it was by ordinary standards, whatever they are. But we also lived simply, made few demands on each other, and had a relaxed attitude when it came to household chores, which we'd tacitly divided up by the time we were on University Place. Frank supplied the liquor and always made sure the ice trays were full, and I bought the groceries and did most of the cooking. Economically, the arrangement put me ahead, for the liquor bill must have come to at least twice the amount of money I spent on food. But we never argued about money or about who was doing more around the house than the other one. We saved our energy for arguing about important things, like the merits of a new Balanchine ballet or what movie to see.

By now Frank was assistant curator in the museum's international program, which handled traveling exhibitions. This meant that he had bigger responsibilities, and as a result he was sometimes distracted from his writing. He realized what was happening and he worried about it. But he never seriously considered giving up his museum job, because his passion for painting could only be answered by playing an active role in the art world. A line from one of his poems tells it all: "Sometimes I think I'm 'in love' with painting." He also began to have occasional dry spells, but all he could do was go on living and hope that out of his life another poem would emerge. At times like that he drank more than usual and made life hell for his friends, mercilessly took them to task or got difficult at parties. We all put up with this side of Frank, who was ordinarily more thoughtful and gracious than anybody around. Then, too, he usually touched on the truth, and we were grateful.

But Frank could get away with murder, and that wasn't just because his friends were afraid of tangling with him. At a large party given by Arthur Gold and Bobby Fizdale after an Alice Esty recital, Frank lost his temper when a former friend, an art critic, pursued him all evening in an effort to get back in his good graces. "Listen," Frank finally exploded, his voice loud enough so that half of the party heard him, "there are 8,000,000 people in New York and I like about ten of them and you're not one of them." The thorn in Frank's side was promptly removed by Arthur. "But, Arthur," I protested in amusement after the poor guy had been shown to the door, "he wasn't doing anything. If anybody was out of line it was Frank." Arthur couldn't have been less interested. "Frank can do what he wants in my house and if somebody's bothering him they've got to go." That was the kind of affection Frank inspired in his friends.

Besides the Kline piece, a number of other things Frank wrote at this time come to mind as I think back on our University Place days. And, not at all surprising, the works I remember almost inevitably grew out of an experience I shared with him.

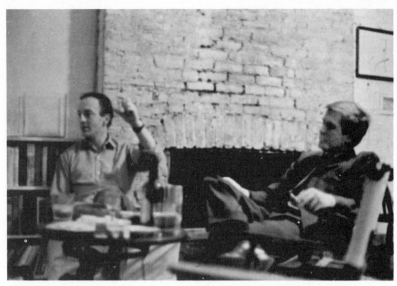

Joe LeSueur & FO'H at 791 Broadway, 1964. (Photo: Mario Schifano.)

There was the weekend John Wieners stayed with us in the fall of 1957. Saturday afternoon John went to do some sort of research at the Forty-second Street public library while we went to see *The Curse of Frankenstein* at Loew's Sheridan. That evening John, high on benzedrine, came home and told us about the horrifying, hallucinatory experience he'd had at the library. Later I said to Frank, ''Isn't it funny, we go to a horror movie and don't feel a thing and John just goes to the library and is scared out of his wits.'' Over the next few weeks Frank wrote ''A Young Poet,'' with its reference to our seeing *The Curse of Frankenstein* juxtaposed with an evocation of John's life. But sometimes it works the other way around: the details in a poem will remind me of a day I would otherwise have forgotten. Mother's Day, 1958, for example. Frank was struck by the title of a *Times* book review, ''The Arrow That Flieth by Day,'' and said he'd like to appropriate it for a poem. I agreed that the phrase had a nice ring and asked him for the second time what I should do about Mother's Day, which I'd forgotten all about. ''Oh, send your mother a telegram,'' he said. But I couldn't hit upon a combination of words that didn't revolt me and Western Union's prepared messages sounded too maudlin even for my mother. ''You think of a message for my mother and I'll think of one for yours,'' I suggested. We then proceeded to try to top each other with apposite messages that would have made Philip Wylie applaud. Then it was time to go hear a performance of Aaron Copland's Piano Fantasy by Noel Lee. ''It's raining, I don't want to go,'' Frank said. So he stayed home and wrote ''Ode on the Arrow That Flieth by Day,'' which refers to the Fantasy, Western Union, the rain, and Mother's Day. I couldn't have pieced together this memoir without Frank's poems before me.

441 East 9th Street

We heard about the place from Larry Rivers and Howie Kanovitz. There were two small bedrooms on opposite sides of the apartment, and I saw this as an ideal

arrangement that would give each of us privacy and allow me to get in the sleep Frank so disparaged. Also, I liked the idea of the apartment being only one flight up and just off Tompkins Square Park. Frank, though never enthusiastic about the place, was eventually won over, and with Al Held's help we made the move. But by early summer, 1959, when we'd been living there only a few months, we realized we'd made a terrible mistake. "Well, it was your idea to move here," Frank reminded me when I complained about the street noises and the alcoholic super who bothered us all the time and the cockroaches (the kind that don't necessarily restrict themselves to the kitchen) and a black rat the size of a well-fed cat that appeared one morning. Even the park turned out to be a disappointment; in those pre-hippie days it was a bleak and forbidding place frequented by disgruntled old people. The apartment's low rent was its only asset, but what we saved in rent money was spent on cabs, as the place was terribly inaccessible.

Yet it was here that Frank probably reached the high point in his writing, both in productivity and quality. The reason isn't hard to find. He was indifferent about his surroundings: it was people who mattered to him. For in the summer of 1959 Vincent Warren entered his life, and right after that began the invasion of younger poets, spearheaded by Bill Berkson, who became his collaborator and great friend. Frank Lima, Tony Towle, Ted Berrigan, Jim Brodey, Kathy Fraser, Allan Kaplan, Ron Padgett, Aram Saroyan, Peter Schjeldahl, Steve Holden, Joe Ceravolo, David Shapiro—some of them found their way to Frank via Kenneth Koch's poetry workshop classes at the New School; a few had been in Frank's own workshop, which he ran only one semester; others simply looked him up on their own and came around. He never treated them as students or disciples but always as colleagues and

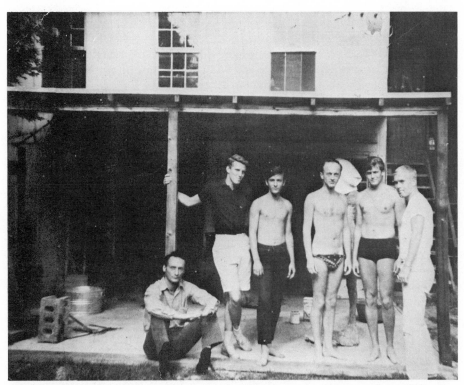

Larry Rivers, J. J. Mitchell, Steven Rivers, FO'H, Bill Berkson, Joe LeSueur in front of Rivers' studio, Southampton, 1961.

friends, and his extraordinary rapport with them rivaled his deep friendship with painters.

It's no wonder, then, that Frank accomplished so much at this time. Still, when I look back on our Ninth Street days, I don't understand how he managed not to be distracted from his writing. Despite new and more demanding responsibilities at the museum, he somehow found time to step up his social life, increase his circle of intimate friends, and galvanize those friends of his—myself included—who needed a little prodding. To get me going, for instance, he went so far as to collaborate with me on a three-act play and two teleplays,[3] none of which turned out too well; but eventually, with his encouragement and show of interest, I wrote a play that was produced on The Play-of-the-Week television series. Meanwhile, he was turning out one poem after another as well as occasional prose pieces. But as I've already indicated, Frank didn't need a great deal of time to do his writing any more than he needed ideal working conditions. I remember in particular how two works from this period were written.

One night after dinner—the manuscript carries the date September 3, 1959—Frank mentioned that Don Allen was coming by for a piece on poetics he'd promised to write for Don's anthology, New American Poetry.[4] It was already long overdue and he hadn't so much as jotted down an idea, though the piece must have been in the back of his mind for weeks. He poured himself a bourbon and water, thought a moment, then went quickly to the typewriter. I asked him if he wanted me to turn off the radio. "No, turn it up," he said. "They're playing Rachmaninoff's Third next." I said, "But you might end up writing another poem to Rachmaninoff." He liked that idea. "If only I could be so lucky," he said. Then the concerto began and Frank was off. Less than an hour later—in fact, about the time it took for the concerto—he got up from the typewriter and let me see what he'd written. "Do you think it's too silly?" he said when I'd finished reading it. "No, I think it's great," I said. The only thing I didn't like or wasn't sure of, I told him, was the title, which was "Personalism: A Manifesto." "Personalism is the name of a dopey philosophy founded in Southern California," I explained. "Oh, then I'll call it 'Personism,'" he said quickly. "That's better anyway."

A month earlier we were planning to meet Norman Bluhm for lunch at Larré's. Norman was flying to Paris that night and I thought it would be nice if Frank wrote a little something for the occasion. I guess, as precedent, I was thinking of such off-the-cuff occasional poems of his as the one for John Button's thirtieth birthday and the one celebrating Jane Freilicher's marriage to Joe Hazan. So I called him at the museum and told him my idea. "Are you crazy?" he said. "We're meeting him in less than an hour and I've got piles of work to do." But at lunch he gave Norman a poem, the one called "Adieu to Norman, Bonjour to Joan and Jean-Paul" and beginning, "It is 12:10 in New York and I am wondering/ if I will finish this in time to meet Norman for lunch." (Joan Mitchell and Jean-Paul Riopelle were flying to New York from Paris at about the same time, so the poem was written for them as well.) Come to think of it, I wonder if this story contradicts what I said earlier about Frank's never trying to get a poem going. Well, it's all speculation anyway. Maybe it's an example of action writing or spontaneous poetry. In any event, it's probably the only one of his Lunch Poems written before lunch.

Frank may have written in a casual, offhand way, but he also took his work seriously and had a high regard for it. By that I mean he had enormous confidence, and that was why he was so indifferent about being published, so free of envy, and so generous in the support of poets he admired. When an attack was leveled against Allen Ginsberg at a Wagner College symposium in 1962, Frank came to Allen's defense with an argument that was both persuasive and impassioned. As I recall, it was implied by someone in the audience that Allen's poetry didn't merit the attention it received. But Frank wasn't bothered by Allen's fame any more than he was by his own lack of it. At the same time he rarely put down poetry he didn't like,

and this attitude held for the work of the poets who won all the prizes. "It'll slip into oblivion without my help," he said once, then immediately began praising several poets whose recent work he admired. "But what about *your* work?" I asked at length. He looked at me as though he didn't understand the question. "What about it?" he said. "I mean," I said, "how do you think it stacks up against their stuff?" Very simply and without elaborating, he said, "There's nobody writing better poetry than I am." That was in 1961, if memory serves. But earlier than that, not too long after I met him, his confidence was so great that Paul Goodman interpreted it as downright arrogance. That was funny coming from Paul, though he may have had a point. But Frank's arrogance, if indeed it existed, was free of smugness, vanity and petty ambition.

791 Broadway

Now, at last, in the spring of 1963, we found ourselves ensconed in a clean, comfortable, cockroach-free, eminently handsome apartment. A floor-through loft converted into a two-bedroom apartment, it looked directly out on Grace Church and had enough wall space to accomodate big-scale paintings by Helen Franken- thaler, Alex Katz, and Mike Goldberg. But we made the move from Ninth Street with considerable reluctance, as it wasn't our style to devote time, money and energy to fixing up any of the places we lived in. Also, had it not been for Donald Droll, who occupied the second floor of the Broadway building, we would never have made such an ambitious move. Backed up by all of our friends, who seemed more depressed by Ninth Street than we were, Donald convinced us that we owed it to ourselves to live in a decent place.

It worked out beautifully—the apartment, I mean; Frank and I couldn't have been happier with the place. We had bigger and better parties, we filled the place with plants, we even managed to keep it reasonably neat. Beyond that, I find there's not much I can say about this final phase of our life together. It's still too close to me. Right now I attach some significance to the fact that lovely old Grace Church— as opposed to Joe's Deli and Garfinkel's Pharmaceutical Supply Company on Ninth Street—never found its way into Frank's poetry. But later on, I might see things in a different light. Frank, after all, was as energetic and as involved in life as he'd ever been. He kept up almost all of his old friendships and constantly added new ones; the last readings he gave, at the Loeb and the New School, were well-attended, particularly by the younger poets; his trips abroad for the museum were, I gathered from the way he talked, among the happiest and most enriching experiences of his life. And in 1965 and 1966, respectively, he organized and selected the Motherwell and Nakian shows. There was an engaging, semi-professional production of *The General Returns From One Place to Another* in 1964, and the year before his death *Lunch Poems* and *Love Poems* (*Tentative Title*) finally appeared. But I have no memories of, no stories to tell about, Frank's writing anything while I was living with him on Broadway. He didn't write a great deal then in the first place, and if he had I'm not sure I would have known about it. Gradually, our lives had become separate; he went his way and I went my way. And in a sense Frank's life, though no more hectic, had become less private, for it was move involved with his museum work than with his writing.

Yet the less we saw of each other, the more we got on each other's nerves. At Christmas-time, 1964, we had a series of long discussions and came to the conclusion that it was time to part. If we weren't going to share each other's lives the way we always had, we couldn't very well share the same apartment. We realized, too, that by separating we could go on being good friends. So in January, 1965, after nine and a half years, I went out and got a place of my own.

1. I recently asked Alvin Novak what he remembered about the play. He told me he thought it was inspired by a Lubitsch drawing room comedy from the thirties that Frank had seen that week at the museum. (That would figure, and the movie was probably *Trouble in Paradise,* which he described in his only movie criticism, an unsigned piece in *Kulchur*, as "the greatest drawing room comedy ever made.") But Frank's play was a drawing room comedy with a difference, namely its tragic denouement. It was set in a European capital during the thirties, and it was all very light-hearted and sophisticated, somewhat in the manner of Noel Coward and, as Alvin says, reminiscent of a Lubitsch movie. But I think Frank was making a comment on the period. At its climactic moment —and this is about all either Alvin or I can remember, as we'd read the play only once through quickly and its plot was awfully slight to begin with—the leading lady, whose part was written with Lotte Lenya in mind, throws herself in front of a diplomat or general to shield him from an assassin's bullet. As she dies, she explains (this was the play's curtain line): "I was afraid it would mean war."

2. This play I never read, and I've been unable to find anyone who remembers much about it. John Myers tells me it was inspired by an unusual house and household in Snedens Landing, N.Y., where Frank went for drinks circa 1954. The house, an architectural nightmare, spilled precariously over the side of a ravine, and the hostess was a bigger-than-life creature who'd had the doors removed from the johns. From what I gather, the play had absolutely no line of action.

3. The three-act play, called *The Heat of the Night*, dealt with the problems encountered by a young black and a pretty blonde who decide to marry. The girl's Quaker parents have no objection to the marriage, but the guy's proud, middle-class mother isn't sure the girl's good enough for her son. One teleplay, called *Stay Out of the Rain*, concerned a more conventional couple whose only problem was too much happiness, of all things, while the other one (untitled) had to do with the marital and financial problems of still another couple, a struggling New York painter and his ambitious wife. All three works had some good lines, most of them Frank's, but they also lacked genuine dramatic conflict.

4. As it turned out, Don eventually used another statement by Frank in his anthology, and "Personism" first appeared in LeRoi Jones' magazine *Yugen*.

1968
(*The World*)

Ossie Davis reading WHY I AM NOT A PAINTER in front of "Sardines" by Michael Goldberg on "Creative America," CBS-TV, 1963.

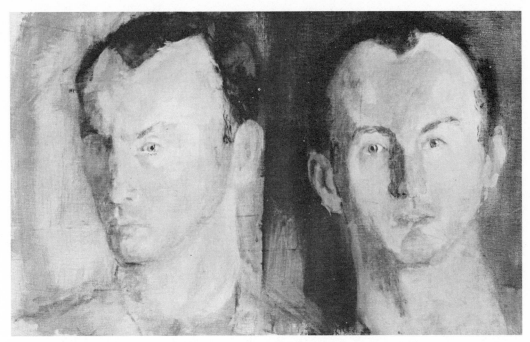

Larry Rivers. "Double Portrait of Frank O'Hara," 1955. The Museum of Modern Art.

I began doing portraits of Frank in the fall of '52. That was after I'd slit my wrists over something. I phoned Frank, who happened to be in, and he came over and bandaged me up. Then we began seeing a lot more of each other and it was only natural for me to use him as a model. Sex we got into later, when I'd already started drawing and painting him. There was always a dialogue going on during our working sessions. He gave me feedback and made me feel what I was doing mattered, and after a while I found I needed him for my work. He was a great model. For one thing, he liked to model; he even felt complimented that you asked him to, and you ended up wanting him to like you. He had blazing blue eyes, so if you were stuck you could always put a little blue to make the work more interesting. His widow's peak gave you a place to anchor the picture, and his broken nose was dramatic and easy to get. At the time, I had no idea I was making so many pictures of him; I think I must have made a dozen portraits, and that's not counting drawings or paintings like "The Studio" and "Athlete's Dream" he appeared in. I always felt I was close to getting him but I never did, so I kept on trying.

—Larry Rivers in conversation, paraphrased by Joe LeSueur

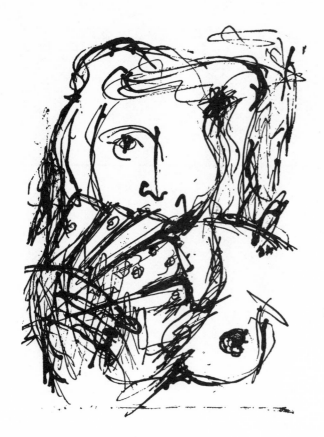

Rivers & O'Hara 1952-67

Drawing for A CITY WINTER, 1952.

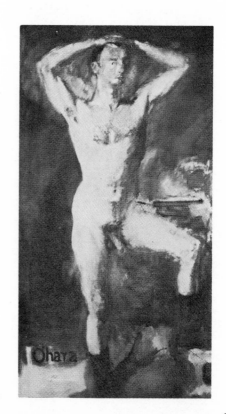

"O'Hara," 1954.

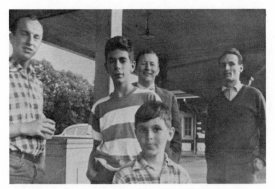

FO'H, Joe Rivers, Hal Fondren, Steven Rivers, Larry Rivers, Southampton RR Station, Spring 1954. (Photo: John Ashbery).

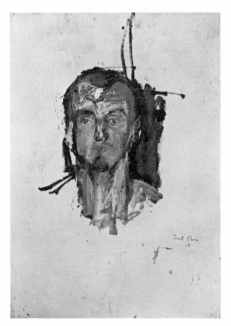

Oil on paper, 1956.

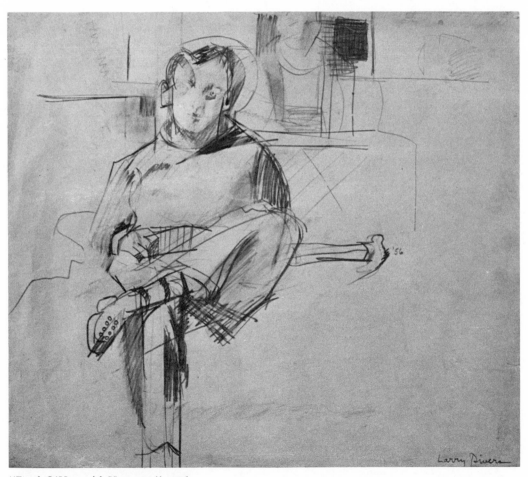

"Frank O'Hara with Hammer," 1956.

"It's Raining Anita Huffington," 1957. Collection: John
Bernard Myers.

"The Athlete's Dream," 1956.

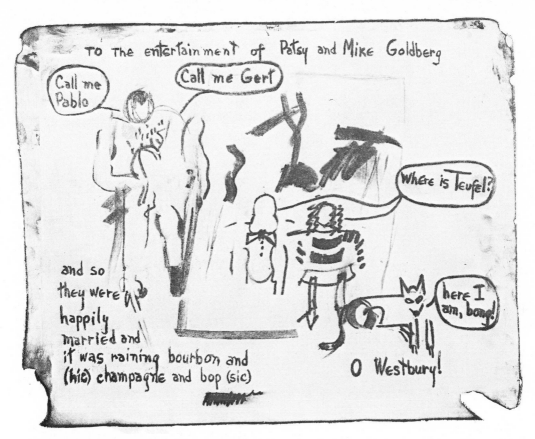

From STONES, 1957-8.

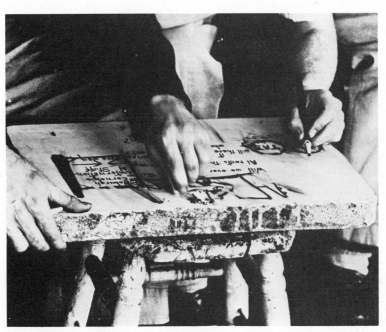

At work on STONES (Photo: Hans Namuth).

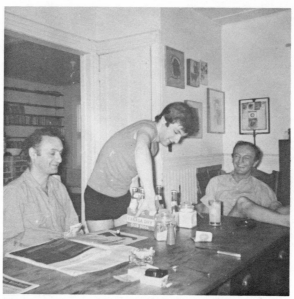

Larry Rivers, Steven Rivers, FO'H; Southampton, July, 1964.
(Photo: Bill Berkson)

Robert Duncan: *When Allen was talking about Kerouac the other day, I thought,
"Gee, no wonder we're in a common area that can be defined. We know that the
poem is an occasion of spirit. Yet my relationship with the New York school has
been very difficult—O'Hara was absolutely intolerant of my existence. My
correspondence with O'Hara was only one long letter to him when I read a
marvelous love poem of his and said, "What a pouring-out of soul this is!" But for
O'Hara it was wrong to have read his poem as a pouring out of soul, I guess, really.*

* * *

Allen Ginsberg: *I had come to San Francisco from New York, and simultaneously
there were poets in New York also who, oddly, had picked up on Williams—the
poets that Robert mentioned, Frank O'Hara, John Ashbery, and Kenneth Koch,
among others. They had picked up on Williams from, again, the point of view of a
common-sense statement. O'Hara had picked up on Williams because he saw
Williams as goodhearted. O'Hara did have passion, and of all those poets was
romantic in the sense of poetically romantic—in other words O'Hara did speak of
love. And I remember him receiving that letter from you and his comment on it,
which was, what he was going through was a feeling of complete freedom, that
anything written—just as with Kerouac, or with yourself, I think—that any gesture
he made was the poetic gesture because he was the poet, so therefore anything he
did was poetry.*

I'll just read a little poem of O'Hara's so we know what we're talkin' about.
(reads Poem ("Khrushchev is coming on the right day!"))

*So his poetry was all gossip, local gossip, social gossip, with sudden "ozone
stalagmites," inspired images of New York, mixed with blueberry blintzes, also
inspired. So that he felt any gesture he made was poetry, and poetry in that sense
was totally democratic. So that there were no kings and queens of poetry. So when
you wrote him, he saw you as the Queen of Poetry, giving him the scepter, and he
said "Well, I don't want a scepter from that old queen!" He wanted to be
independent, or, in the New York context, he felt it was like a San Francisco plot, so
he got paranoid, a little.*

(from "Early Poetic Community" discussion at Kent State
April 7, 1971; in ALLEN VERBATIM.)

CHOP-HOUSE MEMORIES

We took a boat to Provincetown one spring day, just Frank O'Hara and myself, to visit Edwin Denby, the poet, who lived all summer on the dunes, while Frank was in Cambridge at the Poets' Theatre on a Rockefeller Foundation grant. We worked together on John Ashbery's *The Compromise* or *Queen of the Caribou*; and on plays of Hugh Armory and V.R. Lang, not to mention Mary Manning's adaptation of *Finnegan's Wake*.

Frank introduced me to various poets before this, Edwin Muir, James Merrill, George Montgomery, May Sarton, and John La Touche and had sublet for that winter and spring of 1956 Lyon Phelps' apartment on Massachusetts Avenue, where we two met to read poetry once. He wanted me to visit Mr. Denby, who had been dance critic for the *New York Herald Tribune* during the early forties and who also wrote verse.

Frank worked on *Art News* sporadically as a critic and during the cruise to Provincetown, suggested I move to New York and write for them.

The hard, wooden planks of seats below deck, choppy waves as we sailed through Boston Harbor, sordid memories of lost love's jazz morning's intermingled in our devotion to each other so forced to change our mind often we roamed listlessly above deck fore and aft in search of surcease from the throbbing motors of the boat.

We both thought of suicide as the final resolution of our desire as we stood again below deck by the hectic Atlantic cutting at our feet, speaking of Hart Crane and the last words we would have in our mouths at that moment of surrender. Only chains saved us from its vengeful force. Masses of seagulls followed us down the coast and dark clouds forbade our entry into Provincetown Harbor.

Seated on the side of the dance floor we waited, music drifted out of the bar and told of the inability to dock on Cape Cod because of inclement weather. We glumly returned to Boston and my room on Hancock Street.

We had met Jack Spicer previously at the Harvard Gardens, and while I read my poetry in the humid summer evening of Beacon Hill, the both of them wept through the incipient rain and electric-charged air.

It was a dreadful room infested with roaches, as I mention in my Scenario for a Film published with Selected Poems, over twelve years later.

At that time Frank was always asking me for poems and when the Poets' Theater took *Finnegan's Wake* to New York for production at the YMHA Poetry Center, I went along and visited his rooms 90 University Place, which he shared with Joseph LeSueur, who worked for a while then at the Holliday Bookshop, and he got one printed in John Bernard Myers' *Semi-Colon*, out of the Tibor De Nagy Gallery on West 57th Street, writing me before that for them; the one called "With Mr. J R Morton" was my first published poem outside of undergraduate work.

We corresponded before that while I was a student at Black Mountain College in North Carolina and he says, July 21st, 1956:

> How are things down there in the South, where men are men and girls are glad? Are you writing lots and what is it like? Here it is raining and sort of light-grease-colored. It's been fairly cool and I've been out to visit Larry a couple of times and gone swimming etc., but haven't gotten up to New Hampshire yet. I think I may go before August and work is upon me, but inertia prevails and I just read all the time. Can't

write. I took your tip on Lawrence and read Aaron's Rod and am now in Kangaroo. Yes, he is marvellous. I used to have a lot of his poems but I can't find them now in this pig-sty and am dying to read The Ship of Death and get cheered up.

I met Jimmy Schuyler while out at Larry's, since he's staying in Southampton for the summer and he seemed very well and asked for you. He's at c/o Fairfield Porter, 49 South Main St., Southampton, NY, if you want to write him. I remember you said you wanted to, did you?

John Button and I saw one of the all time great movies the other day, LA STRADA and man, was it ever! It has Anthony Quinn, Richard Basehart (what a nice last name) and someone named Giulietta Masina who is a genius, she's the End. Also the director, Federico Fellini seems to have a few insights into the soul not often granted by the Heavenly Hiders. Do you know this poem of Thomas Hardy?!

"Had you wept; had you but neared me with a
* hazed uncertain way,*
Dewy as the face of the dawn, in your large and
* luminous eye,*
Then would have come back all the joys, the tidings
* had slain that day,*
And a new beginning, a fair fresh heaven, have
* smoothed the things awry.*
But you were less feebly human, and no passionate
* need for clinging*
Possessed your soul to overthrow reserve when I
* came near;*
Ay, though you suffer as much as I from storms
* the hours are bringing*
Upon your heart and mine, I never see you shed a tear.
The deep strong woman is weakest, the weak one is the
* strong;*
The weapon of all weapons best for winning, you have
* not used;*
Have you never been able, or would you not, through
* the evil times and long?*
Has not the gift been given you, or such a gift you refused?
When I bade me not absolve you on that evening or
* the morrow,*
Why did you not make war with me with those who weep
* like rain?*
You felt too much, so gained no balm for all your torrid
* sorrow,*
And hence our deep division, and our dark undying pain."

I went to his reading later that year at the Poetry Center after my return from Black Mountain and heard for the first time publicly his sonorous notes on the film industry in crisis and his Elegy to James Dean, whose photograph, now in my possession, he had stuck to the wall of Lyon's apartment, and his memorable "Ode on George Washington Crossing the Delaware." Allen Ginsberg and Peter Orlovsky met us after at a small German restaurant on Lexington Avenue and we cabbed downtown together for the first time to the *old* Five Spot in Cooper Square. Allen was unknown then and sat on my lap and Frank accused me of liking him too much.

We were both at the terminus of separate love affairs and would console each other on the banks of the Charles, the old Cronins' off Howard Square and upstairs

at Joe's over Wursthaus for the mistakes we made, one loving too desperately and the other too hard. How mad we were on moonlit nights and railways stations, bidding farewell and future encounter.

Meet again we did, at Morris Golde's apartment for an evening soirée, with Aaron Copland in attendance, Virgil Thomson, Marc Blitzstein and Alvin Novak, at his own apartment, where I was a house-guest to meet John and Jane (Wilson) Gruen and take phone messages from Grace Hartigan and Jane Freilicher, and at his close friend's John Button, finally to meet Edwin Denby, whose calligram by Frank I later was to see in print.

Our friendship lapsed when I moved to California in October of 1957, though I did get to see all of *Second Avenue* years before it appeared.

His earlier work had been brought to my attention also and I remember what delight *A City Winter and Other Poems* elicited, before he was surrounded by museum vagaries and lesser-known versifiers. What pleasure to meet years later when he was truly well-known, and living off Tompkins Park. I would visit him in the half-dark apartment before poetry readings and off to dinner at Sing Wu with Kenneth Koch and Kynaston McShine, whose friendship Frank and I shared, then later on Broadway for a small-time Saturday afternoon and the crowded events of John Ashbery's return from Paris and Edwin's 60th birthday party, upstairs, with Stella Adler, Rudolph Burckhardt, LeRoi Jones, Bill Berkson and Barbara Guest as faithful guests.

News of his death was a painful shock. I had written him from Italy the summer before of the great joy the poetry festival he had arranged for us with Gian-Carlo Menotti brought and how I longed for him to be north of Rome, with Stephen Spender, Charles Olson and Ezra Pound.

Little did we know those summer weekends would be so disastrous and that the simple fun of Fire Island or Race Point would run out such a pointless end. Poignant hoydens, we reviled death, as witness his words on V.R. Lang :

> "Well it's just as well that we didn't write each other sooner since I've been fiendishly depressed. Isn't Bunny's thing the worst thing that ever happened, I mean in my life (because with love ruined you can always see your way to blaming yourself for a few things and then give yourself some post-mortem whacks or do anyway), but I never really thought such a thing could happen. But I have gotten out of it somewhat, not meaningfully, I don't know how, but am in it less frequently, so it just nags and makes me feel tiresome and malevolent and malicious and not feeling like doing the world no good. Or life or god. Fuck that. It is a hopeless dealing because if I did reach a rationale it would mean I had adjusted, it would mean nothing to her being, and what we want to do is alter if not destroy facts, isn't it? I mean is it? I'm sorry, this is fruitless."

(May 1968)

FRIENDSHIP GREETINGS

Carelessly all fixed up a can of beer
several cigarets a cup of coffee I don't care
whether school keeps or not
thinking of Frank O'Hara in Paris right this minute
or the basement of the Museum of Modern Art as the case may be.

 23:ix:61

INSIDE STUFF

Swede-bread honey and tea to breakfast half a canteloupe
Honey inspires prophecy & beneficent wishes, thus:
 Boundless ancient delight for Frank O'Hara
 Kerouac will get the Pulitzer Prize *Visions Of Gerard*
 I shall travel to my death in a far country

 Frank has Hart Crane's eyes.

 15:x:63

 Philip Whalen

Willem de Kooning: Drawing for IN MEMORY OF MY FEELINGS, 1967, Museum of Modern Art.

My arrival in Black Mountain the spring of 1954 was equally a coming to that *viability* in the language of an art without which it, of necessity, atrophies and becomes a literature merely. Robert Duncan, in recent conversation, recalls that that was then his own intent, "to transform American literature into a viable *language*—that's what we were trying to do..." Speaking of Frank O'Hara, he notes that extraordinary poet's attempt "to keep the *demand* on the language as *operative*, so that something was at issue all the time, and, at the same time, to make it almost like chatter on the telephone that nobody was going to pay attention to before...that the language gain what was assumed before to be its *trivial* uses. I'm sort of fascinated that *trivial* means the same thing as *three* (Hecate). Trivial's the *crisis*, where it always blows. So I think that one can build a picture, that in all the arts, especially in America, they are *operative*. We think of art as *doing something*, taking hold of it as a *process*..."

Robert Creeley
(from "On The Road: Notes on Artists and Poets 1950-1965," in *Poets Of The Cities*, 1974).

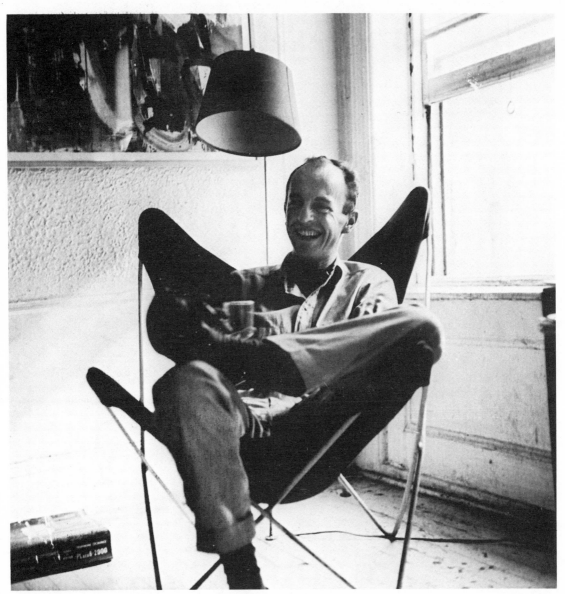

In 441 East 9th Street, September 26, 1959.

10 Photographs by Fred W. McDarrah

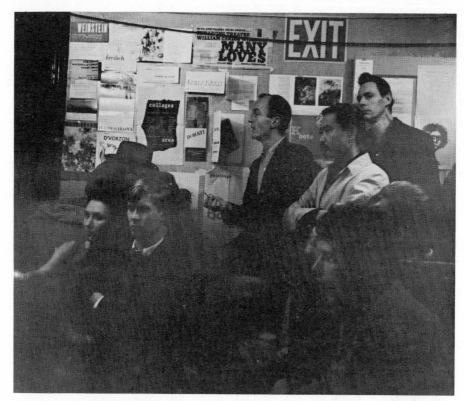

At The Club, with Lucia Dlugoszewski, Joe LeSueur, Mike Kanemitsu, Ronald Bladen, Golda Lewis, March 1959.

With Franz Kline at the Cedar, March 1959.

Benefit reading for Yugen with Ray Bremser, LeRoi Jones, Allen
Ginsberg, The Living Theater, November 2, 1959.

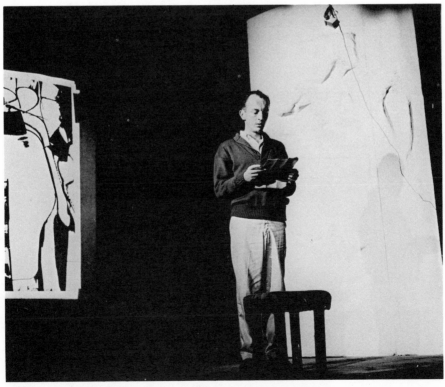

Reading for A New Folder, The Living Theater, June 12, 1959.

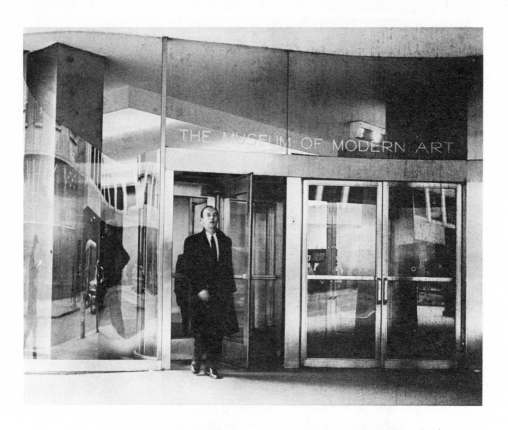

January 20, 1960: (top) at The Museum of Modern Art, (below) on Fifth Avenue.

"In a midtown bar," January 20, 1960.

Closing night of the original Cedar Tavern, with Barbara Guest, Allan Kaplan, Abram Schlemowitz, Jack Micheline, et al, March 30, 1963.

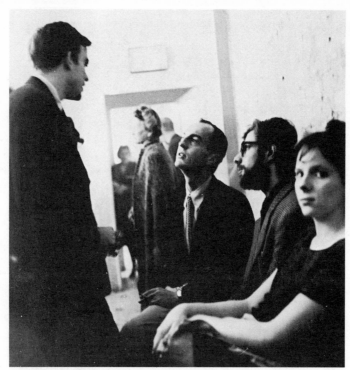

With Vincent Warren & Peter Orlovsky at The Living Theater, 1959.

Vincent Warren

Frank. Frank and the Dance. Frank and Me. It's all in his poems. I think his whole life is. Reading them now in Don Allen's marvelous *Collected Poems of Frank O'Hara* I am learning things I never knew about him. The poems are all full of personal references that mean so much to me—and maybe nothing to strangers—but there are *many* references in the earlier poems that I don't get, except the intimacy of Frank's feelings about whatever he's referring to—so I guess the "strangers" who read the love poems too, get what Frank's talking about. I hope so. But my "familial anxieties" in "Saint" and the references to Florida (I was born there) and Canada (I left him to work here) were shared secrets between Frank and me—and now the world. St. Paul, mentioned in at least 2 poems, is a play on my middle name. The "Airplane Whistle (after Heine)" was one of the crackerjack prizes I used to give him which he'd carry in his pocket with other charms—and "Hate is only one of Many Responses" was written because I resisted being drawn into arguments. One of Frank's greatest qualities was not being afraid of emotional upheavals when they were necessary, he was very healthy that way, and would expend enormous energy, exhausting himself and his friends, whenever he felt the time was ripe for it. He faced crisis bravely and forced his friends to do the same—and we all did, with his help of course—and we relied on his help. Almost all of the poems written from the summer of '61 after which I was in N.Y.C. for only short periods of time) have these extra meanings for me—but then, because of Frank, everything has extra meaning for me. He marked my life. He marked the lives of everyone he loved and the joy is that through his poems he can reach other people.

About the dance. Frank, of course, was a great fan. We would go together to

the N.Y.C. Ballet which was still playing at the City Center—with a very different audience from the one they presently have at Lincoln Center—a faithful band of intellectuals delighting in Balanchine's latest masterpieces. We went two or three nights a week. My dream was to join the company, for that I studied faithfully until I realized I wouldn't be as happy dancing Balanchine ballets as I was watching them.

Frank and I thrilled together to Melissa Hayden in "Allegro Brillante," (3 years after Frank's death I partnered Melissa in this same ballet in London and Paris—and thought of him all the time), Patricia Wilde in "Divertimento No. 15," (again, there was a special meaning for me when I danced it later in Germany), Diana Adams and Allegra Kent in "Agon" and Violette Verdy in "Tchaikovsky Pas de Deux." Frank loved them all. I never saw Tanaquil Le Clercq, (except in films, much later, when I finally understood), but Frank spoke of her poetic intelligence in "La Valse" particularly of an expression of abandon when she put her arms into the long black gloves offered to her by Death—and he was a staunch fan of Maria Tallchief—whom I never cared for, notwithstanding my admiration for her technique, but Frank talked about her earlier performances, which I hadn't seen, in such a vivid way it made me look for and find remnants of her hard, diamond-like style and understand how perceptive a dance fan he was.

He also admired the modern dance—Merce Cunningham, Paul Taylor and others—and saw and wrote about, retrospectively, James Waring's "Dances before the Wall," a poem full of slapstick references to figures in the modern dance world.

One of his dearest friends was Edwin Denby, the poet, who is as well one of the most lucid critics in the history of dance literature. Frank also knew Lincoln Kirstein, General Director of the N.Y.C. Ballet, and told me once of a libretto he wrote at Lincoln's request. He chose "The Seasons" and wrote a wildly romantic story about a nymph (to be danced by Le Clercq) and faun (Nicholas Magallanes) to be done in modern dress—it doesn't sound very Balanchinesque—it was refused not because of the story, but because "Mr. B." didn't like "The Seasons"—though years later he did a marvelous Glazunov ballet, so maybe it *was* the story—however this was all before my time. A ballet which meant a lot to us both was "Liebeslieder Walzer." It inspired me to write my one and only poem—which I include here only because it shows how I felt about Frank at the time (I even copied his style) and also how we referred to the dancers by their first names although neither of us knew any of them offstage very well (I from classes and Frank from cocktail parties) but we felt intimate with them all when they were onstage.

An Evening with Frank ("Liebeslieder Walzer")

I

Selfishly, as usual, I want to be alone,
Drawn into love
I rebel.
After a trip through France and China
We arrive at the ballet.

II

Jillana, high kicking with Conrad,
Violette and Nicky, moody and romantic,
Diana, hoydenishly skipping with Bill,
Millie being gently pushed by Jonathan
And me clutching at your knee.

III

At Morris' party I kiss Maxine and Marc.
Ann Truxel rubs her breasts on my back,

Talks with Gene, Bob Cornell,
Andrea, Rudi and Richard Barr
And a real talk with you.

IV

As I walk home alone (because you love me)
I pass a group of deaf people
who don't hear me—they laugh
at a joke told in sign language
and silently I love you.

1960.

In the spring of 1966 Frank and I came together again. I decided to return to N.Y. We had one beautiful weekend at Patsy Southgate's on Long Island in June and Frank was planning to come to Montreal in August to see what would have been my last performance here when his life was interrupted.

Montreal 1973
(*Panjandrum 2 & 3*)

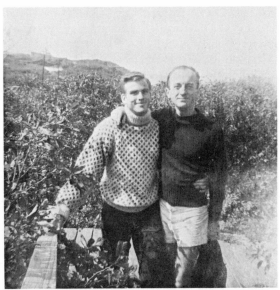

With Vincent Warren at Water Island. October 1960.
(Photo: Morris Golde.)

Franz Kline: Etching with Poem by Frank O'Hara,
from the portfolio "21 Etchings and Poems," 1960.
Collection: The Museum Of Modern Art.

Frank and I happened to be in Paris at the same time in the summer of 1960. I was staying there with my family and had been very busy with the Guide Bleu looking at every placard on every building I could find. And I had located the "bateau lavoir" where Picasso and Max Jacob had first lived and where they had held all those studio parties with Apollinaire and Marie Laurencin. And across the street was a very good restaurant. I suggested that we have lunch there, our party included Grace Hartigan and her husband at the time, Robert Keene. We had a "marvelous" lunch, much wine and talk and we all congratulated ourselves on being in Paris and moreover being in Paris at the same time—a continuation of the Cedar St. Bar, where we had formerly and consistently gathered. After lunch I suggested that we cross the street to the "bateau lavoir," a discovery of mine and one I thought would intrigue Frank. Not at all. He did go across the street, but he didn't bother to go into the building. "Barbara," he said, "that was their history and it doesn't interest me. What does interest me is ours, and we're making it now."

Barbara Guest

Irving Sandler

SWEEPING UP AFTER FRANK

In one of his poems, Frank O'Hara called me "the balayeur des artistes" and admitted that he too was a sweeper-up after artists: "(Sometimes I think I'm 'in love' with painting.)" And so he was. His passion led him to assume a public role in the New York art world, as a critic for *Art News* and a curator at the Museum of Modern Art.

Frank's contribution in both jobs was substantial, such was his taste and knowledge of art, but what was really important about his public role was that it augmented his private role, that of the friend of artists. He had the ability to focus in on someone he liked so intensely that the one could only feel like Frank's best friend—and he had the generosity to have had dozens of close attachments, as Larry Rivers said. His attention was of vital significance to artists, literally sustaining them. Morton Feldman wrote that "what really matters is to have someone like Frank standing behind you. That's what keeps you going. Without that your life in art is not worth a damn."

I find it difficult to talk about Frank's generosity to me without sounding pretentious—the self-aggrandizement of the statement: he saw my promise when, before anyone else, and he tried, not just talked, really tried, to help me along. Frank did that for me without asking, twice that I know of. Neither of us said much about it.

Frank was to be found wherever lively artists met, and naturally he attended the Club, organized by the Abstract Expressionists in 1949. Because he was admired as a poet, critic and curator by the artists, he was asked to participate in panels and to read from his own writing. For example, on April 19, 1957, he took part in a panel discussion entitled "The Painter As His Own Poet," with David Hare, Nicholas Marsicano and Harold Rosenberg who moderated. It was my privilege on that night to sweep after Frank. Below is a summary of his comments jotted down in long hand and therefore not word for word. (Unfortunately, I lack Frank's ability to recreate an artist's conversation, making it appear truer to the personality of the artist, as I am sure he did in his brilliant interview with Franz Kline. Only by inventing could Frank have "recorded" Kline's quick, intricate and witty verbal style as convincingly as he did.)

When Frank's turn came to speak, he remarked that painters when they talk immediately declare that they are inarticulate. This has charm. Many painters talk in paradoxes, and this too is nice. Poets are just as inarticulate as painters when they talk about how it is done. Poets who have distinguished themselves as critics—Baudelaire, Apollinaire—talked it over with the painters first and made a work of it. It was not just jotting things down. It was work. Baudelaire was critical. Apollinaire wrote prose poems.

In response to Rosenberg's question as to whether artists should talk, Frank said they should. To whom? You can talk to a wrong person, but it doesn't matter. What's important is what the artist didn't say. Everyone knows this. The rest is propaganda. We can't be afraid of unfriendly people. It is necessary to verbalize if anyone is interested, because it places you in society. You are free not to believe.

Later Frank elaborated on the relation of the artist as his own poet and the poet as his own poet. What poet means in this sense is critic, one who explains art and poetry in another medium, namely prose. Poets are no better at elucidating a work of art or poetry than anyone else. They are often the worst critics—worse than having no poet at all. The poet as critic succeeded when he was a great poet writing about a great painter—two great men in one package. Frank ended this remark by saying

ironically that today art does not require explaining. Everyone goes to galleries. No one reads poetry.

Frank then talked about conventions of communication about art, the most common of which was to take an important component in a work and to make it a point of contact between the work and its audience. Apollinaire found cubes; Baudelaire, Romanticism. Verbalization about art is of use when a writer by a freak gets ahold of something meaningful to the artist which is also communicable to the public. But an artist can also be his own poet. Look at Picasso who can write with the poetic vision he has in his painting. He doesn't need some literary bird to act as an intercessor to the public.

Frank concluded that what is really needed is more intercommunication among artists.

Addenda

Other Club panels in which Frank participated were:

"A Group of Younger Artists," March 7, 1952, with Jane Freilicher, Grace Hartigan, Alfred Leslie, Joan Mitchell, John Myers (moderator), and Larry Rivers. This panel was one of a series on Abstract Expressionism. See P.G. Pavia, "The Unwanted Title: Abstract Expressionism,' *It Is 5*, Spring 1960, and my article on "The Club," *Artforum,* September 1965.

"The Image in Poetry and Painting," April 11, 1952, with Nicolas Calas (moderator), Edwin Denby, David Gascoyne, and Ruthven Todd. Frank may have spoken on "Design Etc.," the notes of which appear in *Standing Still and Walking in New York.*

"New Poets," May 14, 1952, with John Ashbery, Barbara Guest, Larry Rivers (chairman), and James Schuyler.

"Where the arts Meet,' April 3, 1952, with John Cage, Herbert Ferber, John Ferren, and Ary Stillman.

An untitled panel, April 1, 1954, with Philip Guston, Harry Holtzman, Franz Kline, Willem de Kooning, Joan Mitchell, Roy Newell, Ad Reinhardt, and Larry Rivers. I have a postcard from the Club which says that this panel took place and who was on it but nothing more.

"A Panel on Frank O'Hara's Essay: 'Nature and New Painting,' " January 21, 1955, with Alfred Barr Jr., Clement Greenberg, Hilton Kramer, and John Myers (moderator).

"Nature and New Painting II," January 28, 1955, with Michael Goldberg, Grace Hartigan, Elaine de Kooning, Joan Mitchell, and Milton Resnick. Frank moderated.

"Nature and New Painting III," February 11, 1955, consisted of Thomas Hess, Harry Holtzman (moderator), Franz Kline, Willem de Kooning, and Ad Reinhardt. Frank was in the audience and spoke from the floor during the open discussion.

My notes are very fragmentary at this point, but they indicate that Reinhardt in response to a statement by Aristodemis Kaldis said: I didn't know I was involved in geometry. Wolf Kahn then talked of his feeling for nature and for painting, and of his intention of turning a subject into a painting. Hess asked: Why can't Ad feel strongly about a square? Frank interjected: No one feels naturalistically or abstractly when one paints. Reinhardt questioned whether using subjects as keys to painting, that is, providing easy access for viewers, is valid. Frank responded: A painting can look like something. Reinhardt asked: But if it does, can it transcend. Frank said: Yes. It just refers to life. Reinhardt concluded: Perhaps life is what we should be talking about.

I also recall an exchange between Hess and Frank as to whether the dictionary meaning of words in poetry is comparable to the meaning of subject matter in painting, the specifics of which I did not jot down.

"Hearsay," April 25, 1958, with Norman Bluhm, Michael Goldberg, Elaine de Kooning, and Joan Mitchell. The script was published as "5 Partipants in a Hearsay Panel," *It Is 3,* Winter-Spring 1959. An accompanying note states that the script was primarily conceived and recorded by Elaine de Kooning after three evenings of private discussion with the

participants, but was "tampered with by Frank O'Hara" and further altered by other members of the panel.

My notes indicate that during the discussion period, someone in the audience asked: What is our attitude toward our elders? Frank responded: Works of art don't compete. They are either exemplary or not. It has nothing to do with age or anything like that. Harold Rosenberg once said that talk about different generations has to do only with publicity. Your career depends on where you are; that doesn't affect the quality of your work. Art has an absolute value.

* * *

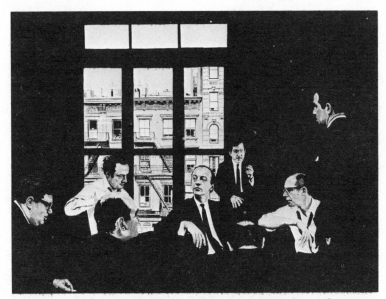

Howard Kanovitz: "New Yorkers II," 1966, Liquitex. (*Left to right:* Morton Feldman, Larry Rivers, Sam Hunter, Frank O'Hara, Howard Kanovitz, B.H. Friedman, Alex Katz. "His back turned to the viewer is no one.") Collection: Mike Stoller.

Salut
Frank
O'Hara

de Paris

le jour
de Noël
1960

a vous

un bon jour
d'un ami

J'ai lu
le
Poème
là
dans

Big
Table

bonne
année !

Jean
Dubuffet

FRANK O'HARA: POET AMONG PAINTERS (excerpts)

I first met Frank at a party at John Myers' after a Larry Rivers opening: deKooning and Nell Blaine were there, arguing about whether it is deleterious for an artist to do commercial work. I was most impressed by the company I was suddenly keeping. A very young-looking man came up and introduced himself (I had already read a poem by Frank in *Accent*, the exquisitely witty "Three Penny Opera," written either at Harvard or at Michigan). He asked me if I had read Janet Flanner that week in the *New Yorker*, who had just disclosed the scandal of Gide's wife burning all his letters to her. "I never liked Gide," Frank said, "but I didn't realize he was a *complete* shit." This was rich stuff, and we talked a long time; or rather, as was so often the case, he talked and I listened. His conversation was self-propelling and one idea, or anecdote, or *bon mot* was fuel to his own fire, inspiring him verbally to blaze ahead, that curious voice rising and falling, full of invisible italics, the strong pianist's hands gesturing with the invariable cigarette.

Frank told me he had taken a job at the Museum of Modern Art, working in the lobby at the front desk, in order to see Alfred Barr's monumental retrospective of Matisse. Frank had idols (many) and if Matisse was one, so was Alfred Barr, and remained so during all Frank's years of association with the museum. The first time I dropped by to see him, I found him in the admissions booth, waiting to sell tickets to visitors and, meanwhile, writing a poem on a yellow lined pad (one called "It's the Blue!"). He also had beside him a translation of André Breton's *Young Cherry Trees Secured Against Hares* (although he made translations from the French— Reverdy, Baudelaire—his French was really nothing much). Soon we were sharing an apartment on East 49th Street, a cold water flat five flights up with splendid views.

Frank O'Hara was the most elegant person I ever met, and I don't mean in the sense of dressy, for which he never had either the time or the money. He was of medium height, lithe and slender (to quote Elaine deKooning, when she painted him, "hipless as a snake"), with a massive Irish head, hair receding from a widow's peak and a broken, Napoleonic nose: broken in what childhood scuffle, I forget. He walked lightly on the balls of his feet, like a dancer or someone about to dive into waves. How he loved to swim! In the heaviest surf on the south shore of Long Island, often to the alarm of his friends, and even at night when he was drunk and would turn waspish. That was both unpleasant and alarming, since he would say whatever came into his head, giving his victim a devastating character analysis, as with a scalpel.

Frank's friends! They came from all the arts, in troops. As John Ashbery has written in his introduction to *The Collected Poems* (nearly seven hundred pages of them): "The nightmares, delights and paradoxes of life in this city went into Frank's style, as did the many passionate friendships he kept going simultaneously (to the point where it was almost impossible for anyone to see him alone—there were so many people whose love demanded attention, and there was so little time and so many other things to do, like work and, when there was a free moment, poetry.)"

Then there were the events. Frank was in love with all the arts: painting and music and poetry, almost all movies, the opera and, particularly, the ballet. Then there were the parties and dinners and old movies on late night TV. When did the poems get written?

One Saturday noon I was having coffee with Frank and Joe LeSueur (the writer with whom Frank shared various apartments over the years), and Joe and I began to twit him about his ability to write a poem any time, any place. Frank gave us a look

—both hot and cold—got up, went into his bedroom and wrote "Sleeping on the Wing," a beauty, in a matter of minutes.

Then, his book *Lunch Poems* is literally that. In 1955, Frank became a permanent member of the International Program at the Museum of Modern Art at the behest of the then-director, Porter A. McCray. I later wended my way into the same department and had ample opportunity to observe Frank in action. He would steam in, good and late and smelling strongly of the night before (in his later years, his breakfast included vodka in the orange juice, to kill the hangover and get him started). He read his mail, the circulating folders, made and received phone calls (Frank suffered a chronic case of "black ear": I once called him at the museum and the operator said, "Good God!"; but she put me through). Then it was time for lunch, usually taken at Larré's with friends. When he got back to his office, he rolled a sheet of paper into his typewriter and wrote a poem, then got down to serious business. Of course this didn't happen every day, but often, very often.

It has been suggested that the museum took too much of so gifted a poet's time. Not really: Frank needed a job, and he was in love with the museum and brooked no criticism of it. At times, of course, he became impatient with the endless and often seemingly petty paperwork connected with assembling an exhibition, and I have seen him come from an acquisitions meeting with smoke coming out of his ears (he never divulged a word of what passed at these highly confidential affairs). But Frank had a rare gift of empathy for the art of any artist he worked with; he understood both intention and significance. And he was highly organized, with a phenomenal memory. When I say "he got down to work," I mean it; he worked, and he worked really hard.

(*Art News*, 1974)

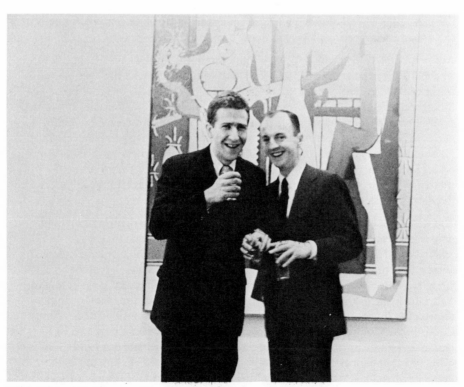

With Michael Goldberg at The Museum of Modern Art, ca. 1960.

FRANK O'HARA IN THE MUSEUM

I first met Frank early in 1955 when he began working for The Museum of Modern Art's International Program. He was hired by Porter McCray, then Director of the International Program, on a temporary assignment to an exhibition then in preparation for showing in Paris. I had joined the staff of the International Program a few months previously. The exhibition to which Frank was assigned, *From David to Toulouse-Lautrec: French Masterpieces from American Collections*, was to be shown at the Musée de L'Orangerie in Paris later that spring. Frank's work on this exhibition was to coordinate the correspondence with lenders and to assist with some of the complex organizational details. The work did not require art History background or curatorial experience, but it needed administrative ability—mainly common sense, the talent to pick up on detail and to draft clear business correspondence. Frank had a good organizational sense which carried him through work on the exhibition, and in the process he began to learn about museum techniques and the specific museum scene at "the modern."

By this time Frank was already in the thick of the art world, having moved to New York in 1951. He had worked briefly but memorably (with a few good stories to document it) as Cecil Beaton's secretary,* and at the end of 1951 had begun working at The Museum of Modern Art's bookstore, where he remained for the next two years. In 1953 he began writing for *Art News* (where, under Tom Hess's direction, aspiring poets and writers could find some means of survival). He had already met and become friends of many of the leading abstract-expressionist artists and participated in several of their panel discussions at The Club on East 8th Street. The Cedar Bar, their meeting place, was home away from home for him.

As for me, I had only been in New York a few months, having come from Oregon where I had worked at the Portland Art Museum for two years. I had seen a few works by Pollock, de Kooning and other abstract-expressionists in a traveling exhibition organized by The Museum of Modern Art and shown in Portland, but mostly my awareness of contemporary American art was through art magazines, and especially Clement Greenberg's articles in *Partisan Review*. I had come to New York for graduate study in art history at NYU's Institute of Fine Arts, but like so many others I was particularly drawn to New York as center of the art world. Since I wanted to pursue a museum career in the modern field, it was great good luck to be hired by Porter McCray almost immediately after my arrival.

The timing for both Frank and me couldn't have been better. The museum had only recently established its International Program under Porter McCray (in 1952) and it created a sudden upsurge of activity in preparing exhibitions for circulation abroad. The program's intent was to stimulate cultural exchange programs in the visual arts between the United States and other countries. Elsewhere such programs were largely the province of governmental agencies or ministries, and in many respects the International Program was similar to organizations like The British Council which promoted British art abroad. However, it was not restricted to a national promotional role, as most such organizations were, since its exhibitions could be international in character and cover the entire field of modern art. Moreover, the program also organized exhibitions of foreign art for showing within the museum and for tour throughout the country, hence its activities were to some degree reciprocal.

My own work in the museum was at first almost entirely clerical and technical. I

helped supervise framing and packing, prepared handling instructions and other material accompanying the exhibitions, and typed endlessly for other aspects of the exhibitions, especially for catalog and publicity material. Later on I served as an exhibition assistant, requesting loans and coordinating the preparation and cataloging of the works. I became increasingly involved in advance planning for exhibitions and in general administration of the department and became its Assistant Director, later heading the department after Porter McCray's resignation in 1961.

Porter McCray was a superb and demanding teacher, one from whom Frank and I learned enormously. With the perfectionist's attention to detail, he conveyed to us how an exhibition is organized, from the persuasive wording of letters requesting the loan of works of art through all the concrete details of assembling the works, examining them for condition, framing both for protection and effective presentation, installation design, and packing and shipping. Frank and I shared a love of these concrete operations which are not only fascinating in themselves but a way of expressing your respect and affection for the work of art and of getting to know it intimately.

After completing work on *From David to Toulouse-Lautrec*, Frank was given a permanent position on the staff as an administrative assistant, but held that position for only a few months (until December 1955) when he resigned to accept a fellowship at the Poets' Theatre in Cambridge. My collaboration with Frank and our friendship really began when he returned to the museum in 1956. I still recall vividly my first real impression of him the year before—one afternoon when we had coffee in the museum's penthouse restaurant. Perhaps I remember it so well because the memory is conflicted: he was in a rather campy, teasing mood, I think, and I felt a little embarrassed and fascinated at the same time. His voice—the same voice I hear in the poems—was soft and slightly nasalized, with odd flat traces of Massachusetts accent which I couldn't place and which still seemed very New York. He wasn't handsome but he had a kind of beauty: the taut Irish fairness and freckles, the high brow and profile like a Roman coin with an elegant thug's broken nose, the delicate curving mouth. We talked about opera or movies or both.

The friendship developed slowly and I can't now recall the stages until it became a real infatuation of friendship. Of course our work at the museum was the binding ingredient: it wasn't long until we learned that the things we wanted to do in the museum we could best do together. But there was so much else besides. Perhaps dance most intensely. I had studied a little ballet and modern dance (continuing, a little later in the 'fifties, with Aileen Pasloff and occasional classes from James Waring, in whose company Vincent Warren danced, and later still with Paul Taylor's company members.) Edwin Denby's book "Looking at the Dance" was a great inspiration for me, and I was as thrilled to meet him through Frank as any of the painters and sculptors to whom Frank introduced me. Frank and I talked endlessly about Balanchine's ballets, to both of us, I think, as important works of art as those by Matisse or Picasso. The great stars of the New York City Ballet in that period were Maria Tallchief, Tanaquil LeClerq and Diana Adams, each with distinctive gifts to be recounted and reseen through one another's eyes. But the stars from the recent past—above all the matchless Alexandra Danilova who had introduced both of us to the miracle of the great dancing, Alicia Markova, Hugh Laing, Frederick Franklin, Igor Youshkevich, Nora Kaye, Alicia Alonso—were almost as vivid, and so were the young dance geniuses then emerging (Allegra Kent, Edward Villela whose first "Prodigal Son" left no dry eyes, later Suzanne Farrell).

Music, too, with opera dominating. Many imitations of Zinka Milanov's grand stage gestures, reminiscences of her "Norma" and "Gioconda" and "Ballo in Maschera." I remember John Ashbery once gave Frank tickets to "Ballo" for his

birthday in return for tickets to "Manon" for his; Manon's "Je suis encore co-quette" was a favored line. A great performance I remember was a Leontyne Price "Butterfly" which my wife and I saw (partially and with many tears) with Frank from the extreme side of the Met's Family Circle. At lunch in La Scala Restaurant on 54th Street we could see Dmitri Mitropolous, whose great conducting of "Woz-zeck," "Ernani," "Walküre," "Onegin," indeed anything in his incredible reper-toire, was an inspiration. From Frank I learned to take seriously composers I thought were silly (Saint-Säens, Rachmaninov, Grieg, Lizst); to listen more carefully to composers I already knew; and to hear more completely the classic moderns (especially Berg and Webern) and for the first time the new (Ben Weber and Morton Feldman). The composers I most associate with Frank (after Rachmaninov) are Prokofiev and Poulenc: both romantics with a qualifying irony. The best portrait of Frank I know is the second movement of Poulenc's Sextet for piano and winds: it's not just that I heard it with him, it's the clear dry grace of the piece that reminds me of him.

So much talk, often over martinis after work which left me gasping for air in the taxi afterwards, or an infrequent long lunch at Larré's, or dinner after an opening. In those days the gallery opening was a ritual event. Almost every Tuesday we went to Sidney Janis, Martha Jackson, Leo Castelli, Tibor de Nagy, Betty Parsons, the Stable, Sam Kootz or Poindexter. Frank was for a long time my cicerone, making some bridge into what so often seemed hostile ranks.

And always the talk came back to the new art which was being made almost before our eyes. Of all its aspects, I think it is the grandeur of the best of American painting and sculpture to which Frank responded most deeply. ("Grandeur" is a word which frequently recurs in his writings about their work). His own personal style was casual, off-hand, anti-heroic, but he was attracted to "stars" and particularly by those "stars," whether Marilyn Monroe, James Dean or Jackson Pollock, who possessed a tragic aura. His love of the virtuoso performer could find as much dazzling virtuosity in de Kooning's paintings or Smith's sculptures as in Horowitz playing Scriabin or Tallchief dancing "Raymonda." Perhaps most of all he was inspired by the artists' confrontation with themselves as the source of their art. I think in a sense this gave him permission to do the same thing in his poetry. I remember Frank quoting a line from O'Neill's late one-act play "Hughie": "He gave me confidence." It refers to the gift of love from a friend who is never seen in the play. I can hear him say the line, his voice became husky as he said "confidence," there were tears in his eyes. I think the painters and sculptors gave Frank confidence.

He had a lot of confidence himself, or at least he projected it. It may have been that quality, that conviction, which Porter McCray saw, along with Frank's energy and enthusiasm, and which encouraged him to support Frank in assuming more respon-sibility for selecting exhibitions. It was not always easy for Porter to do so. In the early years Frank was under suspicion as a gifted amateur. He didn't have the credentials of art history training or a long museum apprenticeship to support his claim to direct exhibitions. His very closeness to the artists was questioned as a danger to critical objectivity. (He was very aware of this, and I know from conversa-tions with him that he weighed the considerations of personal friendship very care-fully). He wrote eloquently about the artists he admired, but not with the analytical distance of the scholar nor the broad theoretical base of the critic. Essentially he was the artist's spokesman, and that was considered in some quarters a questionable role for a museum professional and compromising to the institution.

He was very adroit in adapting himself to the institution. So little an "organization man" himself, he managed to work within it and yet keep a distinct separation from it. It was a special quality of grace he had, and no mean feat. He had a wonderful facility for collaborating with others without losing his own identity or unduly

imposing it. It gave him pleasure, as you can see from his collaborations as a poet working with painters, and this seemed to be true at the museum as well, even when his collaboration was essentially on a subordinate level, as it was on several exhibitions for which he assisted Dorothy Miller, James Thrall Soby or René d'Harnoncourt. He had such an equable temperament, he communicated so much wit and warmth and good humor, that he violated the basic tenet of the Puritan work ethic on every hand: with Frank, work was fun.

Of course, there were cases where competition or envy intervened, and I don't want to falsify by suggesting there were no conflicts. Frank was ambitious, and he could be a tough customer in an argument. His tongue could be sharp and, after a few drinks, more than that. He loved a fight, he loved drama, he enjoyed being a star, and all of these traits could be trial minutes after they had been an entertainment. He wasn't exactly the model museum employee nor the trustees' dream.

Someone once accused him (to me, not to him) of being hungry for power. I remember I was quite baffled at the time, it seemed terribly remote from Frank. But of course the accusation has some truth: it *did* require power to be able to do as much as he did. He *was* ambitious, very; but it was about his own work, his poetry, and that was intensely private, or it was ambition to do something important about the work of other artists presented in his exhibitions, and that was outside himself. It wasn't petty, it wasn't about job status or title or prestige. The kind of power Frank needed is the kind he described in writing about Franz Kline: ''. . . that dream of power which shuns domination and subjection and exists purely to inspire love . . . To Kline, as to Gertrude Stein, art meant power, power to move and to be moved.''

A larger question is whether Frank's work in the museum deflected him from his poetry. Naturally I don't want to think so, I was too involved in his museum work, believed in it too strongly, to want to feel guilty about my part in that career today. I believe that Frank's work at the museum was a creative effort important in itself and a force in the history of American painting and sculpture in the '50s and '60s. I don't think his museum career depleted him. On the contrary, I think his involvement with American painting and sculpture fed into his poetry, both as a creative model and as part of his subject matter—which I take to be his sensibility operating in the specific New York art world arena which was part of his life. At any rate, the museum career existed and I am writing about it—partly because it is an opportunity for me to pay my respects to him, and partly because my account may be useful for biographical and critical studies—and those studies will be about Frank the poet and not Frank the museum curator.

Thanks to Porter's support, Frank was quite quickly given some important assignments soon after his return to the museum. The first was an exhibition to represent the United States in the Fourth International Art Exhibition of Japan (which opened in Tokyo in May 1957). The show is interesting as a compatible mix of second-generation abstract expressionism and figurative styles, and also an indication of the quickness with which Frank ''picked up'' on young artists (several had only recently had their first New York one-man shows.)* Sam Francis, who had lived in Japan and was quite well known there, won a prize but I don't think the exhibition otherwise took Japan by storm.

His next assignment, again to represent the U.S. in an international exhibition, was the IV Sao Paulo Bienal, also in 1957. It was a more important test case and the exhibition he selected was brilliant. It was in two parts: a Jackson Pollock retrospective (which toured Europe separately after its Brazilian showing); and a group exhibition with four or five works each by the painters Brooks, Guston, Hartigan, Kline and Rivers and sculptors Hare, Lassaw and Lipton. The choice of artists represented was made by a museum committee consisting of Porter McCray, James

Thrall Soby, Dorothy Miller and Sam Hunter, in which Frank was the junior member. But the choice was congenial to him and all of the artists were shown at the peak of their achievements.

The Pollock retrospective was to some degree an adaptation of the exhibition which had been directed by Sam Hunter and shown at the museum that winter (1956). But there were significant differences in the selection, largely in the slightly broader range of dates in Frank's version (his selection began in 1937, Hunter's in 1943, and Frank included a larger number of late works, as well as an expanded group of works on paper). To my mind, Frank's selection showed more of the process of Pollock's art, providing a clearer image of his early development and of those troubled last years from 1953 to 1955 when Pollock was trying out different styles. Frank was a champion of Pollock's late works, challenging the prevailing view that Pollock's gift had dried out and convinced that for all their undeniable unevenness the late works were pointing towards new directions. An inveterate defender of the difficult, he had a special predilection for sensibilities which could be stubbornly independent.

Frank played a supporting role in the next major exhibition undertaken by the International Program, but the exhbition itself is so important and determined so crucially the course of later events that it deserves special consideration. This is *The New American Painting*, the first show devoted exclusively to abstract-expressionism which circulated in Europe in 1958-9 and was shown at the museum after its tour. More than any other, it is the exhibition which won European recognition for American art and confirmed the ascendancy of abstract-expressionism.

The exhibition nearly didn't happen, or at least for a time was about to be postponed—not for lack of enthusiasm for the art on the part of anyone in the museum, but simply an over-committed schedule for many of the key departments concerned. For Frank and me it seemed the great opportunity to do something important about American painting, and timing seemed critical. Together we drafted a schedule of preparation for the show which made it seem a feasible proposition (which it only barely was—less than five months was an incredibly short amount of time in which to prepare so major an exhibition and its catalog). Porter used our memo to push his case for the show and Frank volunteered to help Dorothy Miller with the selection and all the paper work concerned, while I assisted with arrangements with the European museums and general administration. Work began on the show in November 1957 and it opened in the Basel Kunsthalle in April 1958 in a joint showing with the Pollock retrospective. Those months of working on the show were pressured beyond belief but enormously exciting.

A special significance the exhibition had for Frank and me was the feeling our role in it gave us that we had access to important decisions in the museum, and that working together was a good way of furthering that access. It was a kind of breakthrough—maybe more important for me than for him, but it did bring us together more closely than we had been so far, establishing a working relation between us which persisted until his death.

In the nine years left, Frank's sheer productivity in the museum is remarkable: he directed or co-directed 19 exhibitions, many of them major retrospectives or large-scale surveys. A few seem rather surprising subjects for him to work on. I'm thinking of such exhibitions as *20th Century Italian Art from American Collections* (for which he was James Thrall Soby's assistant), *René Magritte and Yves Tanguy* which he selected for the national circulating program in 1961, and *Gaston Lachaise,* also a national traveling show, prepared in 1962. The fact is that the exhibitions he worked on were assignments and not all were really central to him. He was a professional, however, and could become absorbed in such assignments and produce creditable results. Sometimes there were ironies involved. For the American exhibition for the

Venice Biennale in 1958, for example, Frank was assigned selection of small one-man shows by Seymour Lipton and Mark Tobey, while Sam Hunter was assigned Mark Rothko and David Smith. Rothko's work was much closer to Frank than Tobey's which he admired but considered relatively minor, but Frank's Tobey selection was beautifully balanced and won the artist the International Prize for Painting—the first American to be awarded it since Whistler.

One of the most important and also one of the least known exhibitions Frank worked on was the American exhibition sent to *Documenta II* in Kassel in 1959. The selection was a collaboration between Frank and Porter McCray. In a sense, it is an expansion of *The New American Painting* and, in my opinion, gave an even stronger picture of American art of that period. Sculpture as well as painting was included (with Calder, Ferber, Gabo, Lassaw, Lipton, Noguchi, Roszak and Smith), and several younger painters were represented who were not in the earlier show (including Rauschenberg whose presence pointed to a new direction in an exhibition largely devoted to abstract-expressionism). Hans Hofmann, who had not been included in *The New American Painting*, was represented, as were Cavallon, Marca Relli, Pousette-Dart and Tobey who similarly expanded the range of the show. Emphasis was different, too, with more works from earlier stages of the artists' careers providing a greater range of stylistic developments (de Kooning, for example, with the painting of around 1945 which had hung in Frank's apartment for several years—the painting which appears in his poem "Radio"). Barnett Newman emerged in particular as a greater "star" than he was generally then considered to be, represented by two of his greatest works: *Tundra* 1950, a brilliant orange field with red stripes, and *Cathedra* 1951, nearly eighteen feet long and eight feet high of blue field with white stripes, one of the masterpieces of American art.

In 1960 Frank's exhibition *New Spanish Painting and Sculpture* was shown at the museum and afterwards circulated throughout the country. It is one of only three exhibitions directed by Frank which were shown in the museum (the others were *Robert Motherwell* in 1965 and *Reuben Nakian* in 1966), and as the first it helped to establish his position within the museum more firmly. He had met many of the artists on a trip to Spain in 1958 (to supervise dismantling of *The New American Painting* in Madrid and its shipment to Berlin where he assisted Porter McCray in its installation, once again shown in conjunction with *Jackson Pollock*). The Spanish artists *were* "new": most of them had only begun showing outside their own country in the past few years, and it was largely in international exhibitions in Sao Paulo and Venice that they had attracted attention. Today few of the artists in the exhibition seemed to have fulfilled the promise they showed then, but at the time the work looked fresh and vigorous, if perhaps a little "handsome" by comparison with its American counterparts.

But the core of Frank's work remains his series of homages to American masters: the drawing exhibitions of Arshile Gorky and David Smith and the full retrospectives of Kline, Motherwell, Nakian and Smith which he undertook (in Motherwell's and Smith's cases, in more than one version) from 1961 to 1966. All were very "inside" their subjects, all passionately felt and all, I believe, major contributions to American art. It is extraordinary how often death affected them, beginning with the Pollock show, first planned by Sam Hunter before Pollock's death in 1956, with Frank's version only a year later—and, in a sense, ending with Pollock, too, because Frank had already begun work on a larger Pollock retrospective at the time of his own death. The Kline exhibition was undertaken in 1963, only a year after Kline's death, and I saw how difficult it was for Frank to cope with selecting the work of an artist to whom he had felt so close and whose loss he still grieved. The Smith exhibition was even more painful. Both Frank and I were particularly close to Smith (I

remember a wonderful visit to Bolton Landing in 1963 when Frank and I saw virtually all of Smith's drawings, spending the evening and enjoying one of David's sumptuous dinners), and we had planned an exhibition of his work for European tour for several years before Smith's tragic death in an automobile crash in May 1965. Before then, David and Frank had worked together very closely on the selection, and David was exuberant about the challenge this first major exhibition of his work in Europe would provide. But by the time it opened at the Kröller-Müller Museum in The Netherlands in May 1966, he was dead and only two months later so was Frank. A few weeks after Frank's death I traveled to London to install the exhibition at the Tate Gallery. Both friends were gone, but the work was there.

As of course it still is. The works of Frank I knew best, his exhibitions, were ephemeral but I remember them as I do great performances, as brilliant jabs of imagination, daring exercises of power and lyricism. But there is that other great body of work which is his poetry, like Smith's sculptures there for you to see.

*I remember only the Garbo one. Beaton had given a cocktail party in his apartment in the Waldorf which Garbo attended. As she was leaving, Beaton rushed through the rooms gathering an armful of flowers which he thrust at her in the elevator. As the doors closed on an image of Garbo covered with roses, she murmured: "Beaton, you fool." Frank's Garbo imitation was awfully good.

August 1977

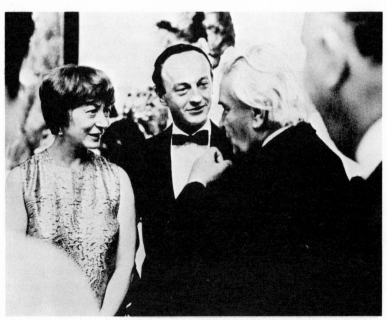

With Elaine deKooning & Reuben Nakian at Nakian opening, The Museum of Modern Art, 1966. (Photo: George Cserna)

Renée S. Neu

WITH FRANK AT MOMA

Dear Frank,

Do you remember? Do you remember the morning phone calls? They started tentatively enough to give me instructions on what to do before your arrival at the museum, and they developed into such long and lively conversations—*conversations?!* To be truthful, I was just the delighted listener, taking in all the witty remarks and gossip generated by the events of the night before. More serious items, such as reminders on what to do that day, found their way in almost hidden among the flow of words and wealth of disparate information. Then when you arrived at MOMA, you'd glance at the phone messages I'd piled on your desk and begin working without much need for talk.

Sitting at my desk, with my back to you in our cramped little office, I never tried to learn whether you were drafting a letter, working on an introduction or writing a poem. You would go on working and then the phone would ring: Frank, can you recommend someone for such and such a job? asks personnel; Frank, from what poem is the following line? asks a well-known and literate trustee; Frank, *Help!* says one of your many friends who proceeds to dump on you his problems and/or the problems of his friends. And you always managed to come up with the right answer. Then, when your reputation grew there were staff members dropping by— sometimes even on legitimate business—and friends or out-of-towners turning up, and you'd take care of them in your usual matter-of-fact way, never showing impatience or boredom—amazing! And that's when you had to cope with colleagues jealous of the recognition you were beginning to receive (and so did I because I was working so closely with you).

But somehow the work got done. It always surprised me how the poet, the dreamer, the man about town would pay attention not just to the major problems but to every tiny detail as well.

And do you remember when a young and ambitious colleague fell ill and we volunteered to hang his show, his first at MOMA? That evening, as soon as the place had emptied out, we set to work in our usual determined and nonchalant way, having a good time joking together and with the attendants, when unexpectedly Mr. Barr appeared, accompanied by four or five people, going through the galleries. Looking terribly serious, he gave us what we considered a stern look—and we felt put down. Was it a crime to be informal and enjoy your work? Only later did we learn that there had been a bomb threat and that Mr. Barr and those others were on their way to investigate it.

And do you remember the furious arguing you occasionally engaged in mostly when you felt that some artist was being belittled or not respected enough? You would defend him with passionate stubbornness, as a matter of principle. The same stubborness, veiled only by your witticisms, saw that your causes were defended and promoted. You would seldom give in if you felt there was a chance to win.

I couldn't help laughing, Frank, when I ran across a newspaper item by a young critic who referred to your legend as "an inextricable tangle of fact and inflated memory." Could he have been present, say, at any of your poetry readings? I remember one in particular held in a remodeled carriage house on the East Side. The usual audience—other poets, some painters and their friends, their chatter a steady hum . . . then a sudden hush, a "frisson" went through the room. Someone had just said: Frank is here . . . there is Frank O'Hara. And everyone turned around like sunflowers as you made your entrance full of smiles and friendliness. So why the hush, the expectation, if the aura of excitement around you did not exist? Those

memories are not inflated; if anything the opposite is true.

Frank, was it pride, your enormous pride, that gave you such class? You had an innate sense of elegance, of noblesse oblige, and you certainly considered unbecoming anything that could be construed as self-serving. I don't believe you ever asked for anything; it just happened or was offered to you.

Working with you at MOMA was a very special experience: the camaraderie, the fierce loyalty and enthusiasm, produced a mood of excitement that made bearable our long hours of hard work. Later things weren't always so smooth. Established curators and others in high positions didn't always appreciate your style or understand what you stood for.

During the last year or so you were often in a somber mood. There was one crisis after another. Friends and well-wishers would have liked to help but that often provoked only more irritation. The recognition you were receiving pleased you, but the demands became greater and greater. You looked troubled, and I have often wondered if it was true what some people said, that your museum job interfered with your writing, or was it something else? Something you had agreed to, malgré toi, but which your sense of ethics could not accept? Probably I'll never know.

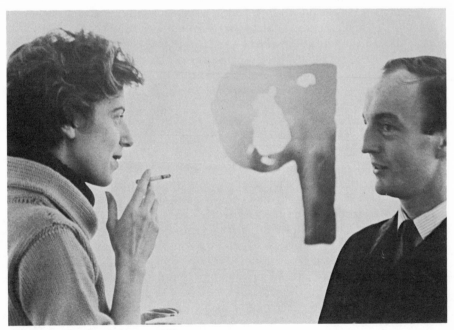

With Helen Frankenthaler, ca. 1961.

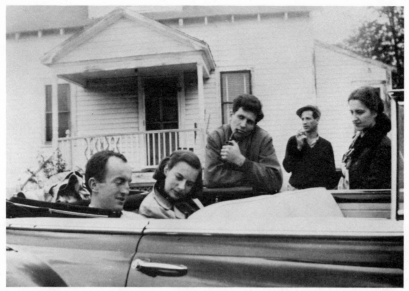

FO'H, Grace Hartigan, Allan Kaprow, Joe Hazan, Jane Freilicher at George Segal's house in New Jersey. ca 1955 (Photo: John Ashbery.)

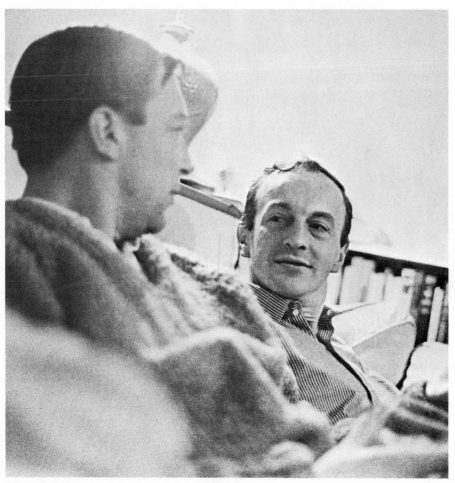

With Jasper Johns, 1964. (Photo: Mario Schifano.)

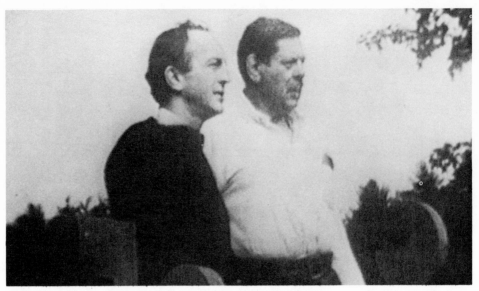

With David Smith at Bolton Landing, 1965. (Photo: Colin Clark.)

With Barnett Newman on WNDT-TV, 1964.

FO'H & Robert Motherwell, Bill Berkson
in background. Provincetown, 1965.
(Photo: Helen Frankenthaler.)

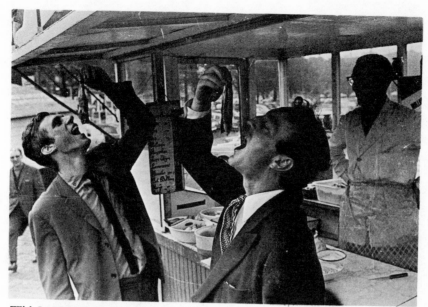

With Jan Cremer, Amsterdam, 1963. (Photo: Wim Van Der Linden.)

Biarritz, Spring 1960. (Photo: John Ashbery)

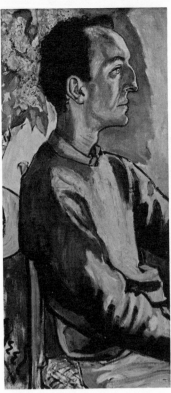

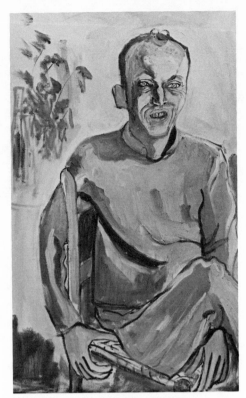

Alice Neel:"Frank O'Hara," 1960.

Alice Neel: "Frank O'Hara," 1960.

I met Frank O'Hara in the fifties at the Abstract Expressionist Club. He came to see me in Spanish Harlem, where I lived, and said he would pose for me. He had just been to Spain where as Curator at the Museum of Modern Art he had picked a show of Spanish painters. When I saw the show it was rather shocking as the artists had all cut and slashed large canvases. This seemed to me the conversation of a very poor country with a very rich one or a condemnation of art.

When he posed I first painted the poetic profile where I thought he looked like a falcon and then when he came for the Fifth time I really had finished the profile so I asked him if I could do another one quickly and I did the second beat one in a day. When he saw it he said "My God those freckles—still the Fauves went as far as that." The reason I wanted to do the second one was that when he came in the door he looked beat. I started with the mouth with those teeth that looked like tomb stones and then included the lilacs that had faded. I feel that the second one expressed his troubled life more than the first.

Alice Neel

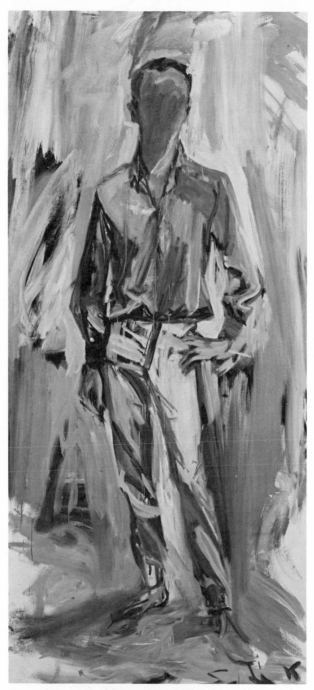

Elaine de Kooning: "Frank O'Hara," 1962.
Collection: J. Philip O'Hara.

The thing about people one knows intimately is, you don't even have to look. You just paint, let's say, Frank O'Hara, in pale blue or some kind of color, and he occurs within the painting... When I painted Frank O'Hara, Frank was standing there. First I painted the whole structure of his face; then I wiped out the face, and when the face was gone, it was more Frank than when the face was there.

Elaine deKooning
(*Art in America* 1975)

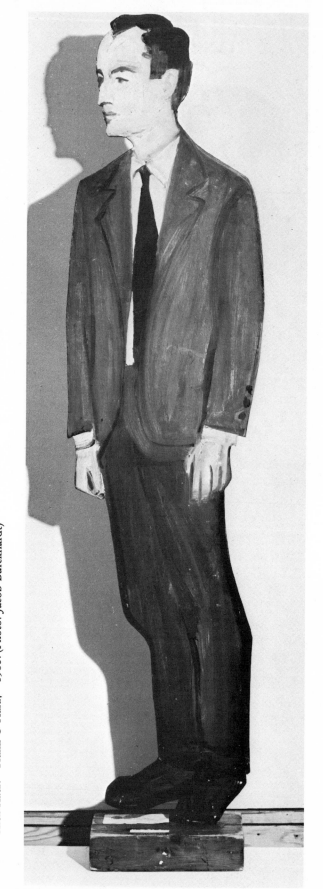

Alex Katz: "Frank O'Hara," 1960. (Photo: Jacob Burckhardt)

MEMOIR

I'm in Ogden, Utah, in a Victorian carriage house. It's clean and there are rugs on the floors. There is an excellent library and an excellent gym, one block away. We live on the top floor and I have a studio below. The studio is about 30 by 40 feet and is also soot free. The country around here is exhilarating. There are huge mountains to the east and flat farms on the west which run into the Great Salt Lake. The farms are well irrigated, some by channels from the mountains. They are mostly truck farms, some dairy, some wheat, and some with pigs, sheep, or beef.

The last time I saw Frank, we ate at the Grand Ticino on Thompson Street and went to the Judson Church to see a play by Ruth Krauss. Frank had gotten the tickets in advance but we brought Vincent along and were one short. Frank put himself on the waiting list and met us inside. It was hot and sweaty in the theater but there were some good lines. When we got out it was balmy and pleasant. We had some ice cream and went to his place for drinks. I don't remember what we talked about. Could have been anything from Ruth White to the Pomodoro sculpture on his coffee table.

It was a pleasant end to a pleasant evening.

The late afternoon made long shadows at Lincolnville Beach. Edwin, with taped ribs, Gerry, Ada and myself were strangely manic waiting for the Greyhound bus to take us to the funeral.

At times Frank seemed to be a priest who got into a different business. Even on his 6th martini-second pack of cigarettes and while calling a friend, "a bag of shit," and roaring off into the night. Frank's business was being an active intellectual. He was out to improve our world whether we liked it or not. Although I could question his judgements I found his reasoning difficult to resist. The frightening amount of energy he invested in our art and our lives often made me feel like a miser.

The elusive quality of Frank is his sense of style. To say he was interested in what was right and what was wrong wouldn't make him different from a lot of people. Frank's particular idea of what is right, is what negotiates with maximum vitality. Vitality being what emanates from the surface, manners and intent have no meaning.

Sneakers and suntans are the exotic wardrobe of the out of towner to a native New Yorker. There was more chaos, more cocktail parties and more telephone calls. Now our lives are more orderly but less interesting.

(1967)

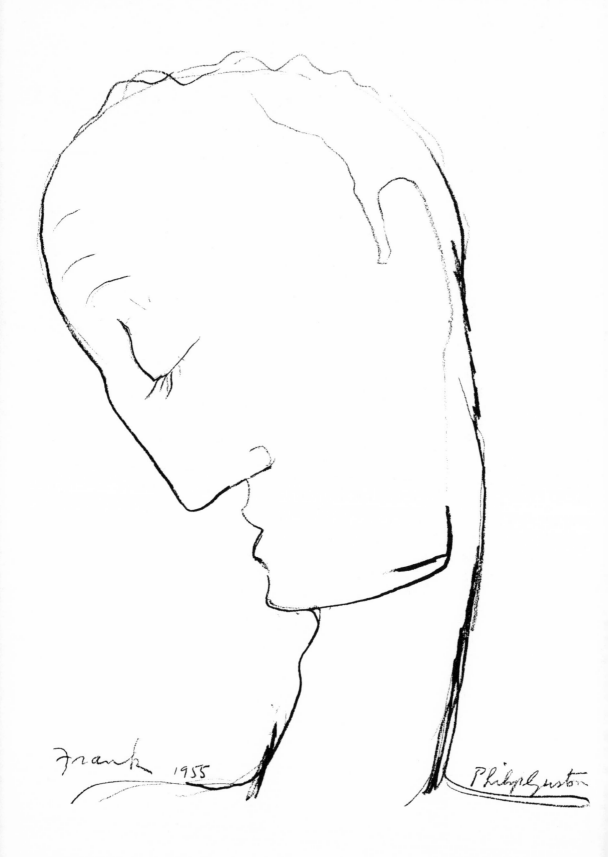

Frank 1955 Philip Guston

Dear Bill,

You ask if I have memories of Frank I would care to send on to you.

One memory in particular involves the three of us—of a night he brought you to my loft to have us meet and see new paintings. The loft was over an old Hook and Ladder Co. in Chelsea—the oiled wooden floors a giant ashtray, black-tarred skylights, oceans of dried paint on my palette, brushes stuck (I must have fled out into the streets when the latest painting was at long last realized). It must have been 1960—I know I was starting those black and grey paintings.

You were silent. Frank was in his most non-stop way of talking, saying that the pictures put him in mind of Tiepolo. Certain cupola frescoes. Suddenly I was working in an ancient building now a warehouse facing the Giudecca. The loft over the Firehouse was transformed. It was filled with light reflected from the canal. I was a painter in Venice.

Leaving the enchanted loft, we went for beers in a bar nearby on Seventh Ave., making small talk. We parted at 1 a.m. or so. Frank grabbed a cab and we another. As if we weren't certain what had happened, not a word was spoken. When I got out first at my flat we mumbled some amenities—glad to have met, etc.

Philip Guston
March, 1977

Mercedes Matter, Willem deKooning, Philip Guston, FO'H & Elaine de Kooning, Cedar Bar, ca. 1958. (Photo: Arthur Swoger.)

FRANK O'HARA IN HOLLYWOOD

Hollywood, its movies and its stars, excited Frank O'Hara's imagination unashamedly. The first time I met him in 1953 in New York—in the San Remo Bar on a crowded Saturday night in the village, he was holding forth in his witty and engaging way on a variation of his Hollywood theme. (after all, as he later wrote, the stars in movie heaven operate on "a divine precedent.") Joe LeSueur introduced me as just having come to New York from the West Coast, and I became Frank's friend from Hollywood. (Joe, I guess, was considered to be from Los Angeles, or maybe already a New Yorker.)

Frank, at that time, seemed a brilliant young poet-playwright who was also the enthusiastic friend and explainer of every extraordinary artist in New York City. He supported himself working at the information desk of the Museum of Modern Art and was yet to become the important curator and tastemaker there that he was when he came to Hollywood in 1965.

In July of that year, the Los Angeles County Museum opened its new premises with a major exhibition of the first generation New York abstract expressionists, and Frank, now eminent in the international art world, was asked to Los Angeles to be the key speaker for the opening of the show.

He stayed at Los Angeles Curator Jim Elliott's apartment over the merry-go-round on the Santa Monica pier. Iris Tree had lived there, Chaplin and even Garbo came there to her parties, and it was to that pier that Marilyn Monroe's analyst suggested she drive on the last night of her life as "it always picked up her spirit." I must have told Frank some of the gossip-history of the pier, but I don't remember doing so. I've forgotten much of what was said in the few days Frank was in Los Angeles, but I remember well how he was, what we did and what happened to Frank the night of his "speech."

I drove him around town as he didn't have "wheels," or possibly didn't drive a car; New Yorkers often don't. The first day of his stay we were both invited to lunch by the staff at the museum as Frank, being Frank, had recommended that they premiere a play of mine in their new theater when they had asked for a play of his. "Why perform a New Yorker when you have a perfectly good playwright right in Los Angeles?" was his typically generous response related to me. Lunch was to discuss his "talk," my play, set dates with the Los Angeles collectors who wanted to meet Frank and after lunch, see a preview of the New York exhibition. He had a bad hangover when I arrived to pick him up. He'd flown in the night before and there had been some sort of party. "Quel head," he said as he let me in. It was a sunny blue day and the view of the ocean shore from over the merry-go-round was glorious. However, the gay music of the calliope was blaring by noon and wasn't helping Frank's "head." He continued to sip tomato juice, talk, and finger a large collection of photo-slides as he went about shaving and dressing. I remember being reminded of the paintings of him by Larry Rivers and Elaine DeKooning when Frank, glancing at himself in a mirror, suddenly said, "I'm not as sylph-like as I was wont to be." The slides, it turned out, were of every painting in the exhibition and he intended to study them to choose which ones he wanted to have projected and comment on during his speech.

We had lunch in a private dining room in the new Wilshire Boulevard museum with Jim Elliott and the other curators, Bill Osmun, Henry Hopkins and Maurice Tuchman. There were other hangovers among us and we laughed a lot. Then Frank and I went off to tour the many rooms hung with the huge exhibit of abstracts. I now recall only the merest line of his walking commentary of observation and

anecdote about all the painters and paintings, but I felt illuminated then for he was brilliant. Specifically, I remember the warmth of his appreciation of a Kline, his love of deKooning, and a comment he made about the strength of the "ugliness" of the colors of a Guston. Many of the paintings were on loan from West Coast collectors and Frank had been told at lunch that it would be appreciated if he commented on those in his speech. I realized from remarks of his that he had that in mind.

In the early evening we went for drinks with Dennis and Brooke Hopper (now Hayward again) at their Spanish-style house in the foothills just above Hollywood Boulevard. They were both beautiful, both talented, had a beautiful blond child, and were both old friends of mine. They also had an amazing pop art collection that crowded their walls and ceiling (three Andy Warhol helium-inflated mylar pillows and a huge Mexican pinata-figure hovered vertically overhead). Frank didn't like pop art very much but he liked the Hoppers. And Dennis was not only a movie star, but had acted with James Dean, whose death inspired a number of Frank's early poems. Dennis had arrived shortly after we did, bringing home a large fake rock from a movie ranch to add to their pop collection. There was much admiration of the rock over drinks, except from Brooke who was cool about it. Later that night, I have a vague memory of eating with Frank in one of those candle-lit Mexican restaurants that look like caves hewn from such movie rock.

The next day we sat around Jim Bridges' and my house until the afternoon, then kept dates with the Los Angeles collectors and "did" the La Cienega galleries. Jim and I had recently brought back from New York four small collaborations by Frank and Joe Brainard, framed by them in dime store frames. The glass on two of them had been cracked in traveling and I hadn't replaced it yet. Frank, on seeing them, said, "Oh, don't change it. Now they're Cornells as well as Brainard/ O'Hara's."

At the Frederic Weissmans', something surprising occurred. Their collection (she's the sister of tycoon Norton Simon) also crowded the walls of their Trousdale estate and ranged the change in their taste from early to late. First there was a pallid Matisse that Mrs. Weissman seemed tentative about, and she wanted the confirmation of Frank's good opinion. He hedged. Then room after garden of Giacomettis, huge pronged Rickeys and two large Clifford Stills, which that careful artist would "permit to be sold in Los Angeles only to us and one other collector." As long as I had known Frank, a vivid deKooning, all green and orange, had hung on the tenement or loft walls wherever he and Joe LeSueur had lived. It had been given to him by Fairfield Porter long ago, but that previous year Porter had wanted it back. Frank obviously had acquiesced for there it was hanging on a wall at the Weissman's, surprising us in the hills above Sunset Boulevard. Both of us were stunned and moved at the sight of it. Recovering, I only remember Frank being gracious about it and Mrs. Weissman relating how they'd acquired it from their dealer. It was my first encounter with the alchemy of the art world: paint and canvas into gold. Later at the galleries, we saw where some of that alchemy takes place. And of course, Frank worked for the Museum of Modern Art where the gold is certified. Gallery owners, Irving Blum and Nick Wilder, opened their storerooms to Frank and he became excited over the work of Los Angeles artists unknown to him till then. The colors, even of abstracts, were often "pure California" as he observed it. Also, he was very impressed with Wilder's carefully mounted exhibit of a series of Barnett Newman lithographs on slanting temporary cases.

We had been given an open invitation by Don Bachardy, whom Frank knew and who drew one of the best portraits of him at that time, and by Christopher Isherwood, whom Frank wished to know, to visit them in Santa Monica Canyon any free afternoon. On his next to last day in Los Angeles, or "Hollywood" as Frank referred to it,he arranged the afternoon for that visit. Every time I called for Frank at the merry-go-round, he made a passing reference to the ever present picture slides that he "really had to give some serious attention" and select from for use with his

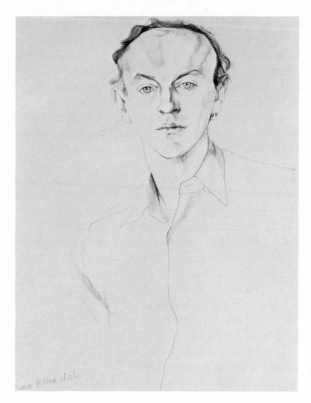

Drawing by Don Bachardy, 1965.

speech. But other than shuffling them about with the hand that wasn't holding the also ever present tomato juice, they didn't seem to get much attention.

When we arrived at Chris and Don's, they had another guest, Julie Harris. Frank had admired her as Chris' "Sally Bowles" of storied Berlin on stage and screen opposite "actor-Christophers" in *I am a Camera*. Now here they were in a beautiful living room overlooking the Pacific Ocean. I can remember the sunny light and the laughter, all the geneality and physical charm of that lovely afternoon; how each person looked and where each sat in that white and blue room, glows in my memory. But I can't remember a word of what was said. I know that Chris keeps a voluminous diary, so perhaps one day he'll be able to fill in the talk. For now, I can just recall the tag of that afternoon; after we left and were speeding along in my MG, Frank remarked on how thrilling it was, life imitating art, to have met the real Herr Issyvoo and the stage and screen Sally Bowles at the same time.

The Los Angeles art world turned out in full force to hear Frank's speech. The large Museum theater was packed and hundreds of people were turned away. Those inside greeted Frank with an homage of applause and he began to talk with wit and lucidity in that Eastern-Irish, street-elegant voice of his. The audience responded with laughter and total attention. Then the projected slides began. For about the first dozen of them, Frank developed a seemingly extemporaneous theory about the development of painting from figure to surreal, Southwest Indian-like squiggle to the squiggle as the figure to Jackson Pollock's abstract expressionism. It was fascinating but as disordered as the slides. And the slides went on relentlessly with Frank having something nice to say about each one, presumably with the idea in mind that each might have been of a painting on loan from a local collector and therefore wanting comment. After two hours, when it became apparent that Frank was going to speak about every painting in the huge exhibit, the audience began to thin out quite seriously. In fact, an exodus took place. I began to have a horrible fear that his talk might end with Frank alone on stage chatting beside those endless

projections, and only Jim and me in the empty house. Anyway, he was at last giving those slides his serious attention.

Everyone, including Frank, recovered at a delightful Museum reception afterwards where it appeared that most of the audience had only been hiding and had come out again to meet Frank over drinks and congratulate him.

He returned to New York the next day, just missing the Watts riot in Los Angeles, and by his death the next summer, all the progressing events, life styles and movements of the late sixties and early seventies. I often wonder, when I read his wonderful poems, what he would have made of all that.

A week or so later, Jim and I received this card from him:

Dear Jack and dear Jim,

Have been thinking about you a lot since I got back, roaming through the sweltering heat and wondering what all of us masochists are doing in this city? It goes to show that 8,000,000 people can be wrong, especially in August. As you see, even the typewriter is objecting. My ''work'' is going along, though always slower than necessary for exhibition deadlines (if I were a scientist, international peace would be assured). Haven't heard about anything very desirable in apts but have alerted Joe, JJ and others to watch out. I want to thank you so much for so much fun while I was there. I loved it. Everyone is very worried about you both and the riots. For heavens sake be careful. Ours weren't anything like that. Come here and when it shifts to here we'll all go there. Nomadship is reinstated.

LOVE to Allen, Don, Christopher and especially to you two.

Frank

Two collage comics by Joe Brainard & Frank O'Hara, 1964.
Collection: Jack Larson & Jim Bridges.

Joe Brainard & Frank O'Hara: Collage comic, 1964.
Collection: Bill Berkson.

6 Collaborations by Joe Brainard & Frank O'Hara

Collage comic, 1964.
Collection: Patsy Southgate.

Collage comic, 1964.
Collection: Joe LeSueur.

Collage comic, 1964. Collection: Patsy Southgate.

Actually, in the strict sense of the word, Frank and I never really collaborated. (Alas) never on the spot, starting together from scratch. Giving and taking. And bouncing off each other. What we *did* do was that I'd do something (a collage or cartoon) incorporating spaces for words, which I'd then give to Frank to "fill in." Usually he would do so right away, with seemingly little effort, over a drink, at a large cluttered table : (or such is my vision). And, once, I remember T.V. being the source of inspiration. Some mundane western dialogue because very "saucy" by selection (isolation) and through the inflection of Frank's particular tone of voice. Visualize hands on hips : loaded "throw away" lines that would be hard to top, unless maybe you were Bette Davis.

Joe Brainard

Page from "Hard Times" in *C Comics*, 1966.

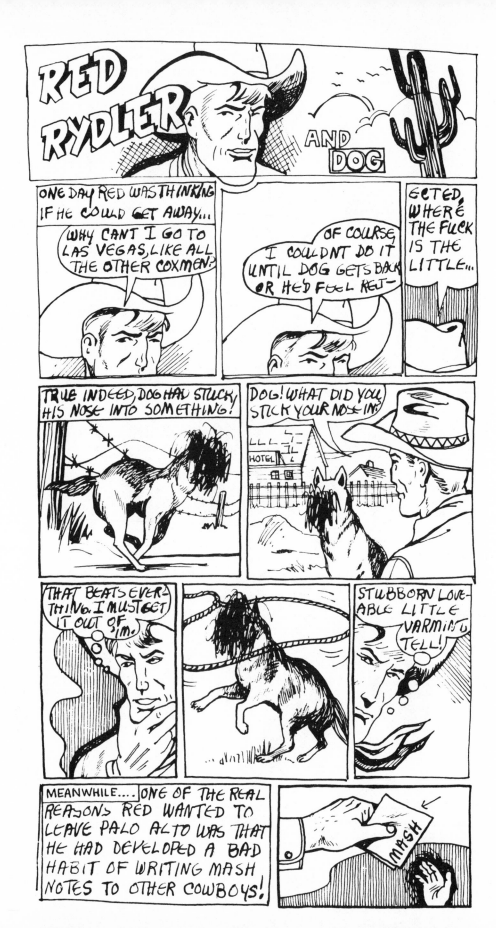

Collage comic, 1964. Collection: Patsy Southgate.

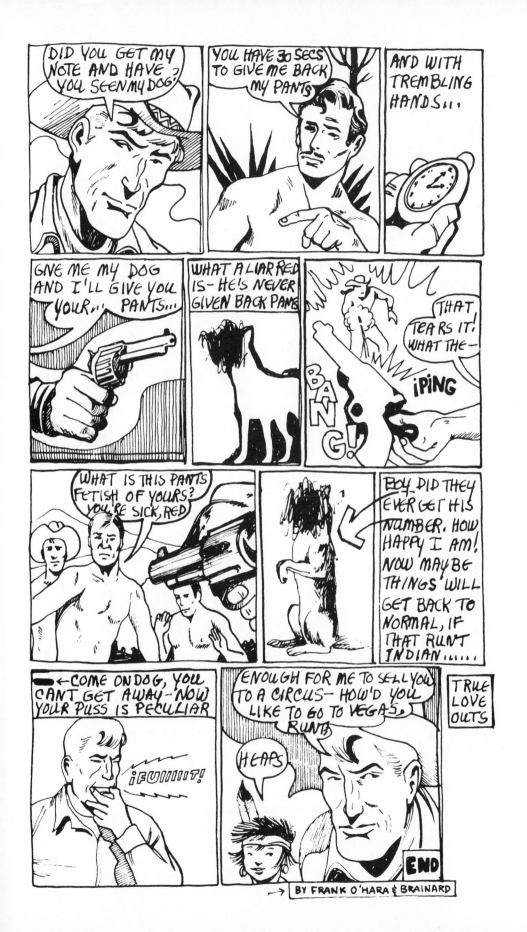

BY FRANK O'HARA & BRAINARD

FRANK'S HUMOR

I don't recall spending a dull moment with Frank. He could change the most grotesque vernissage, or sleep-city cocktail party into a veritable romp—mysteriously, as if by magic, almost as if he could do it with his *attitude* alone—a sudden shriek of delight, or a Madison high-kick.

His sense of humor was one of the keenest I have ever encountered. We would carry on elaborate charades, just the two of us, and never crack. When Frank was working at the Museum, for example, we would occasionally have lunch, and he would tell me all about a new acquisition, somehow conveying the excitement of the work by his own extraordinary perception and his remarkable gift for expressing it— as though he himself had shared in the experience of its creation. He would end up exhausted by the time we finished eating. "My God," he would sigh, perhaps thinking he might have seemed overly dramatic, "now then, Terry, *you* say something! What shall we do next? 'What shall we *ever* do:'"

"Well..." I would venture tentatively, "we *could* go back to your office and make an obscene phone-call to Patsy Southgate."

"What a marvellous idea!" Frank would exclaim. "Did that just occur to you? Is that what you were thinking of all the time I was talking about the Rauschenberg?"

"No, no, long before that. I've been thinking about it for years."

"Oh she'll *love* it! What shall we say?"

"We'll think of *something*," I assured him.

"Good!"

On the walk back to the office, Frank would pursue it gleefully.

"And who else? Who else shall we call?"

"How about Maxine?"

He would stop in the middle of Fifth Avenue, the traffic bearing down on us, and throw back his head with a great whoop.

"Maxine! Oh dear Mary, how can we *ever* think of anything to shock Maxine?!?"

"I did not suggest," I would remind him primly—at the same time trying to get us safely across the street—"that the project was without certain challenge."

He would abruptly remove his arm from mine and look at me with haughty disdain. "And *why*," he would demand icily, "are *all* of these calls to *girls*? Don't you think it's *possible* to shock a *fellow*? What are you anyway, some kind of weirdie *hetero-nut*?"

Back at the office, I would surreptitiously slip an envelope (previously prepared) onto his desk. It would be addressed:

F. O'HARA
Personal

"Well, now," he would exclaim, snatching it up, "what's *this* all about?!?" And '*personal*'! Good grief, shut the door!"

"Probably from one of your lovers," I would suggest blandly, while Frank searched the desk for his letter-opener.

"My lovers," he would say, with a closed-eye imperious toss of his head, "know far far better than to write me on a *typewriter*! They all write in *marvelous . . . beautiful . . . flowing . . . script*!"

"Well, maybe it's from a *new suitor*—who doesn't yet know how demanding you are."

"A new suitor . . . " He would reflect, "yes, that's quite possible, isn't it? I wonder . . . " He would strike a pensive pose, tapping the letter thoughtfully, deli-

cately, on the desk, "there *was* that young lacrosse player at the Coast Guard Beach last weekend. He seemed awfully keen... now what *was* his name? Bruce? Dirk? Don't you *just* love people named 'Dirk'? *Guys*, I mean, of course. He, ha. Yes, it could possibly be from *Dirk*, but that possibility seems fairly remote—"

"Maybe," I interrupted, "...maybe it's from somebody you met at one of those spade-bars in Riverhead—you know, *The Bluebird,* or that one across the street."

He would throw his head back and grimace in a gesture of distaste and exasperation.

"*The Bluebird!* Oh my God! *How* did you know about that?!?"

"Larry Rivers told me," I would say, "Lar said you insisted on stopping at Riverhead and cruising *The Bluebird...* 'for heavy dork' is the way he put it, while he waited in the car."

"Ah, but *did* he tell you the *real* reason? The reason *behind* the *reason*? Namely, that *he* was looking for a new 'assistant'—if one may employ a euphemism for the *slave-labor* he uses—and was hoping that I might recruit—dare I say 'shanghai'—one of those poor potato-pickers from Mississippi for his own vile purposes of commerce?"

"I'll check it out with Lar," I said loyally, as one not to be easily duped.

"Oh well," Frank would counter in mock annoyance, "if you don't *believe* me!" Now what was that about 'dork'?"

"'Cruising for dork' is what Lar said, *dark* dork," and I'd spell it out.

"Oh?" Frank would lift a brow, "he said that, did he? '*Dark dork*'?" And he would begin to sing spiritedly: "Oh there's no dark dork like my Dirk's dark dork!"

"You're making that up," I'd say, accusingly.

"No, no, it's from an early work." And then in great agitation: "Where *is* that letter-opener?!?"

"Why don't you just tear it open?" I'd ask.

"Oh?" would be the raised-eyebrow reply, "with my *teeth* I suppose?!? No, you see, Terry, *that* is the difference between us. *I* do things properly, or not at all, whereas *you*—and some others I could name—behave in an animal fashion... Ah, here it is!" And finding the opener, he would slit the envelope in a grand manner, and take out the paper, which might read:

> "F. O'Hara, attention!
> All sexual excess in and
> about your offices to
> stop at once."
>
> signed
> A. Wallingford
> Chief Curator

Frank would feign outraged indignation. "*What!?!* Why that old *queen*! Ha! Methinks the lady doth protest too much!"

"Perhaps it's simply another case," I would venture, "of *unrequited love...* Berkson told me that old Wallingford was *plenty hot* for your heavenly bod and gross dork."

"Precisely!"

"Hell hath no fury, eh Frank?'"

"Right, Ter!" and he would shake the paper in a show of annoyance . "And I don't have to take this... this *hypocritical innuendo!*" He would reach for the phone. "I think I'll give him a piece of my... ha-ha, *mind* right now!"

"Wait," I cautioned, "why not just a simple "*J'accuse!*', and then hang up—I daresay he'll get the message."

"*No,*" Frank would insist, "no, I shall require more satisfaction than *that*! Besides I don't think he speaks French—the great clod! Ha, ha, ha!"

One time Frank took me to a swanky East Hampton lawn-party, given by a grand old dowager patron of the Museum. We were immediately separated as Frank was swept up into the swirl of the excitement his arrival always generated. A little later our paths crossed again. "Oh *there* you are!" he exclaimed. "Come, I want to introduce you to our hostess, Mrs. Henrietta Tiffendale! You'll simply *adore* her!" He led the way.

"Oh pardon me, Mrs. Tiffendale," he said in his most courtly manner, "allow me to present one of my dearest friends, the very distinguished American writer... Mr. *James Baldwin!*"

"Oh how delightful!" the dowager would cry, beaming idiotically, "I am *such* an avid reader of yours, and needless to say, a great admirer! You have no idea!"

"Well..." I managed, "thank you very much."

"Oh!" exclaimed Frank, peering over our heads, pretending to recognize someone across the room, "please excuse me, someone's just arrived whom I *must* see!" And he would hurry away, barely managing not to break up before abandoning me.

"Who is it?" I might shout after him, somewhat irate at my predicament, "*Franz Kafka?*"

I countered Mrs. Tiffendale's small talk with a bit of my own, and was on the verge of a graceful withdrawal when several other guests strolled over.

"It is such a pleasure," she said to them, "to introduce you to the distinguished American writer, Mr. James Baldwin."

There were cordial handshakes all around—while in the distance, at the bar, I could see Frank doubled with laughter as he recounted the 'bit of mischief' to Mike Goldberg and Joe LeSueur—who, to be sure, were not long in joining in his show of mirth at my expense—heightened, no doubt, by the fact that one of the guests I was being introduced to was Alfred Kazin, or it may have been Dwight MacDonald—in any case, someone fairly knowledgeable re the Quality-Lit crowd.

"Well," said our hostess, "I suppose *you* two have quite a bit to talk about," referring to Kazin/MacDonald and me/Baldwin.

"Yes," said the former, in what must have appeared to the others as a cryptically terse manner, "we certainly do—but I think *not just now.*" And he brusquely escorted his wife away.

About an hour later I was standing at the bar and heard a familiar hiss in my ear. "Be careful! I'm afraid the hostess knows you're a *fraud!*" I turned to see Frank scurrying away in one direction, and the hostess approaching from another.

"Young man," she said sternly (this was about 20 years ago, of course) "I now happen to know that you are *not* James Baldwin."

Meanwhile Frank was unable to resist returning to witness my chagrin (and perhaps compound it). She turned to him sympathetically: "I am very much afraid you have been deceived, Frank—this is *not* James Baldwin."

Frank, munching a canape, regarded me in thoughtful silence, then sighed and shook his head as though with sadness at having been thus betrayed. I decided, however, to take it a step farther. "Well," I began, "I didn't mean to say that I was *the* James Baldwin—merely that my *name* was James Baldwin. A coincidence."

"No, no," she countered, "you distinctly said 'the very distinguished writer, James Baldwin.'"

"No," I reminded her, pointing at Frank, "*he* is the one who said that."

"But you must have given him that impression," she insisted, but I remaind adamant. "No," I said firmly, "and moreover I don't know why he insists on calling me "James'—everyone else calls me 'Jim'." Then someone like J.J. Mitchell or Arnold Weinstein—would come over. "Oh," Frank would say, "have you met Jim Baldwin?" and quickly explain, "not *the* James Baldwin, of course, but just plain 'Jim Baldwin.' *Poetry*—isn't that basically your field, Jim?"

"Yes, poetry is my basic field."

"Yes, he was telling me something about an 'Ode to Dirk'—was that it, Jim?"

"Ode to *dork*," I reminded him. And so it would go, until one of us could no longer keep a straight face, and hurry away leaving another Hampton dowager hostess hurt and confused . . . or at least confused.

One remarkable quality of Frank's was his consummate sense of *fairness*—his willingness, or ability, to see the other side of things. If someone were putting down the work of another artist, and it all got to be a little too unanimous, or strident, Frank would find something good to say about it—or, again, whenever the praise was relentless and overwhelming, Frank might nail it with a zinger: "Yes, but I suppose it does get to be a bit, uh, *predictable*, doesn't it?" Or he might turn to you, beaming, and say: "Aren't sycophants just *too* marvelous!"

This kind of thing, this ambidextrous percipience (he'd like that) was no where more apparent than in his humor. I remember, for instance, one summer Sunday when we were lolling about at someone's house in Southampton—the Oppenheims, if memory serves—and I said to Frank: "Now then, let me ask you this, Frank—do you think, do you honestly think that it's possible to tell, simply from someone's appearance, whether or not he is *completely gay?*"

"'Completely gay'?" He seemed intrigued by the phrasing, and considered it for a moment—before speaking firmly and with great authority: "No, you certainly cannot." Then, five minutes later, he was leafing through the Sunday *Times Men's Fashion Supplement,* pointing out the different male models. "Now this one is *completely gay,*" he would say, "you can tell by his *stance,*" or "here's one who is *partially* gay now, but will probably be *completely gay* with 6 or 7 months . . ." and "now here's someone who is *completely gay,* but doesn't know he's gay at all!"

One of our great mutual friends was the fabulous Patsy Southgate, and we would often tell her outrageous lies about each other. Despite her breath-taking Miss America plus type beauty, she was very perceptive, with a keen sense of mischief, and would always go along with the deception, feigning annoyance, indignation, anguish, or whatever the ruse might warrant.

"Do you know what your so-called friend, Frank O'Hara, did the other night?" I recall asking her on more than one occasion, in a tone of sharp rebuke.

"Now what?!?" she would demand in feigned exasperation, all wide-eyed astonishment, and, of course, doubly fab because of it.

"Well!" I'd explain, "there was this ultra posh soiree at Plimpton's—a super smart gathering of Quality Lit heavies—Burroughs, Capote, Corso, Gelber, Genet, Ginsberg, Heller, Mailer, Roth, Styron, etcetera, etcetera—not to mention certain personal, and *very straight*, friends of mine—Marquand, Mathiessen, and of course, the venerable host himself.

"But what happened?" Patsy would demand, in breathless (and, as previously noted, breath-*taking*) anticipation.

"What happened," I would begin, in a most effectively pained, and martyrized, tone, "was the arrival of a certain Frank O'Hara."

Frank *crashed* the party?!?"

"No, no, no—he was invited, of course, and not without good reason . . . *but,* what happened was that when *we* met—*very center-stage,* if I may say so—he *embraced* me, which in itself was no surprise, and which I took, in the first flush of my naivete—to be in a manly European fashion . . . just as he had done with Genet and Ionesco . . . you know, the perfunctory hug and the perfunctory 'kiss' on the cheek. Quite acceptable, I think you'll agree."

"But of course!"

"Imagine then, *if you can*, my devastating *malaise* when, during what I had anticipated as a classic, indeed prosaic, embrace of friendship, Frank should . . . *try for tongue!*"

"What!''

"Yes," I said grimly, "a French kiss, he tried for French."

"Oh no!" She would stamp her foot in a show of pique, and would rush to the phone. Frank would sheepishly admit to the incident, claiming he had "been overcome with feeling and desire" and then go on to invent some fantastic story about "Terry's warm—shall I say 'passionate'—response," leaving the fab Pat, of course, in a state of most artfully contrived bewilderment.

We managed to get quite a bit of mileage out of this over the years.

"Ran into your friend, Frank, the other night," I would say to Patsy.

"Gosh, I hope he didn't . . . " she would hesitate, but I would force her to say it.

"Didn't *what?*"

"Well, you know," demurely averting her eyes, "try for French . . . "

"No, thankfully he did not," I would reply, "Norman was there, and you know how he feels about that sort of thing—and, in fact, Norman Bluhm was also there, and *he* feels even stronger."

"Well thank goodness!" Patsy would say.

"But," I would caution her, "I am now *fairly certain* there's something *going on* . . . between Frank and Ruth Kligman.

"Frank and Ruth?!? Something hetro?!?"

"No, this is *beyond hetro,* because Lar (Rivers) is somehow involved—a three-way thing, with Frank, Ruth and Lar—so it's got to be *heavy* and *extremely weird.*"

Patsy would get right on it, phoning Frank, demanding an 'explanation.' Frank would play it to the fullest, hinting at all manner of unspeakable curioso.

Once I asked Larry Rivers about Frank's closest friends, who did he think was Frank's *best* friend, and so on.

"Oh my God," he said, "there were so many people who thought they were his best friend. I mean, he had this thing about making each person feel he was his best friend. I guess it was because he *cared* so much, about everybody."

Yes, I guess it was. Anyway, I know there are people who were better acquainted with Frank than I, but I'm certain there are none who enjoyed him more fully, think of him more often, or more fondly.

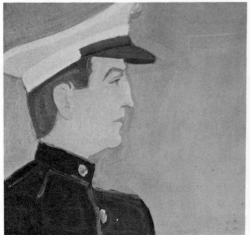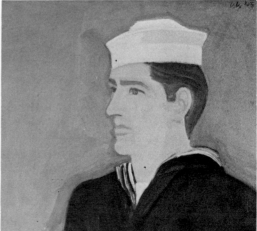

Alex Katz: "Marine and Sailor" (Frank O'Hara & Bill Berkson), 1961. Oil on canvas, diptych.

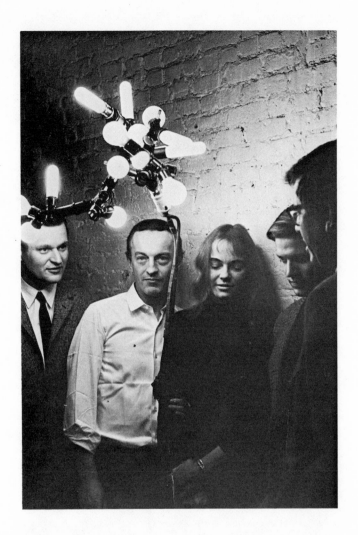

1964: Mario Schifano & Anita Pallenburg were subletting Donald Droll's loft one floor below Frank's at 791 Broadway. Mario decided he was going to produce plays by Frank, me, Patsy Southgate, John Ashbery, & Kenneth Koch at a theater in Rome, and these pictures by Mario, taken in Frank's loft, were meant to spearhead publicity for the series (P.S. which never happened). Lamp sculpture by Larry Rivers. —B.B.

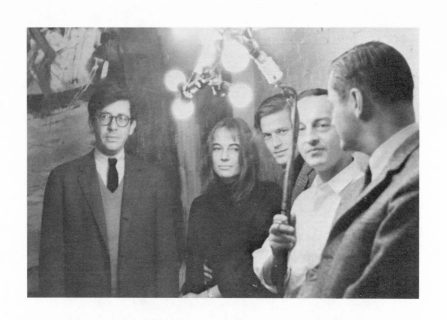

Patsy Southgate

MY NIGHT WITH FRANK O'HARA

It occurred in August, a hot night in the early sixties. It seemed as though that whole summer were spent partying in a Banana Republic, with heat and humidity at equatorial highs. During the day, we played a lot of Jamaican music loud, and a lot of Ray Charles, and at night some heavy operas, which only enhanced the tropicality. My then-husband Mike Goldberg and I had rented a house in the traditionally hot Springs on Eastern Long Island, and it was a hot house, with cedar trees pressing against the windows like big women in bushy fur coats, blocking out the air. In bed at night, one felt as if one were lying on a sale table in Klein's basement during a failure of the air conditioning.

I can't imagine how I managed to have this night with Frank since there were always so many other people around: Mike, my two kids Luke and Carey, the housekeeper Sylvia Robertson and guests stashed here and there. Frank was living in Larry Rivers' house in Southampton, and that was usually chock full too. What with the heat and the crowds and the distance between houses, it was not an auspicious set-up for a night alone with somebody.

But, fate occasionally does throw one a fish. I can't recall what we were drinking that summer, whether it was still Martinis or whether we'd moved on into Negronis or even further into Bloody Marys. Whatever it was, I distinctly remember consumption had been high, due to the heat and all. There had been a party, or something, and then everyone had suddenly disappeared into New York City leaving me with the responsibility of driving Frank back to Southampton. It was about five a.m. when we finally hit the road in the old Chevy wagon, and dawn was breaking. At once it became clear to me that the driving responsibility was too

much and, prudently, I pulled over, or swerved over, as Frank no doubt would have put it, to let him take the wheel. As I recall, we had only gone about a hundred yards.

Frank was probably in no better shape to take the wheel than I, but he was better at assuming responsibility, and as we rolled along at a stately twenty m.p.h. through the "Lawrence of Arabia" daybreak I remember marvelling at his responsibility-assuming, leadership qualities, and complimenting him lavishly on these as well as on his driving skills. I remember leaning against him on the front seat and thinking how noble his profile was and how my yellow dress with the big white polka dots rested in perfect harmony beside his blue and white striped seersucker jacket. I commented on this as we passed the duck farm, the yin and yang of it, and he agreed.

After a safe arrival at Larry's, it was settled that it would be folly for me to drive all the way back to Springs alone, and I should spend the night, or rather the morning, there. Mysteriously, no one was in the house, so Frank put an Eric Satie record on and made us a couple of bedtime Screwdrivers. (I don't think we called them that then. I think they were just something we made when we'd run out of tomato juice.) Miraculously alone, we sank onto the white sofa in Larry's bay window, in the cool pale gothic-American interior.

Listening to music and drinking Screwdrivers with Frank at dawn was no new experience. We did it all the time. Usually we had *Manon* turned to extra-loud, playing the last three sides, the tear-jerkers, over and over again as the sun relentlessly rose. But we had never been alone before. Mike and Joe LeSueur and the kids had always been in nearby bedrooms trying to sleep above our din. Sometimes Mike or Joe would yell at us to turn the thing the fuck down, and we would, for a little while, but then we'd turn it the fuck back up. Volume was an integral part of our nightly carousal.

As Satie wound down, Frank and I fell to quoting lines of poetry to one another. I remember telling him that "When in Disgrace with Fortune and Men's Eyes" had always been my favorite Shakespeare sonnet, and him saying it had always been his favorite too. We muffed our way through it together, ending triumphantly with:

> *"For thy sweet love remembered such wealth brings*
> *That then I scorn to change my state with kings."*

At this point we decided to go to bed together. Frank freshened our drinks to help us along with this new "first" in our lives.

Perhaps inside the heart of woman lurks the desire to convert a homosexual, a sort of female version of the male dream of seducing a virgin, but I do not think this was what made me want to go to bed with Frank. I think I was madly in love with him in a way, and afflicted with one of those simple cases of hot pants that love, in all its innocence and wisdom, brings on. In any event, we lurched to the bedroom, drinks in hand, and somehow got undressed and slipped between the sheets.

A pall of silence and immobility fell over us as we lay there side by side staring at the ceiling, gripped by shyness. I remember saying:

"Frank, this must seem so funny to you. I mean, you're used to two penises clashing in the night, and everything, and all I have is this blank, this patch of pubic hair with nothing sticking out of it. It must seem so empty!"

I remember Frank laughing and saying it was perfectly all right with him that I didn't have a penis, he really hadn't expected me to. After that we relaxed and kissed and stroked each other, starting to have fun. I reached down to touch his cock, which was big and erect! What a piece of luck! (That summer, Frank's bathing suit had been a rather unreliable blue canvas triangle, a French number, I believe, that sort of floated above his personal parts. Through its vagaries I had glimpsed that Frank had a big cock and had loved the idea. It went with his flamboyance, his

"thrust.") I scrambled down under the sheets and kissed it. Then I surfaced and we were hugging and kissing each other when he drew back. He came out with this unbelievable soap opera remark.

"I just can't go through with this," he said. "Mike's too good a friend of mine."

Rats, I thought, not knowing whether to laugh or cry. And, hey that's *my* line, I thought. And, the reason fags are fags is that they don't like to screw women, *can't* screw women. It's nothing personal, you dope, it's just Frank's way of begging off. And, I wonder if Mike were here instead of me if it would work. (Mike was not heavily into monogamy—I did not feel guilty, for once in my life.) Then my final thought, the only one I said aloud after disentangling Frank's and my arms and lying back down in our original side-by-side position, staring at the ceiling, was:

"Listen, Frank, I really don't give a flying fuck whether we make it together or not. Just lying here in bed with you is enough. In fact, it's pure heaven."

"I know," he said.

That afternoon when we awoke, not hungover, as I recall, feeling peppy and happy and wonderful because we'd slept together, I donned my yellow dress with the white polka dots, got into the Chevy wagon and drove back to Springs. Sylvia and the kids came bounding out to meet me: where had I been? Why was I so late? Could they take the car and go to the beach? I handed over the car and went in the house to wander around alone. I was in a kind of ecstasy. I had never felt so close to anybody as I had to Frank that night. I put a record on, Ray Charles singing "You Don't Know Me."

> *"You give your hand to me*
> *And then you say good-bye*
> *I watch you walk away*
> *Beside the lucky guy*
> *To never never know*
> *The one who loves you so*
> *'Cause you don't know me."*

I played this verse over and over again, very loud, at the top of its lungs, laughing and crying at the idea of watching Frank walk away beside the lucky *guy*, for Christ's sake, what a switch, a switch that really didn't matter at all. I took off my dress, a dress that would always remain sacred to me and which I could hardly bring myself to throw away even when it had grown moldy from years in summer closets, and took a shower, the record still playing and playing. Then I put on some other dress, totally forgettable, and welcomed the kids and Sylvia back, the song still belting out, them telling me to turn it down, for heaven's sake, or turn it over, it was driving them crazy, but me not doing that, just concentrating on my eye shadow because it was the cocktail hour again and I was hurrying to meet Mike at the station and go off with him to another party where Frank would be.

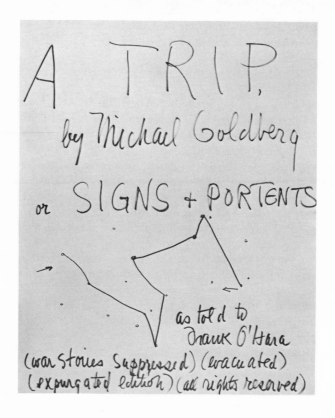

I don't remember when the DEAR DIARY number was done. The art reminds me '62-'63. Frank was to keep a record of a trip he was taking for MOMA—particularly mentioning cities' names—as we both felt that nothing so became European cities as their triumphal arches, or lack of them. Although the history of Europe is so long that even the slowest city must have won sometime. Frank mentioned cities, I did arches & we pieced it together (winged it?).

—Michael Goldberg

Entered through Amsterdam
"Gateway of Europe"

... strange, since it's in the middle, already

I decided I really like water

AJAX

5 Poem-Paintings by Norman Bluhm & Frank O'Hara

*(Note: 22 of the 26 poem-paintings, which Bluhm &
O'Hara did in 1960, are in the collection of New York
University; the 4 others are in private collections.)*

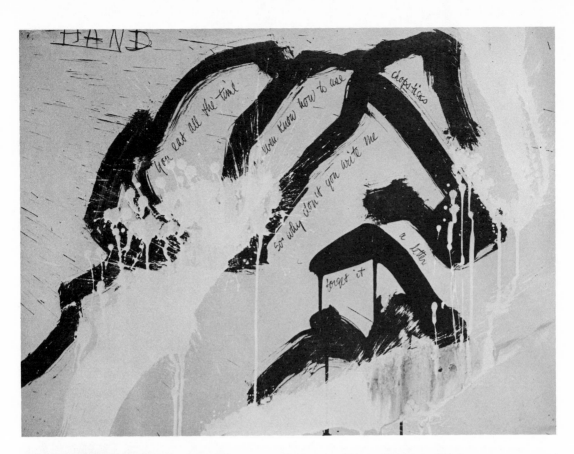

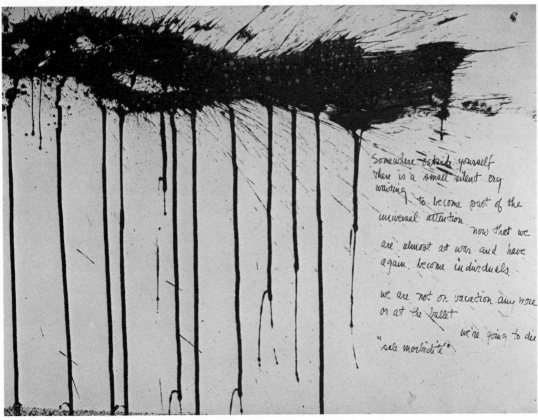

a haiku

I was up at Hiroshima
m. a. the other night
and ran into X

it cost me
$2.30 plus tax
I love you.

126

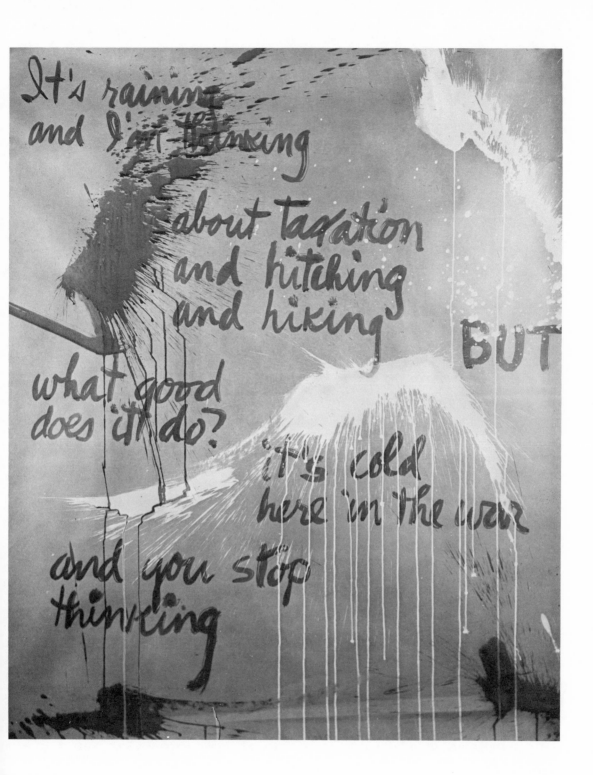

It's raining
and I am thinking

about taxation
and hitching
and hiking BUT

what good
does it do?

it's cold
here in the war

and you stop
thinking

NOTES ON FRANK'S WORKSHOP AT THE NEW SCHOOL

I believe Frank was filling in for Kenneth Koch that season but I may be wrong.

Two things Frank taught me were: 1) YOU call it something—i.e. a play—and everyone will accept it as such. So I did and they do. And 2) some things are better unlabeled: i.e. a poem calling names at the sun: now called ODE.

Teaching styles of Kenneth and Frank were entirely different. Frank did not give assignments and Kenneth did—although one of course did not have to do them.

Other people I *think* in the workshop included: Tony Towle, Joe Ceravolo, Jean Boudin, Anne Fessenden, Allan Katzman, Gerry Malanga, Jim Brodey—and others I do not remember the names of.

I learned a great deal from Frank's actual poetry—i.e. my poem beginning

> Reading about the Wisconsin Weeping Willow
> I was thinking of you
> and when I saw Plus Free Gifts
> I was thinking of you
> and when farther down the page I saw
> Eat Five Kinds Of Apples From Just One Miracle Tree
> I was thinking of you
> I was thinking of you

 *

''Frank,
 the derivation is obvious.
 How shall I acknowledge it?
 This is because I think someone will
 publish it maybe.
 Also, it's said to be correct to ask
 permission to use someone else's name, such as
 For Frank O' sounds misleading?
 To Frank O' considering the refrain.
 Speak up, will you. What is granted who?''

''Anything, you know that, Ruth!

(I always suspected I got it from somewhere
too—and I don't mean Cohasset, Mass.)''

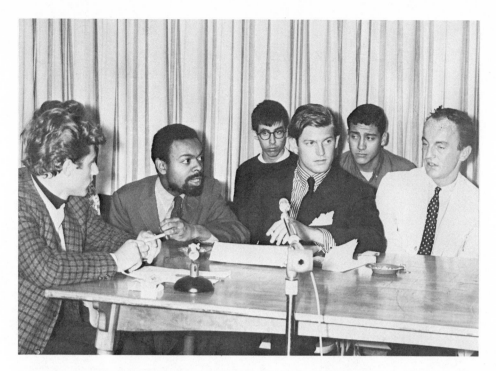

Above: Poet panel at Wagner College, 1962: Gerard Malanga, LeRoi Jones, David Shapiro, Bill Berkson, Frank Lima, FO'H. (Kenneth Koch also present, to Frank's right.) (Photo: William T. Wood) Below: Reading with Robert Lowell, Robert Harson, Willard Maas & Gerard Malanga, Wagner College, 1962.

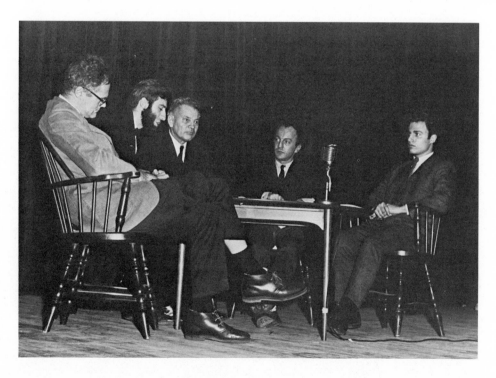

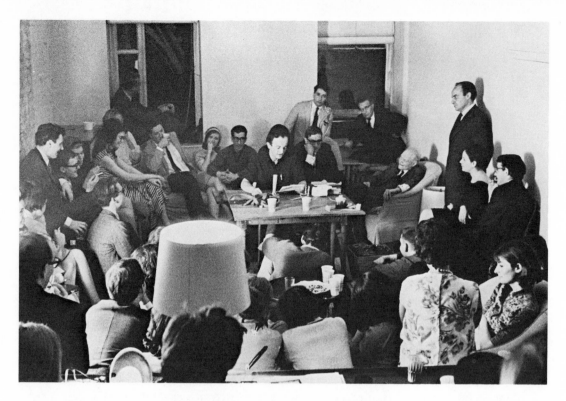

Above: Reading in honor of Guiseppe Ungaretti, New York, May 2, 1964. (Ungaretti in armchair at right.)
Below: With Allen Ginsberg at Ungaretti party. (Photos: Camilla McGrath)

Julia Gruen's third birthday party, Water Mill, N.Y., 1961. *Back row, left to right:* Lisa deKooning, Frank Perry, Eleanor Perry, John Myers, Anne Porter, Fairfield Porter, Angelo Torricini, Arthur Gold, Jane Wilson, Kenward Elmslie, Paul Brach, Jerry Porter, Nancy Ward, Katherine Porter, Unidentified Lady. *Second row, left to right:* Joe Hazan, Clarise Rivers, Kenneth Koch, Larry Rivers, Miriam Shapiro, Robert Fizdale, Jane Freilicher, Joan Ward, John Kacere, Sylvia Maizell. *Sitting & kneeling in front:* Steven Rivers, Bill Berkson, FO'H, Herbert Machiz, Jim Tommaney, Willem deKooning, Alvin Novak.

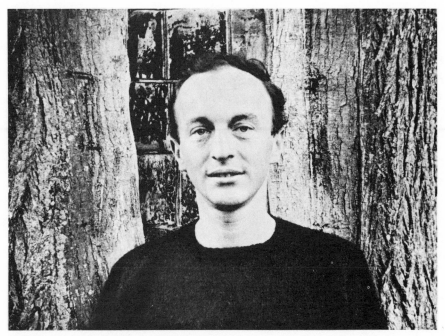

Southampton, 1962. (Photos: John Gruen)

SIX MEMORIES OF FRANK

Fall 1964 (?)

My wife and I had been invited for the first time to Frank O'Hara and Joe LeSueur's loft at 791 Broadway. We rang the bell and groped our way up the stairs. At the top of the second landing Frank's head appeared. I think he said something ironic about the marvelous condition of the stairs. When we got to the door he extended his hand and, smiling, said, "I've been reading *In Advance of the Broken Arm* and I really like your poetry." Flabbergasted, all I could say was, "I like your poetry too!" And we both burst out laughing, he because he was feeling congenial and expansive, me because I had just uttered the most inept understatement of the century.

Meditations in an Emergency had scared me when I first read it, in New Orleans, visiting Dick Gallup at Tulane, at Thanksgiving, 1959. At the time a high school senior in Tulsa, I thought Frank really did go around finding people lying in pools of blood, and I thought all those exclamation points were indications of pathological hysteria. My attitude changed, via poems such as "Why I Am Not a Painter," and then "Ode to Michael Goldberg's Birth (And Other Births)" in *The New American Poetry 1945-1960*, so that by the time *Lunch Poems* appeared, I was ready for it. It knocked me over. And it still does. I love those poems.

So it was dazzling to sit down and eat chili with him, at a table with Joe LeSueur, Joe Brainard, Kenneth and Janice Koch, and my wife Patty. The conversation flew thick and fast, mostly between Frank and Kenneth, who engaged in some of the most brilliant conversational duels I had ever heard.

After dinner I found myself sitting next to Joe LeSueur, who was a thoughtful host: he made me feel as though he thought my attending Columbia was interesting and worthwhile. Frank sat across from us. I was afraid to look at him too much—he was talking to Irma Hurley, who had arrived after dinner. At one point he launched into a sort of paean to Genet, whose books were in the long bookcase that lined the wall. Then he looked at me and asked, "Ron, what do you think of Genet?"

I said, "I like his books but I can't remember them very well. I think I read them, forget them, and use them somehow in my own writing."

"I know just what you mean," he laughed, "it's all grist for the mill, no?"

I was basking in the warmth of his approval—a childish attitude I had achieved quite on my own.

Walking to the subway, I said to myself, "God, this is wonderful!" And it was.

1963-1964

Ted Berrigan and I were, in 1963 and 1964, cheap chiselers, and we were poor. Every time we went to the Modern we'd call Frank from the Membership Desk phone to ask him for a pass to the museum for that day. A chore he did with unfailing good humor. Sometimes he'd say, "Come by my office and chat a minute." There came to me a wonderful and intimate connection between the museum's collections and Frank, between modern painting and modern poetry.

(Date?)

I was surprised by how formal Frank was when he read his poems at the Eisner-Lubin

Auditorium at N.Y.U. one Sunday afternoon. He read with a dry dignity I found inappropriate, but the beauty of his voice, the part he couldn't disguise, was compensation, a voice that often reminded me of bourbon and smoke, nightclubs, a phonecall that changes your life, and warmth.

Late Summer 1965

Joe LeSueur was giving an afternoon cocktail party, perhaps to celebrate his new apartment. Soon my wife and I would be off for a year, bound for Lille, France. ("Lille?" Frank asked. "Yes," I said, "the birthplace of Charles de Gaulle and Lalo." "What a marvelous combination," he laughed.) I had brought my copy of *Lunch Poems* for Frank to sign, which he did:

> for Ron & Pat
> and Lille and
> Leconte & Lalo
> and all of Spain
> Love Frank

At one point I went into the bedroom and discovered him in his underpants, otherwise completely dressed. Joe LeSueur was holding his trousers. He was just changing clothes, probably for a concert or the ballet that night—a black suit. He looked at me and said to Joe, in mock alarm, "Oh dear, what *will* he think of us now?"

August 1966

Just back from Europe, I dropped by to see Aram Saroyan in his apartment on West 85th. In the course of the conversation he told me Frank had been involved in a serious accident. Aram had heard this the day before from Kynaston McShine, who had been a witness.

I went back down to Avenue B where my wife and I were staying, at Joe Brainard's. It was a terribly muggy day. I got in the shower. I stood there thinking, "Frank is alive. Any second he might be dead, no, yes . . ." as I stared at a bright green bottle of Prell.

Fall 1964(?)

There is the story of how Dubuffet, quite out of the blue, had sent a personally inscribed drawing to Frank, in a battered mailing tube which Joe LeSueur had almost mistaken for trash. Dubuffet had read Frank's poem "Naphtha" which begins, "Ah Jean Dubuffet." Frank was electrified by the unexpected gift. I stood in Frank's bathroom, looking at the drawing, electrified by just being there.

(March 1976)

POEM

Funny, I hear
Frank O'Hara's
voice tonight
in my head—
e.g. when I
think in words
he's saying them
or his tone
is in them.
I'm glad
I heard him
when he was alive
and I'm glad I can
hear him now
and not be sorry,
just have it all here,
the way Jimmy, stark
naked with rose petals
stuck to his body,
said, ''Have you seen
Frank? I heard
he's in town tonight.''

Ron Padgett

BURIED AT SPRINGS

There is a hornet in the room
and one of us will have to go
out the window into the late
August midafternoon sun. I
won. There is a certain challenge
in being humane to hornets
but not much. A launch draws
two lines of wake behind it
on the bay like a delta
with a melted base. Sandy
billows, or so they look,
of feathery ripe heads of grass,
an acid-yellow kind of
goldenrod glowing or glowering
in shade. Rocks with rags
of shadow, washed dust clouts
that will never bleach.
It is not like this at all.
The rapid running of the
lapping water a hollow knock
of someone shipping oars:
it's eleven years since
Frank sat at this desk and
saw and heard it all
the incessant water the
immutable crickets only
not the same: new needles
on the spruce, new seaweed
on the low-tide rocks
other grass and other water
even the great gold lichen
on a granite boulder
even the boulder quite
literally not the same

II

A day subtle and suppressed
in mounds of juniper enfolding
scratchy pockets of shadow
while bigness—rocks, trees, a stump—
stand shadowless in an overcast
of ripe grass. There is nothing
but shade, like the boggy depths
of a stand of spruce, its resonance
just the thin scream
of mosquitoes ascending.
Boats are light lumps on the bay
stretching past erased islands
to ocean and the terrible tumble
and London ("rain persisting")
and Paris ("changing to rain").
Delicate day, setting the bright
of a young spruce against the cold
of an old one hung with unripe cones
each exuding at its tip
gum, pungent, clear as a tear,
a day tarnished and fractured
as the quartz in the rocks
of a dulled and distant point,
a day like a gull passing
with a slow flapping of wings
in a kind of lope, without
breeze enough to shake loose
the last of the fireweed flowers,
a faintly clammy day, like wet silk
stained by one dead branch
the harsh russet of dried blood.

James Schuyler

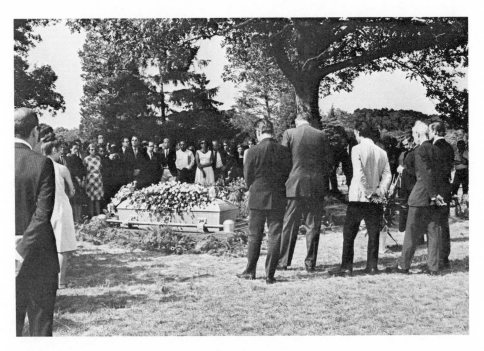

Springs Cemetery, July 27, 1966. (Photos: Camilla McGrath.)

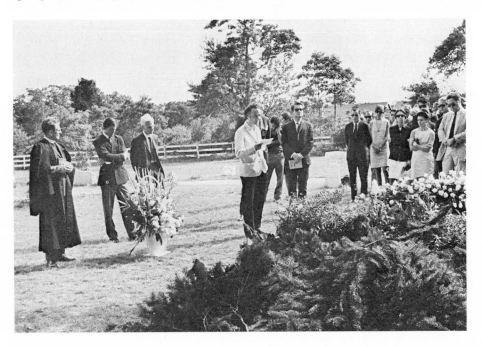

SPEECH READ AT FRANK O'HARA'S FUNERAL
SPRINGS, LONG ISLAND, JULY 27, 1966

Frank was my best friend. I always thought he would be the first to die among my small happy group. But I day-dreamed a romantic death brought about by too much whiskey, by smoking three packs of Camels a day, by too much sex, by unhappy love affairs, by writing too many emotional poems, too many music and dance concerts, just too much living which would drain away his energy and his will to live. His death was on my mind all the sixteen years I knew him and I told him this. I was worried about him because he loved me. His real death is a shock because he died—and died horribly in an absurd situation. Frank was killed on the soft, safe, white sand of Long Island. This extraordinary man lay without a pillow in a bed that looked like a large crib . . . He was purple wherever his skin showed through the white hospital gown. He was a quarter larger than usual. Every few inches there was some sewing composed of dark blue thread. Some stitching was straight and three or four inches long, others were longer and semicircular. The lids of both eyes were bluish black. It was hard to see his beautiful blue eyes which receded a little into his head. He breathed with quick gasps. His whole body quivered. There was a tube in one of his nostrils down to his stomach. On paper, he was improving. In the crib he looked like a shaped wound, an innocent victim of someone else's war. His leg bone was broken and splintered and pierced his skin. Every rib was cracked. A third of his liver was wiped out by the impact. What can talking about it do. I don't know. Frank O'Hara was my best friend. There are at least sixty people in New York who thought Frank O'Hara was their best friend. Without a doubt he was the most impossible man I knew. He never let me off the hook. He never allowed me to be lazy. His talk, his interests, his poetry, his life was a theatre in which I saw what human beings are *really* like. He was a dream of contradictions. At one time or another, he was everyone's greatest and most loyal audience. His friendships were so strong he forced me to reassess men and women I would normally not have bothered to know. He was a professional handholder. His fee was love. It is easy to deify in the presence of death but Frank *was* an extraordinary man—everyone here knows it. For me, Frank's death is the beginning of tragedy. My first experience with loss.

Larry Rivers

Peter Schjeldahl

FRANK O'HARA: 'HE MADE THINGS & PEOPLE SACRED'

It was 3 a.m. of a Saturday night on Fire Island, pitch black on the beach except for the headlights of a disabled taxi and those of another jeep headed its way, sloughing through deep ruts at maybe 25 miles an hour.

Frank O'Hara, one of nine temporarily stranded passengers, stood alone off in the darkness, his companion and friend J.J. Mitchell wasn't sure just where. Within inches of the crippled taxi, the second jeep churned past. Evidently O'Hara was just turning to face the blaze of its lights when it ran him down.

Panicked, Mitchell rushed to him. O'Hara stirred, then mutterered something. He was in a rage. His delirious fury made it hard to hold him still during the efficient relay from jeep to police boat to ambulance to tiny Bayview Hospital in a place called Mastic Beach. There he subsided, however, and was examined, then laced with innumerable stitches. The doctor was encouraging: contusions, gashes, shock, and a badly smashed left leg, but nothing ostensibly lethal.

Then around dawn O'Hara's blood pressure fell. Pints of rare RH-negative blood began arriving at the hospital by police car every few minutes. The exploratory operation that afternoon, when enough blood was on hand, revealed a partly ruptured liver and some damage to the kidneys, among other things. The liver, now a good deal smaller, was sewn shut; the kidneys were left for later.

Meanwhile, the New York art world was collectively thunderstruck. In 15 years as a poet, playwright, critic, curator, and universal energy source in the lives of the few hundred most creative people in America, Frank O'Hara had rendered that world wholly unprepared to tolerate his passing.

The next day, Monday, July 25, the day of his death, he seemed to be holding his own, even improving. A very few friends were let in to see him, a few seconds apiece. In his speech at the funeral two days later, Larry Rivers, incensed at fate, said O'Hara "lay in a bed that looked like a large crib" and that he resembled "a shaped wound." He said he had always expected Frank to die, but "romantically," somehow, voided by his generosities and done in by his methodical excesses, not shattered by a jeep on a white sand beach. Willem deKooning found O'Hara in terrible pain. "When I spoke his name he opened his eyes and he said, in that way of his, 'Oh Bill, how nice!' With such elegance! He had so much grace, that man, even through all the delirium and agony.''

At about 8:50 p.m., very suddenly, he was gone. He was 40 years old.

The sketchy obituary in the Times next morning barely mentioned his poetry, focusing on his role as an assistant curator at the Museum of Modern Art, responsible for the recent Motherwell and Nakian shows. It also rehashed the notoriety of a certain nude portrait of O'Hara (after Gericault, plus combat boots and erection) done by Rivers 11 years ago. The account of O'Hara's funeral, in Thursday's Times, led off with an exaggeration of people's shock at Rivers' speech, proceeded to misspell 10 of the 25 names it mentioned (uncorrected in later editions), then invented the presence of "many bearded, tieless friends of Mr. O'Hara," a funny thing to lie about.

Nor did the Times note poet and dance critic Edwin Denby's remark that O'Hara had been America's greatest living poet; nor did it refer to poet and art critic Bill Berkson's eulogy: "Frank's was the most graceful, quick, courageous, sometimes terrifying intelligence. Often, no matter how intimate or involved you might be, you could only begin to imagine what and how much he was feeling. It was electric, full of light and air and blood, amazing, passionate, and full of sense. As a poet, a

genius, just walking around, talking, he had that magic touch: He made things and people sacred . . .''

Rivers, in his speech, said, ''There are at least 60 people in New York who thought Frank O'Hara was their best friend.'' Before the funeral, Reuben Nakian had a member of O'Hara's family attach to his coffin a terra-cotta sculpture from the series ''Voyage to Crete''—work that had moved and excited O'Hara in his preparation of Nakian's show. After the funeral, Allen Ginsberg stayed to intone Indian sutras over the grave. Ginsberg: ''I never realized until now how attached I was to the presence of that man on Earth.''

His friends, in attempts to communicate the breadth of their loss, almost inevitably allude to Guillaume Apollinaire. It's a natural. Both poets were patron spirits of the avant-garde literature, painting, theatre, music, and dance—indeed, the sensibility and moral vision—of their times. Both had enormous personal charismas. Both revised the aesthetic assumptions of poetry, leaving poetry changed. And both died horribly, at the height of their powers, leaving life changed.

Another dark parallel, one that O'Hara himself might richly have appreciated, takes in Jackson Pollock. O'Hara's first major work of art criticism was a book on Pollock, a massive retrospective of whose work he was just beginning to assemble when he died—two weeks short of the anniversary of Pollock's death, also in an auto accident on Long Island. The two men's graves, in the little cemetary at The Springs, are a few yards apart.

Such references correspond to a certain essence of the man. O'Hara's life was measured out in a sort of endless homage to his heroes—the great exemplars of personal and artistic integrity like Pollock, Franz Kline, and especially Boris Pasternak; the revolutionaries of poetic attitude and style like Apollinaire and Mayakovsky, and the forms of emotional identification, the movie stars like James Dean, Carole Lombard, and so many others, whom he celebrated brilliantly without embarrassment and with only the slightest, functional trace of irony.

This attitude of reverence and enthusiasm may in part account for the virtual mystique O'Hara generated around himself, for it extended into every area of his life, attaching to whatever and whomever he found in the least admirable or delight-ful—and triggering responses so intense his oldest friends do not affect to understand them. Everything about O'Hara is easy to demonstrate and exceedingly difficult to ''understand.'' And the aura of the legendary, never far from him while he lived, now seems about to engulf the memory of all he was and did.

Little is generally known about his early life, except that he was born in Balti-more on June 27, 1926, and raised in Grafton, Massachusetts, serving with the Navy in the Pacific from 1944 to 1946, when he entered Harvard. The one member of his family to whom he was close, a younger sister (now Mrs. Maureen Smith of Brooklyn Heights), respects his unwillingness to speak of those years.

In the spring of 1949, when O'Hara was a junior at Harvard, John Ashbery was a senior. As an editor of the Harvard Advocate, Ashbery had published some of O'Hara's first literary efforts (mostly in prose) but knew of him only by his reputation as a hotshot intellectual with something of an undergraduate following. One afternoon in a bookstore, Ashbery heard a voice behind him airily expounding on the then almost totally unknown French composer Poulenc. Fascinated, he eaves-dropped. The voice said: ''Let's face it, 'Les Secheresses' is much great than 'Tristan.' '' Ashbery instantly turned and introduced himself; and their friendship was joined. ''That,'' he recalls, ''was the sort of thing NOBODY said in those days. It didn't matter that he was wrong.''

O'Hara's first visits to New York, while finishing at Harvard and getting his M.A. at the University of Michigan (where he also won the prestigious Hopwood Award for poetry), were suitably auspicious. In Ashbery's Jones Street apartment and at gathering places of what would be known as the New York School ''Second Generation'' painters, he met Kenneth Koch, Larry Rivers, James Schuyler, Jane

Freilicher, Mike Goldberg, Grace Hartigan, Joan Mitchell, and scores of other young artists and poets, all engaged in a kind of vertiginously euphoric life and activity which O'Hara's presence seemed just naturally to grace with point and inevitability. He was the first of the young New York poets to start reviewing for Art News (to be followed by Ashbery, Schuyler, and Barbara Guest) and in the fall of 1951 he was hired by the Museum of Modern Art, a tenure he was never, save for one two-year hiatus, to relinquish.

Frank O'Hara's body was small and lean—classically ''bantam''—and was topped by a face organized around a preposterous Roman nose, like a falcon's beak. He had a smallish, sensuous mouth; a high, freckled forehead, and limpid blue eyes of a certain hypnotic charm. His every movement bespoke will and self-assurance, poise, and a kind of unmannered courtliness. His physical presence in a room was like that of an exclamation point on a page. That presence quickly became one of the most sought-after, and one of the most freely granted, in the city. The painter Helen Frankenthaler says personal invitations to parties in the '50s often carried the information ''Frank will be there''—the ultimate inducement to attend.

O'Hara seemed to be everywhere at once. He attracted notice even on the Olympian heights of ''The Club'' on 8th Street, fabled clearinghouse of the New York School. DeKooning recalls: ''I liked him immediately, he was so bright. Right away he was at the center of things, and he did not bulldoze. It was his manner and his way.

''There was a good-omen feeling about him.''

Delmore Schwartz had given O'Hara his first professional poetic acceptance in 1950, taking a poem for the Partisan Review and strongly encouraging the young poet who was to outlive him by two weeks. His first book, ''A City Winter,'' was published in 1952 by John Myers at the Tibor de Nagy Gallery, then virtually the only showcase for the overshadowed young talents of the ''Second Generation''— among them, Miss Frankenthaler, for whom O'Hara's effulgence of creative and emotional excitement ''smacked of Paris scenes in the '20s, their principle of passionate involvement with one's comrades. As the circles and dimensions of our thing grew, everybody had moments of feeling intensely close to Frank. He climbed into your life.''

Ashbery: ''He gave you the feeling of belonging to an exclusive club with him, as if you had hooked into some big, secret continuum of life. Frank had a personal kind of idea about things, which made you feel you could think independently too.''

Ginsberg: ''His feelings for me seemed to vibrate with my feelings for myself. I think he saw my ideal self-image; he articulated it and made it sound right.''

Berkson: ''If you were one of Frank's friends, you were given a grand permission to be direct and interesting, to be full of ideas and feelings.''

Collaboration, a direct extension of O'Hara's mode of living, is a good metaphor for the manner of his relationships—an intimate competition in which each participant goads the other toward being at his best. Among the artistic collaborations: poems with Ashbery, Koch, Berkson, and the French language (before he learned it); the famous ''Stones'' lithographs with Rivers; painting-collages and the book ''Odes'' (Tibor, 1960) with Mike Goldberg; comic strips with Joe Brainard; ''Four Dialogues for Two Voices and Two Pianos'' with composer Ned Rorem; the movie ''The Last Clean Shirt'' with Al Leslie (shown at the New York Film Festival), and innumerable others. In his life, something of the same impulse was everywhere at work— to the ultimate dismay of some friends. Not everyone could cope for long with a mind that leapt at everything and missed nothing. Berkson: ''I never heard Frank say 'I don't know what I feel about that.' He could summon a response, not just an opinion but a real emotional response, for anything.''

Goldberg: ''If you were close to him, Frank forced you to live at a terribly high

intensity. You were always scrambling to keep up with him. He ran through people; almost everyone fell by the wayside at one time or another. It was his incredible appetite for life..."

If O'Hara had a motto, it was perhaps his own summary of his approach to poetic composition: "You go on your nerve." Or, meaning the same thing, a line of Pasternak's: "It's past, you'll understand it later." At any rate, O'Hara was not always tolerant of friends whose nerve failed them, who looked back. On rare occasions, drunk at some late hour, he would mount titanic and vituperative personal rages. He could instill misery and dread to the same extent that he habitually evoked affection and joy. Yet, in the words of a young poet who knew him, "No matter what he did, he never lost that movie-star quality, in the best sense. He never seemed less than glamorous and heroic." Most people saw, at very least, a certain "rightness" to even his wildest tirades, perhaps because, as Goldberg says, "Frank almost always concealed the side of him that was deeply hurt and suffered; you only knew it must be there." So his anger had the inexorable "justice" of a volcano. And when he demanded a return on the love he usually lavished, it had, with whatever anguish, to be credited.

For a man who, in the words of one friend, "indulged every feeling he ever had," this may have been the simple tactic of survival.

If "other people," Sartre's Hell, were O'Hara's element and atmosphere, other people's art was his constant source of inspiration and delight. Jewish Museum Director Kyneston McShine, who worked with him at the Modern, speaks of O'Hara's "amazing clarity" in instantly perceiving the special, most interesting aspect of any work. Painters, poets, and musicians speak of the quality of his concern. He was, on the pattern of Apollinaire, "a poet among the painters," an artist whose domain was all of art.

Elaine deKooning: "He had a sense of what painters are after, he helped you see what you wanted to do."

Rorem: "What amazed me most about Frank's interest was that he really wanted you to be good, he really wanted to like your work."

Ginsberg attributes to O'Hara's persuasive enthusiasm his own first whole-hearted appreciation of the poets Peter Orlovsky, John Wieners, and Gregory Corso. "He had the genius's insight into other genius, plus total lyrical sympathy and magnanimity."

And perhaps no poet since Apollinaire was the subject of so many portraits.

It is generally agreed among the current crop of young "New York poets" that whatever sense they may have of common identity, and of identification with the older, established poets, is due largely to O'Hara. Certainly his loft at 791 Broadway —as, earlier, his apartment on East 9th Street—was a depot for poets regardless of age, clique, or stylistic allegiance. Koch: O'Hara acted as though "being an artist were the most natural thing in the world." Also, he acted as though the art and literary scenes were really for artists and poets, any artist and any poet who wanted to move in them. He held parties expressly for the purpose of bringing people together; at one such he introduced dozens of young writers to the venerable Italian poet Ungaretti. His personal, direct (never patronizing) warmth had a way of melting one's feelings of intimidation at the threshold to his world. Now, it seems, all that may be gone forever.

As it is written, O'Hara' poetry is tough, dazzling, supple and fast, very funny but incipient with the deepest feelings, aglimmer with linguistic and human perceptions, and subject at any moment to lyric eruption or the breakthrough of intelligence.

Ashbery: "His poetry, more than anyone else's, reconciles all sorts of conflicting material. In it, things exist in a sort of miraculous emulsion."

Ginsberg: "Of course he had a tremendous sensitivity for style, for chatty

campy style and also for real high style . . . He was at the center of an extraordinary poetic era, which gives his poetry its sense of historic monumentality . . . And he integrated purely personal life into the high art of composition, marking the return of all authority back to person. His style is actually in line with the tradition that begins with Independence and runs through Thoreau and Whitman, here composed in metropolitan spaceage architecture environment.

"He taught me to really see New York for the first time, by making of the giant style of Midtown his intimate cocktail environment. It's like having Catullus change your view of the Forum in Rome."

O'Hara's reputation, as Ted Berrigan suggests in an article in the current East Village Other, will probably ultimately rest on such poems as "Second Avenue," "In Memory of My Feelings," "For the Chinese New Year & For Bill Berkson" and "Rhapsody," but already a handful of his short poems, embodiments of unique and perhaps unprecedented ways of thinking and feeling about things, seem destined for a kind of immortality—e.g., "The Day Lady Died" and "Why I Am Not a Painter." His best plays include "Awake in Spain!" and "The General Returns from One Place to Another."

And much of O'Hara's work is yet to be published, exactly how much is not immediately clear.

O'Hara did not, while he lived, win a very extensive poetic reputation. For one thing, his preference for the "commercial" world of art over the academic "community of letters" cut him off from the latter's well-oiled media of (relative) fame. The New York Times, as it has again so eloquently indicated, is innocent of poetry unless informed of it through proper channels. Beyond that, O'Hara deliberately neglected measures, such as simply sending off his work to the prestige magazines or using his influence with larger publishing houses, by which he might effortlessly have ascended into more general view.

His reluctance to be bothered with literary renown bespeaks the confidence of a man who knew he had it coming. But, more than that, it testifies that the locus of his ambition lay elsewhere. O'Hara affirmed, in an essay on "Doctor Zhivago," Pasternak's (and his own) "belief that the poet must first be a person, that his writings make him a poet, not his acting of the role." And what is the alchemy by which a poet is first a person: An O'Hara line: "Grace / to be born and live as variously as possible."

(*The Village Voice*, August 11, 1966)

143

THE DEATH OF FRANK O'HARA

July 24, 1966. The weekend began much like any summer weekend in New York. Frank and I had been invited by Morris Golde to his summer beach house in Water Island, not an 'island' but one of the many small communities on Fire Island. An invitation to Morris's is an enviable summer treat and has been extended by him over the years to his many friends and to a generation (or two) of "poets and peasants." The beach house was an extension of the salon (now scattered) that Morris had created in his painting-filled garden apartment on West 11th Street: large crowded parties celebrated the premiere of a new book, play, or concert, and small dinners for six—with a second wave of after-dinner arrivals—bubbled with conversation long into the morning. One met there—as I did—Marc Blitzstein, Ralph Kirpatrick, Aaron Copland, Virgil Thomson, Ned Rorem, Lennie Bernstein, Edward Albee, John Ashbery, Kenneth Koch, Jane Freilicher. I was relatively new to New York, after four years at Harvard, the Navy, and a short stint on the *Washington Post*, and was beginning to settle into a career in publishing. My association with Frank had begun in 1960, when through a maze of circumstances I met Joe LeSueur, who was living with Frank in their East 9th Street apartment. At our first meeting, Frank's legendary capacity for friendship was extended (over bourbon and orange juice one morning with Joan Mitchell) in a way which I doubt will ever be duplicated again (by anyone) in my lifetime. That friendship grew truly marvelous (in the lost sense of the word) over the five years that I knew him. Frank orchestrated it—as only he could—from awe to ease to delight to love. It was reinforced by daily lunches at Larrés French restaurant on West 56th Street (*Lunch Poems* never precluded lunch!), the ballet (Balanchine!), gallery openings, parties, weekends at Patsy and Mike Goldberg's or at Larry Rivers' (the Hamptons!), and Joe's dinners at their Broadway loft across from Grace Church. Late late shows, endless talk, the mad fix, fueled probably by a mutual Irish passion for life, laughter, liquor—and the dread of ever going to sleep!

So that weekend began casually, with a mutual anticipation of the pleasures which drew us together. Virgil Thomson, Morris' longtime friend ("brother") had also been invited, and made us four in the house. We arrived late Friday, after crossing Great South Bay in Morris' small Whaler, had a leisurely dinner and retired early. Saturday was brilliant and sunny, marred (almost ominously) by our constant concern for Virgil, whose exuberant plunges into the Atlantic rollers made us fearful that we would be deprived of the cheerful octogenarian that we know today. That night we dined sumptuously on a gigot which Virgil had me prepare à la Alice B. Toklas, corn sheared from the cob (to our mutual American dismay but delight, and a suitable accompaniment of Moulin à Vent ("the Belgian rule: seven bottles for six people"). Frank and Virgil were not intimate friends, but they often socially, and both relished the opportunity for a frisky repartee—Virgil expounding, Frank deferring—and the inevitable sparks (fireworks) that charged the air, certainly for others present. It was a night of quintessential Virgil: prompted by the bonhomie of the occasion, he delivered a long monologue on life, love, and friendship which left Frank, Morris, and me stunned in silent awe.

Afterward Virgil ("Thank you for letting me be brilliant") said, "Now, let's go look at the animals." That was the bugle cry for Saturday night entertainment: a call for the beach taxi, a sortie into the night life of Fire Island Pines, only fifteen minutes down the beach. Soon after our arrival and an exchange of drinks and mutual salutations with friends, Virgil took his customary snooze (*à table*). Morris, after an hour or so, said he would return to the house with Virgil. Frank and I were having a good time and decided we would stay on longer, have another stinger, and follow them shortly. In time we grew tired of the scene, agreed to return, and took the first available taxi among the many that plied the beach at that hour. The beach taxi was perhaps overloaded with "groupies," going in our direction to Davis Park, beyond Water Island. Within minutes, before leaving the confines of the Pines, the taxi threw a tire, stranding us on the beach. The passengers disembarked, the driver assured us that another taxi had been radioed for, and we were left to mill about. It was probably about 3 a.m. The rest is a hazy nightmare. A beach buggy

approached, traveling toward us in the ruts created in the sand by the previous taxis. (Near the water where the wet packed sand afforded an accelerated speed). For reasons that remain fuzzy to this day (the 21-year-old driver—with girlfriend—said he was blinded by our headlights), the beach buggy failed to slow down, passed perilously close to our taxi, causing at least nine of us to jump hastily aside, and collided head-on with Frank, who had strayed momentarily away from me and the group.

Often in accidents, the truth (horror) is only dimly and perhaps reluctantly perceived. This was no exception. Frank was suddenly lying in the sand, obviously hit by the beach buggy, which had now stopped ahead in the darkness. We all run to his aid. The taxi radios for the police and the Pines doctor. We examine him. He is unconscious, but beginning to stir, moan. It doesn't look disastrous. (Frantic inner denial of the worst, hope for the best.) The young summer resident doctor arrives, miraculously fast. He takes his pulse, probes with his fingers. Frank's leg is definitely broken; contusions, abrasions, but no immediate evidence of internal damage. Arrangements are made by police radio to speed him by police launch across the bay, where an ambulance will be waiting. Everything proceeds with remarkable expediency. I accompany Frank across the bay, holding him down as he begins to come to. Complains of terrible pain—leg, ribs. Terribly uncomfortable. Won't stay still. I try to comfort him: "Easy, don't move, your leg is broken . . . we'll be at the hospital soon . . . bear up . . . everything will be O.K." Not much comfort. Ashore a waiting ambulance takes us to a small private hospital in Mastic Beach. (The emergency rooms are overloaded at Brookhaven and elsewhere because of Saturday night highway accidents.) The hospital looks like it was built with a Girl Scout cookie fund. Hardly any staff, one-night emergency doctor. He sets to work. I'm told to wait in the reception area. After a while the doctor tells me that he has done all he can do; there is still no evidence of serious internal injury. We shall have to wait until morning for the arrival of the daily staff and an orthopedic doctor to set his leg. Meanwhile, his external abrasions have been bandaged, and he is wheeled to a ward to await the dawn. Since that is within an hour or two, I decide to wait before calling and alarming Morris and Virgil. Lulled into false optimism, I try to catch a few winks on the waiting room sofa. At dawn I call Morris, who prepares to make the trip across. And Joe LeSueur: I give him the facts but try not to alarm him unduly. He sounds the alarm among Frank's friends in New York and the Hamptons.

At last the daily hospital staff arrives. A long conspiracy of silence. I push, make inquiries, but am kept out, told to wait outside. Finally, I am told his blood pressure has begun to drop, the sign of serious internal injury. An exploratory operation will have to be performed in the afternoon. A call is put out immediately for blood. Dozens of state troopers arrive at intervals with the designated blood type. By late morning (thank god . . . I'm exhausted) Morris and Virgil arrive, then Patsy Southgate and Norman Bluhm from Easthampton. Safety in friends. Four doctors are to operate. I remember us all waiting silently during an interminable operation, trying our best to chit-chat beneath a tree outside the hospital. At the end of the afternoon, a fatherly looking surgeon confers with us. It is very serious. A fifty-fifty chance to live. Half his liver removed. Serious kidney contusions. Danger of internal hemorrhaging. Everything possible has been done. The night will tell. Nothing more to do. A numb return to New York.

The next day Larry Rivers drives me, Joe, and Kenneth Koch back to the hospital. The family has arrived from divers vacation spots (Maureen, his sister, and her husband Walter Granville Smith; Phillip, his brother). Bill deKooning and Elaine (Bill with a big check book, wanting to pay for everything). Other friends. Rene d'Harnoncourt from the Museum of Modern Art. The possibilities of transfer to New York are explored. Apparently, nothing more can be done. New York surgeons are put in touch with the hospital, but arrive at the same consensus. Frank has survived the night. Again, false optimism. Perhaps he will survive.

The head surgeon says a few close friends may see him, one at a time, for a minute or two. Joe and I decide to go together. We see him enmeshed in all the paraphernalia of post-surgery, but alert and trying to be cheery. I say: "The doctor says you can't drink for a year." He says: "It hurts to laugh. Isn't it nice of Bill (deK) to come?" Brave and gracious to the end. Joe chats a moment, we leave: "Don't worry. We're here. See you tomorrow." On leaving the room we burst simultaneously into tears. A talk with the anesthetist, a charming woman born in France who asks, "Who is he? It's extraordinary that he is alive. His will to live is in his favor. He detected my French accent and joke with me in French." Lunch in a nearby clambar with assorted,

concerned friends who had begun to converge. Again, a numb return to New York. Cheerless drinks at Max's with Larry et al. "What would life be like—New York be like—without Frank?" False hope persists, but foreboding has set in. No one will say it. Home again, alone, listlessly trying to cope, regain some order. The phone rings. Waldo Rasmussen, Frank's friend and colleague at the Museum of Modern Art: "Frank just died . . . at eight-fifty tonight." Tears. I call Joe. He knows: "Come over."

Days later the funeral was held in Springs cemetery, where half the then-known uptown-downtown world of friends, poets, artists, and admirers convened quietly to mark their common love for this one man—person and poet. After that, sometime, I realized I had Frank's weekend bag which Morris had brought back from the island. I went through it, and found two curious items in the usual beachwear mix of sneakers, swim suit, shorts, and toilet kit. One was a manila envelope that contained a carbon copy of a scientific paper prepared by the psycho-analyst of Jackson Pollock, expounding, as far as I could tell, on the role of the analyst *vis à vis* the artist/genius. Weird, I thought, and too neatly prophetic.

Then my eyes went to the second unfamiliar item: a beautiful small journal with an embossed cover which bore (again?) a Pollock-like free form design—a skein of red ink on a cream-colored background. Curious. To my knowledge Frank had never kept a journal. (He could write a poem more easily.) I examined the book. A small sticker inside the back cover noted that it came from "Roma." I imagined that Frank must have bought it that spring when he was in Europe travelling for the museum. The journal's pages were blank throughout, except for a single entry on the first page, which bore the date 4/7/66. The entry was characteristically in ink, in his bold and beautiful vertical hand. It read:

Oedipus Rex

He falls; but even in falling
he is higher than those who
fly into the ordinary sun.

4/7/66

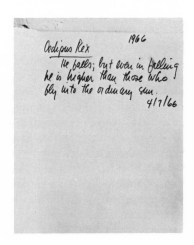

RED RIVER

(in memory, Frank O'Hara)

Peter and Linda in my car gone to Easthampton.
In a bar on Third Avenue, The Rail. Enough money
from this job for beer. Swampy, unpleasant day
Phoebe coming in mad, and rightly so—false claim of facts.
No one home on the lower east side, streets are filled
With me too, uptown to dinner. Peter talks poetry,
explains his dispatch, the food is rotten.

Linda says at the funeral friends stood in clumps,
like people in galleries who know each other.

Fire engines go back down broadway.
Peter downtown writing out the details.
Phoebe and I too tired, go home to straighten out.
The girl is sleeping, I'm smoking, inelegant,
as was never allowed in his poems
which spoke of the small graces we must master
to live in ecstasy in New York City.

 Lewis MacAdams

CITY MIDNIGHT JUNK STRAINS

for Frank O'Hara

Switch on light yellow as the sun
 in the bedroom...
The gaudy poet dead Frank O'Hara's bones
 under cemetery grass
An emptiness at 8PM in the Cedar Bar
 Throngs of drunken
 guys talking about paint
 & lofts, and Pennsylvania youth.
 Kline attacked by his heart
& chattering Frank
 stopped forever—
 Faithful drunken adorers, mourn.
 The busfare's a nickle more
 past his old apartment 9th Street by the park.
Delicate Peter loved his praise,
 I wait for the things he says
 about me—
 Did he think me an Angel
 as angel I am still talking into earth's microphone
 willy nilly
 —to come back as words ghostly hued
 by early death
 but written so bodied
 mature in another decade.
Chatty prophet
 of yr own loves, personal
 memory feeling fellow
 Poet of building-glass
I see you walking you said with your tie
 flopped over your shoulder in the wind down 5th Ave
 under the handsome breasted workmen
 on their scaffolds ascending Time
 & washing the windows of Life
—off to a date with Martinis & a blond
 beloved poet far from home
 —with thee and Thy sacred Metropolis
 in the enormous bliss of a long afternoon
 where death is the shadow
 cast by Rockefeller Center
 over your intimate street.
Who were you, black suited, hurrying to meet,
 Unsatisfied one?
 Unmistakable,
 Darling date
for the charming solitary young poet with a big cock
 who could fuck you all night long
 till you never came,
 trying your torture on his obliging fond body
 eager to satisfy god's whim that made you
 Innocent, as you are.
I tried your boys and found them ready

sweet and amiable
collected gentlemen
with large sofa apartments
lonesome to please for pure language;
and you mixed with money
because you knew enough language to be rich
if you wanted your walls to be empty—
Deep philosophical terms dear Edwin Denby serious as Herbert Read
with silvery hair announcing your dead gift
to the grave crowd whose historic op art frisson was
the new sculpture your big blue wounded body made in the
Universe
when you went away to Fire Island for the weekend
tipsy with a family of decade-olden friends

Peter stares out the window at robbers
the Lower East Side distracted in Amphetamine
I stare into my head & look for your/ broken roman nose
your wet mouth-smell of martinis
& a big artistic tipsy kiss.
40's only half a life to have filled
with so many fine parties and evenings'
interesting drinks together with one
faded friend or new
understanding social cat . . .
I want to be there in your garden party in the clouds
all of us naked
strumming our harps and reading each other new poetry
in the boring celestial
friendship Committee Museum.
You're in a bad mood?
Take an Aspirin.
In the Dumps?
I'm falling asleep
safe in your thoughtful arms.
Someone uncontrolled by History would have to own Heaven,
on earth as it is.
I hope you satisfied your childhood love
Your puberty fantasy your sailor punishment on your knees
your mouth-suck
Elegant insistency
on the honking self-prophetic Personal
as Curator of funny emotions to the mob,
Trembling One, whenever possible. I see New York thru your eyes
and hear of one funeral a year nowadays—
From Billie Holiday's time
appreciated more and more
a common ear
for our deep gossip.

July 29, 1966

Allen Ginsberg

from THE STREET

One night I remember fondly we were with the musician Lee Crabtree, in his somewhat disoriented apartment—Lee a very nonchalant guy, a musician to his fingertips—and all of us were freshly high on grass, and variously arranged in the disjointed furnishings of the apartment when we experienced a rare moment of real hushed communion via Lee's transistor radio which he'd just turned on. There in the night of the lower East Side with no one but ourselves and our separate destinies for protection we all heard for the first time the Beatles record of "Yellow Submarine," with Ringo Starr doing the lead vocal in as relaxed and unassuming a manner as you could imagine somehow thrilling us in our deepest souls.

I suppose the 'sixties at their best had that possibility or promise—that we were all somehow involved in a big gentle conspiracy of music, and love, and peace, and happiness, all of us travelling by yellow submarine through each other's eyes. If it didn't turn out that way, exactly, we learned a lot from the experience anyway. And we did have some real fun together.

Then one night, Ted and I were lingering in some forgotten conversation, as I was about to head uptown to the apartment, when we saw the familiar face of Kynaston MacShine, a curator of the Jewish Museum, approaching us out of the St. Mark's night.

"Have you heard about Frank?" he said to Ted.

"No."

"He was hit by a beach taxi on Fire Island. He's in the hospital."

A few days later Frank O'Hara, perhaps the most central and pivotal figure of the New York School of poets, died in the hospital. The whole New York scene was shaken to its roots. I had known O'Hara only casually, running into him usually in the art galleries where he was continually alertly present in his capacity as a curator for the Museum of Modern Art, but even so I had been able to catch a glimpse of his handsomeness as a person, as well as his humor, that had so long held the magnetic center of the social scene among the writers, and many of the painters as well.

"When Frank died," Ted said sometime later, "he released an enormous amount of positive energy into all his friends' lives."

He was forty years old when he died and maybe that is the case with some people who die while there is still a lot of life ahead of them. They give that life to their friends.

ODE

Permit me to take this sleeping man
And I will help him on his way.

Even with Be and Ice, my head
Bowed down as if I were sleepy.

If I could describe how Frank's
Eyes fell asleep, on hearing of Frank,

Like a painter working from a model
I could show how I went to sleep!

In my ramblings I closed my eyes
And transmuted thought into a product.

Moving in a trance with a keen face
I fell, and what happened to me

She knows who did this: She took my head
And held it down until I swallowed.

A girl walked by and said: I am Julia,
Open your eyes and see who I am.

When I heard this invitation,
She and my sleep went away together.

I have something of New York in me,
Lying against cement to bring it back.

There was almost no time between one ''when''
And the other, I mean the ''when'' of waiting

And the ''when'' of seeing a woman in bed.
Thus, in presenting sleep

The poem must leap over the cut-offs.
You see clearly in a revolution,

Look down and notice how you have slept.

David Shapiro

SUNRISE: ODE TO FRANK O'HARA

The gulls glide, in 1939, into the bonus of another country,
the balloons and machinery of all the Europes and Americas,
a hundred million words at ease in the river,
rising as I think about myself,
and in the history of my ears making a beginning of the frontier.

Ah the complete bunker of the earth and its dirt flying up,
across our view at the peak of the centuries,
pauses and silences as subtle as the wine of Bordeaux, and as words
coming time after time before the vigilance of your dizzying intelligence.

An incredible weight hangs today from my evasions,
you, and my biography which gets a little endless,
your immortal heart disappearing endlessly in the crisis,
slowly to be clear, and quickly to be interesting,
as we stay in the tonic of the bad air.

So what is the distinction of the river drawing you forward,
away from the restiveness of a vast American poetry
which you created with an unfathomable love.
You will be with the few of the past great enough to talk to,
as the remainder of this century of poetry begins to suffer
and your work will burst repeatedly our silence of unbearable memory.

August and then December will close the century
O air of your dreams descending on my day off.

 Tony Towle

"NOBODY OPERATES LIKE AN IBM MACHINE"

(for Frank O'Hara)

You said:
"I love your house because my poems are always on the coffee table!"
"I always have such fun with you!"
"Oh really, don't be an ass!"
"Just pull yourself together and sweep in!"
"Now *stop* it!"

An endless series of exclamation points
Has ended.

Your voice
Ran across the lawn wearing nothing but a towel
In the good old summertime.
You always sounded so positive!
What freedom!
I'll get a flag! (must!)

I loved your house too
With Grace Church looking in the window
And your imposingly empty ice-box;
All that work piled on the table
And lavished love on the walls and everywhere.

You would say, yacking away, shaving at the kitchen sink (*the sink*)
That we were going to be late again, for shits sake, but
"You look perfectly gorgeous, my dear,
"Would you mind feeding the cats?"
In those arrogant days
Before your grave.

You said, during the intermissions, on the phones, at the lunches, in the cabs:
"If you *want* to do it, just *do* it! What else is there?"
"My heart your heart" you wrote.
It all added up.
How flawless you were!

Patsy Southgate

2-EGG CAKE

O'Hara's language shining straight through to Flagstaff
Arizona where the road shifts to reoccur bending down
Into New Mexico allowing the swallows entrance to the sky
As a headache winds between nerve-endings so these birds
Go struggling to be calm (again) before the flutters of
Another sky filled with oranges & slowly heated halves
Of semi-Negro legs and shirts open to the bearded neck
Which shines on rainy desolate streets beside the road
That touches one with a fever to travel & hear the music
Long hair produces in the chest

Older typhoons stretch across Kansas the rhythms the
Meter of matriculated breezy feet lap at the several corners
Of Frank's steamy half-imagined girder sweaty bellies
The trees in South Central Los Angeles have lost their leaves
Preparing for the winter which will never truly come to the city
Which is never really here Landscapes bound to their descriptions
Set in an ocean of geographical tunes melting into our world's
Desperate conclusions Flowers in the quiet garden break
That Gone-With-It's soil back to spasm inbetween bricks Oh birds
Your song fascinates my kitty To introduce magic in my lap

Language spread upon the land like butter from the icebox
Onto a slice of my beloved's sweet cornbread Instant replays
Of Olympic Highlights speed to the backwindow sill warm
Thighs to separate & flow forth their lucious nocturnal juices
To drive back through Kansas roadside empty trucktowns
Loaded with notational experiments of infinite beauty slang &
Wonder at Mt Baldy's deformed ballerina Pull off the road
Crying into a blanket draped over the seat Small deep cross
Collision ceremony neon dusk bakery road

Back in my wooden house the shades grow older tree by silent tree
Held over on punishment of Time My blue socks drying
On the orange painted sun porch The kitchen smells of oven heat
The week-old poem in the heavy typewriter stiff from leaky roof
A few brooding letters from home in the yellow mailbox
Jean-Claude Killy closes the gap TV speeds the picture thru fog
And Oh my thighs ache to part for the pussy of my wife's tongue
To go over the ground He lies within
Puzzling over his verses nomore & feeding his cats from Pasternak's Tomb
The snow I shall never see I envision covering his grave

The cake I conceive baking thru dreams setting my mouth astir
To newspaper heaps blowing thru an empty Sunday city street
The convent-sized peeper peers out from Night
San Francisco in the colder North I've driven too far to be puzzled
Or die end-up migrate & return thru Southern California's tomato fields
Listening to reports of the flight to our moon
The land drapped with illusions LUNCH POEMS in the glove
Compartment attracting canvas renewal of Fleur to the printed text of ODES
To be here and want your presence to attend me now

Jim Brodey

FOR FRANK O'HARA, AN ELEGY

Frank, what can I say? How write one more poem about death?
"sound of the sea in your head, the moon, a Saturday night like
so many others, warm, the sand"....?

I. FROM KERHONKSON, July 28, 1966

Bells like thunder are sounding in the air, the rain
it falls after how many weeks, streams are flowing
beginning to flow, Indra has slain the dragon
the taxi backed over you: a simple horror

* * * * * *

yours a prana, an energy that wanted out
the new age is softer than you or I or

* * * * * *

or Freddie or Larry or Roi—anachronisms, we are being wiped out
like Lhasa, like the Forbidden City
like Tokyo now 90% new—that which must not survive
into the new age:
certain forms of porcelain, minds, a time of love is coming
sure, but squishier, no edge

* * * * * *

you my big brother brought me up
brought me to openings, admired my dumpy style
bought me so many lunches! how often I vowed
to buy *you* lunch when I got a little richer
mornings I'd bring onion bread to 9th St. for Sunday brunch
our walks in Tompkins Square, St. Brigit's looming aside
things you taught without teaching, a style you gave me
mirrored back in the green clarity of your eyes

* * * * * *

you & Vinnie came by at Christmas with presents and bottles
still have a dented silver vase you brought me
you & Joe came to visit at 4th St. when Mini was born
with gladiolas too big for any vases
you & Roi & I read aloud at Rutgers 3 different poems at the same time
 confounding the students
& Mini big inside me

* * * * * *

the sound of the sea in your ears—ridiculous
don't push the taxi—the sand is treacherous
didn't it take Creeley's daughter? and cars
took Pollock, took Betty Olson

* * * * * *

MUST BE WIPED OUT SO THE NEW AGE
will not look backwards
I read my deathwarrant in the facts of it
the underside is peopled with my loves

* * * * * *

Murder me too! Stars, drops of blood, jewels, jewels
a-glint in the porcelain city underground
my will is blind, I am held alive by my children
it is bleak, I am tired, I would like
to sit down by your tombstone
to read you the poems Philip Whalen wrote for you
I am in Kerhonkson & you are in East Hampton
I couldn't even come to your funeral

II. INVERNESS, CAPE BRETON ISLAND

there, I consign you to sand, I turn you back
to sand, to that beach, the mountain lion crouching
on either side, to that beach the color of shells
or the flat and lonely stretches of Long Island, serious houses
rising out of the dunes, serious people
preparing to go to dinner or to cocktails
to the pale whitened sand at the Pines, the crumbling dunes
the color of your face with the blood drained out
the beach at Truro under the high cliff
smell of bayberry in the wind
the oil-blackened sand of Venice, Cal., the oil pumps
moving like silent monsters, it is sad
that you will be there too
(turned to beach under all those moons,
 the ground we walk on)
to the pale grey, stone covered sand of the Bay of Fundy
bleak low eternal dawn moving into twilight
the silence at the cold Northumberland Strait

or here at last, on the Gulf of St. Lawrence
where the sand is fleshcolored under the gentle surf
and young boys with your eyes jump about in it
shouting gaelic at one another
I take you up by the handful, I watch you run through my fingers
I see you disperse on the North American coast

Diane di Prima

AFTER READING *SECOND AVENUE*

for Frank O'Hara

As a jar of Tibetan snow, you melted
at mid-summer, without worry or woe
laughing a way out of disaster
to mock its undertow. Even though

Some of our friends did go ahead
to arrange celebration for that occasion
and some downed since, who toasted
you on arrival, out of frustration

with us here, yes your heart paved a way
divinities erected by cosmopolitan incline.
Names unforgotten, faces etched through blond gravure,
how may they persist, except such mode endure.

2.

A special sense of metropolitan tableaux
trespassed within us, that has
slowly crumbled away since
we haven't seen one another for years

mortared at the New School, or standing supper
in Moi Guy's on Second Avenue
I shan't call by telephone

to mourn the fact you went to Fire Island
over a long weekend, leaving me ruffled
with absence, to a movie on the East Side

at a cocktail party at Morris Golde's.
You were so kind to me, where
I first had lox, & other delicacies

No, there'll be less gossip of movie stars,
as you have written somewhat well
but that is dangerous, I know

and beers at Joe's, above *Die Wursthaus*
nor more parodies in nasal inflection.
Some tone of town gone, some society curse.

3.

Language a power that claps its lid on a poet,
controls our lives suddenly engenders investigation.
As lovers we found ourselves together in a Turkish bath, I never went
that time you asked, I don't know why.

Past resurrection, aspiring theatrical profession
one must submit to speech, when we were in South Station
you shall be forever of my heart. Behind my eye-lids,
I have your books, your mouth to remember me as well.

John Wieners

THINKING OF FRANK

ten years from now
down my eye
maybe
suddenly one tear will come like a silver airplane
over the wide sky of the desert
but in Albuquerque
the new grass in the Alvarado Hotel
patio, before me here today, has the same bright green
as the grass where the minister who never knew you
had droned his nonsense about Robert Burns and you
three weeks ago,
where to drown his voice I'd shouted into my thoughts,
"O-oh, Frank O'Hara's collapsed from too much living.
O our darling boy, get up we love you!"

Allan Kaplan

FRANK O'HARA DIED

he was a poet he had lots of friends
I was one of his friends he had some cats

Vincent Katz
July 1967

FRANK O'HARA AND HIS POEMS

Poet, art critic, museum curator, conversationalist, party-goer, in his youth a student pianist aspiring to be a composer, involved with films and ballet, collaborator on all sorts of artistic projects (a "one-man movement," like deKooning once said of Duchamp), playwright, and catalyst. He died on July 25, 1966, almost a month after his 40th birthday. He had been run down by a car on a beach—a mishap still stunning in its obscurity. Accidents of any kind seemed so foreign to his make-up, so thoroughly did he inhabit that privileged though turbulent neighborhood where, as Pasternak put it, "things smack of soil and fate."

Of sculpture (David Smith's) he said: "They present a total attention and they are telling you that *that* is the way to be. On guard. In a sense they are benign, because they offer themselves for your pleasure. But beneath that kindness is a warning: don't be bored, don't be lazy, don't be trivial and don't be proud. The slightest loss of attention leads to death."

Attention was Frank's gift and his requirement. You might say it was his message. For his friends, it meant a grand permission to be direct and pertinent. He behaved as though all the questions you could ask actually came down to some two or three, each perfectly simple—but you had to keep asking and shrugging off the answers. No hedging on bets. The cheaper ironies bored him. I think he found that one way to cut through the daily glut of useless information and "entertainment" is to postulate (out of egotism, if need be) a grandness that is always taking up theatrical positions just ahead of everything else. The result is a kind of concentration that appears to be just the opposite, i.e. distraction—and distraction (if false) can be a useful front.

He reacted to ideas as inseparable from the people who had them. Theory and experience had to jell, and the varieties of experience around made dogma pointless. Nothing could make his natural suspiciousness bristle more keenly than mimicry of unfelt theory or opinion.

Contrariness kept his spirit up. So it was fun to watch him take a discussion apart—blithely switching his point of view, or even the subject—not so much fun if you happened to be on the receiving-end, though it might have turned out so in retrospect. A great battler, a sharp diplomat, a terrible (also first-rate) gossip—the sweeps of his verbal attack were amazing. He gleaned a whole repertoire of anecdotes out of every day. He dramatized your words to others. If you heard them, or if they came back to you, they weren't exactly *your* words, his voice was too much his own—but he showed what they meant in his terms. Nobody ever seemed to mind. ("A little supper-club conversation for the mill of the gods.")

His poems—the extensive output of some 20 years—remain for the most part scattered. He published 7 books, of which 3 are in print, 1 about to be reprinted, another (a luxury volume of his large-scale ODES) more or less unavailable. He sustains 31 pages (the second largest sampling) in Donald Allen's NEW AMERICAN POETRY anthology. He sent poems mostly to little (often mimeographed) magazines he liked and whose editors asked for contributions. The bigger Establishment reviews missed the boat, except for 1 or 2 token gestures (apparently passed off as "coverage"). I think the last poem Frank wrote was *Little Elegy For Antonio Machado*, a catalog-piece for a New York show of Spanish artists to aid refugees from the Franco regime.

The first poems of his I noticed—*Why I Am Not A Painter, A Step Away From Them* and *On Rachmaninoff's Birthday*—were pointed out in 1957 by the novelist John Hawkes, then writer-in-residence at Brown where I was a freshman. Hawkes

said he ordinarily didn't like poetry but he admired these because their narrative qualities made the surfaces and interior actions dramatic and clear. All 3 were autobiographical monologues with abrupt shifts in tone. They appeared in a number of the Evergreen Review with a photo of Jackson Pollock on the cover and, inside, essays by Camus and Robbe-Grillet, stories by Beckett and Patsy Southgate, and other poems by William Carlos Williams, Gregory Corso and Barbara Guest.

Everything (experienced) is in the imagination. First impressions focus on this: anything can be taken up and said. O'Hara had the ability, and the power, to use in a poem whatever occurred to him at the moment, without reflection. It is not that he lacked selectivity or discrimination, but rather that his poems grew out of a process of natural selection—discrimination conjoining civility of attention—so that any particle of experience quick enough to get fixed in his busy consciousness earned its point of relevance. All kinds of things: the departure of one friend and the arrival of two others, the headlines (Khrushchev, Lana Turner, the mugging of Miles Davis, Billie Holiday dying, Marilyn Monroe), smog, sexual notions and unpermissiveness of childhood, idiotic notions of manhood, "the cheap tempestuousness of our time," sainthood, toothpicks, "arcane dejection," Bayreuth, Canada ("Fuck Canada"), Kenneth, Vincent, Joe and Jane, fantastic realities ("we are all rushing down the River Happy Times... signed, The Saw"). It is a poetry of nouns and pronouns; the verbs often doubtful, in quotes, adornments after the fact (because the names contain actions), or simply useful connectives, refined to prepositions—

> No, you must treat me like a fox; or, being a child,
> kill the oriole though it reminds you of me.
> Thus you become the author of all being. Women unite
> against you.
>
> It's as if I were carrying a horse on my shoulders
> and I couldn't see his face. His iron legs
> hang down to earth on either side of me
> like the arch of triumph in Washington Square.
>
> (Ode)

He wrote quickly, revised little but, as his manuscripts show, brilliantly. He had an inventor's sense of when to be tactful and when to be ruthless towards his inspiration. Reading his poems, you find yourself engaged in a number of intricate calculations made at break-neck speed. Things add up and cancel out—a new trigonometry of emotions with each poem. The poet does not deduce, but he *is* thinking. You are getting the language first-hand, from where it gets put together in the mind. The words are impetuously themselves, caught on the surface, newly amplified, with new resonance.

One learns from O'Hara how to write a poem word-by-word through to the point where the graph (or ellipse) of a set of perceptions is utterly exposed. For him, composition was a matter of performance, of "staying on the boards." The trick was to maintain a voice, to give it enough force, or gusto, so that the lyric occasion might absorb all contradictions and interuptions—subject to both the poet's will and his fancy. The voice Frank invented is readily identifiable. It abounds with personality, revealing personal habits of inflection, irritability and jauntiness. On the other hand, it is not affected or eccentric; its peculiarity is that of authenticity. It talks.

The surface is full of the feel of live talk. It is the voice that holds the surface together, and meaning is everywhere present and multiple:

> There are several Puerto
> Ricans on the Avenue today, which
> makes it beautiful and warm. First
> Bunny died, then John Latouche,

then Jackson Pollock. But is the
earth as full as life was full, of them?
And one has eaten and one walks,
past the magazines with nudes
and the posters for BULLFIGHT and
the Manhattan Storage Warehouse,
which they'll soon tear down. I
used to think they had the Armory
Show there.
 A glass of papaya juice
and back to work. My heart is in my
pocket, it is Poems by Pierre Reverdy.
 (*A Step Away From Them*)

The technical quality in these lines once referred to as "casual" is actually very intense. At each break, instead of a thump or heave or "dying fall," you get a vibration or click. Ending on notes of suspension, the lines pace shifts in the train of thought. The next word is prepared for, the way a fine dancer prepares for the next attitude, carrying it in the momentum of an all-over movement.

"What is happening to me, allowing for lies and exaggerations which I try to avoid, goes into my poems." His work begins and ends with an odd intensity; you have to care a lot about details to guard the whole "from mess and measure." O'Hara's success, it seems to me, sprang from his agility at matching real verbal beauty with basic personal verity.

Part of his method had to do with Surrealism. But he never "did" Surrealism. He wasn't a buff of the unconscious (he kept from taking naps, he once said, because he disliked dreaming) and paranoia (his or anyone else's) generally irritated him. What he learned of Surrealist tactics he applied to his vision of the personal, to his ideas of what an artist should be, and to what he could do to be that artist.

There had to be a lull—or, as it happened, a blackout—before Surrealism could be absorbed usefully into American poetry. (American painting, we are told, was quicker on the uptake, but it was really the painters' ingenious misunderstanding of the program that proved fruitful.) Williams was the only American poet to intuit its application at once, in that he saw "the fortuitous encounter on a dissecting table of a sewing machine and an umbrella" as common sense within the slam/bang vistas of the American cityscape. Others, those who heard Surrealist rumors in the 30s and 40s, got bogged down in the rhetoric (honey in French equaling "fudge" in USA) or scared off by the lack of obvious masterpieces. Still others shared Marianne Moore's view, somewhat justifiably, that "structural infirmity has, under surrealism, become a kind of horticultural blight threatening firmness at the core."

Frank called Whitman his "great predecessor." An early student notebook shows studies of Ronsard, Heine, Petrarch, Anglo-Saxon charms, Rilke, Jammes... There were imitations of Coleridge, translations of Hölderlin, a liking for lines out of Garbo movies, for "Mi Chiamano Mimi" and *Das Lied von der Erde*. Yeats and Eliot were admired from afar; he didn't buy their principles but he respected what they had done. Rather, he accepted Williams as a master and Stein as a deep source of inspiration (although he might argue that the latter's writings were not really poetry). He said, too, that Auden's poem *1929* (beginning "It was Easter as I walked in the public gardens") showed him the possibility of writing down one's metropolitan experiences in a manner neither sentimental nor drear.

He translated Reverdy and Char. These French—and others like Desnos, Breton, Perse, Cocteau, and, preeminently, Apollinaire—exemplified kinds of artistic attitude not conceived or admitted elsewhere. As cosmopolites, they were neither bookish nor solemn. They had that inbred facility for making fine distinctions, and a knack for saying even very silly things in a passionate way that

made sense as poetry. They laid bare the fact that just about any design might be exhibited under the heading "Poem." Their attraction, then and now, is readily understandable if one considers that since the early 50s every American schoolboy has been taught that the "age of experiment" is over. I remember Robert Lowell at a party somewhere opining that French poetry had "ended" with Apollinaire.

Although Williams had done it to some extent, it was up to O'Hara (and a few others so inclined) to demonstrate that "the marvelous" could be right there winking at you from across the room:

> so I go home to bed and names drift through my head
> Purgatorio Merchado, Gerhard Schwartz and Gaspar Gonzales,
> all unknown figures of the early morning as I go to work
>
> where does the evil of the year go
> when September takes New York
> and turns it into ozone stalagmites
> deposits of light
> so I get back up
> make coffee, and read François Villon, his life, so dark
> New York seems blinding and my tie is blowing up the street
> I wish it would blow off
> though it is cold and somewhat warms my neck
>
> as the train bears Khrushchev on to Pennsylvania Station
> and the light seems to be eternal
> and joy seems to be inexorable
> I am foolish enough always to find it in wind
> (Poem)

Poems he wrote in his last few years establish a very keen relation between writer and reader. In some, a one-to-one relation (or, more aggressively, one-*on*-one); in others, a hot-line seems installed between the up-stage voice and that "someone other than the reader" to whom the poem is addressed. Between the end of one poem and the beginning of another, one senses a truce or impasse or "private life goes on regardless." The emotions of neither party have been exhausted. Distance, on the other hand, is ordained by the cancellation of one detail by another, so that the reader is confronted by a language with its own laws of continuity, not necessarily those to which he has been accustomed.

The lines reward one's memory with their relevance as much as their glamor. For someone living in New York, a phrase like "after practically going to sleep with quandrariness" becomes a talisman. The slightest quip might supply articulation for experiences heretofore befogged by verbal stalemates. You might be surprised by the sudden beauty of ordinary late autumn observances:

> but no more fountains and no more rain
> and the stores stay open terribly late.

O'Hara's rhythms can be heard taxi-ing through the New York streets. You do not have to know New York or anyone in it to catch on, but the poems offer a clear expression of New York circuitry and speed.

Breadth, stamina and a vision of oneself alive with living things are the master qualities of his longer poems. Perhaps the best is the infinitely probing *In Memory Of My Feelings* with its charge of self-illumination at full-gallop:

> I am a Hittite in love with a horse. I don't know what blood's
> in me I feel like an African prince I am a girl walking downstairs

in a red-pleated dress with heels I am a champion taking a fall
I am a jockey with a sprained ass-hole I am the light mist
 in which a face appears
and it is another face of blonde I am a babboon eating a banana
I am a dictator looking at his wife I am a doctor eating a child
and the child's mother smiling I am a Chinaman climbing a mountain
I am a child smelling his father's underwear I am an Indian
sleeping on a scalp
 and my pony is stamping in the birches,
and I've just caught sight of the Niña, *the* Pinta, *and the* Santa Maria
 What is this land so free?

Anthology pieces were not his line. No one poem of his is closed-off or exhaustive. One never feels that he intended to accomplish anything other than exactly the poem he presents as written. His range is positive and vital; there is nothing naïve or sloppy about it. Each poem is in some part excessive; each has an element of joy. I remember him saying that perhaps Williams' work was all one long epic poem—not that the individual forays were insubstantial as such, but that they made supreme logic *together*, each suggesting the possibility (and necessity) of the next, all of them amounting to a total expression of the man's existence. O'Hara's work has this kind of complete articulation. His book LOVE POEMS (TENTATIVE TITLE) is an example of what I mean. Written over a 3-year period, the poems are published not necessarily as a chronological sequence—I don't believe they follow chronology at all—but rather as an emotional sequence, as full-circle and moving as Joyce's CHAMBER MUSIC or Lawrence's LOOK, WE HAVE COME THROUGH, graphs of similar content.

Frank had a fabulous scope. The effect of his presence, like that of his work, was to shake us loose from obliviousness and affectation, to prod thought (sans hesitation) into gesture, to challenge all tragical conventions. He made his point in the last lines of *Naphtha*:

apart from love(don't say it)
I am ashamed of my century
for being so entertaining
but I have to smile.

(*Art and Literature 12,* 1967; revised, 1969)

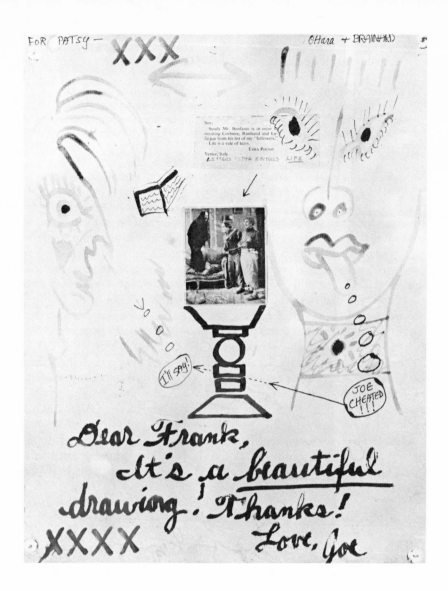

Naturally, Frank and I weren't always messing around. Sometimes we exchanged cultural notes, of which this drawing is a fine example. The exchange began with my sending Frank a clipping from Letters to the Editors, *Life* magazine, from none other than Ezra Pound. (*Life* had just done a big spread on Pound, apparently not big enough, in Pound's view.) Frank seized at once upon the pictorial possibilities of the letter, glued it to a piece of watercolor paper, affixed immediately below a shot of the Marx Brothers in *Room Service* and drew an arrow to indicate that they were the *Life* editors. At that point Joe Brainard evidently came by, Frank grabbed a green magic marker and filled the page with two large faces, a profile of himself on the left and a likeness of an unknown woman sticking out her tongue on the right. Brainard wrote the appreciative words at the bottom in black magic marker. As far as I know, this is the only example in which Frank did the drawing in a collaboration with an artist, and it seems to contain the only surviving self-portrait.

Patsy Southgate

FRANK O'HARA

For a long time now I have been trying to write about Frank O'Hara. But I can't. But I'm going to try again.

I only knew Frank O'Hara for about four years. And I only really knew him well for about two years. Around 1964 and 1965 I think it was. So this is the Frank O'Hara I am writing about. The Frank O'Hara who didn't write very much. Who worked very hard at the Museum of Modern Art. Who didn't sleep very much. Who didn't *need* to sleep very much. The Frank O'Hara who didn't like to talk first thing in the morning. Who loved Leontyne Price and Jeffrey Hunter. The Frank O'Hara that I loved and admired very much.

I remember hearing Frank O'Hara's name long before I ever met him. Through Ted Berrigan and Ron Padgett. They said he was a great poet and so I knew that he was.

The first time I met Frank O'Hara he was walking down Second Avenue. It was a cool early spring evening. I remember that he seemed very sissy to me. Very theatrical. And I remember that I liked him instantly.

Frank O'Hara and Joe LeSueur lived together in a big white loft on Broadway and Tenth Street. I was living then with Tony Towle on East Ninth Street. Frank and Joe and Tony liked to play bridge. So I was a logical fourth. Only I didn't know how to play bridge. So I learned. I learned because I wanted to get to know Frank O'Hara better. He fascinated me. And because I had a crush on Joe LeSueur. I remember that playing bridge with Frank O'Hara was mostly talk.

I remember that Frank O'Hara talked on the telephone a lot. He drank a lot. He smoked a lot. And he ate in french restaurants a lot. I think that almost everything Frank did he did a lot. He went to parties a lot. He laughed a lot. Loved a lot. And he cried a lot.

Frank O'Hara went to extremes. Or perhaps he just found himself there.

I remember Frank O'Hara most in a clean white shirt with the sleeves rolled up to his elbows. Top button unbuttoned. And blue jeans. Almost new. And mocassins. The good kind. Dark brown leather with buck laces and rubber soles.

I remember watching the movie "Romeo and Juliet" with Leslie Howard and Norma Shearer on T.V. with Frank O'Hara several times and how much he loved it.

I remember that Frank O'Hara was always late.

I remember Frank O'Hara putting down Andy Warhol and then a week or so later defending him with his life.

If Frank O'Hara liked a movie one day that didn't necessarily mean that he would like it the next day. Frank O'Hara was very intelligent. Yet many of his likes and dislikes were purely emotional. Depending on how he happened to feel at the moment. This could be infuriating. But it was terrific too. I mean, likes and dislikes are really pretty boring anyway. Once you have them.

I remember Frank O'Hara's tone of voice. It was a very definite tone. Fast. Sharp. Casual. (off hand) To the point. (no bull shit) Sometimes sassy. Elegant. But down to earth. (brass tacks)

I remember that you didn't get into an argument with Frank O'Hara unless you were a *very* good talker.

Frank O'Hara was a star. I don't know if he knew it or not but he was. Frank O'Hara had a way of entering the room.

It's hard, now, to think of Frank O'Hara as being small. But I think he was. Nor short, really, but small. I remember his small waist. His small hands. And his

small feet. I remember that sometimes his body seemed too small to support such a strong face.

I remember Frank O'Hara's classical profile. (Beautiful and active) His high forehead. And his dark brown hair that curled up when it got long. His moist eyes. And his glowing red complexion. Red partly (I think) from drink. And partly (I think) because he was Irish. Or part Irish.

I remember seeing Frank O'Hara write a poem once. We were watching a western on T.V. and he got up as tho to answer the telephone or to get a drink but instead he went over to the typewriter, leaned over it a bit, and typed for four or five minutes standing up. Then he pulled the piece of paper out of the typewriter and handed it to me to read. Then he lay back down to watch more T.V. I don't remember the poem except that it had some cowboy dialect in it.

I remember the night Frank O'Hara bought a construction of mine. Before I had a gallery or anything. Partly because he liked it. Partly (I think) because he liked me. And partly (I think) because I was broke. Frank O'Hara was generous.

I remember Frank O'Hara bawling me out once for assuming something about someone that I had no right to assume. Frank O'Hara was generous.

Frank O'Hara could be impossible. More than impossible. Sometimes, when he was drunk, he could be downright mean. But he was worth it. Some people can get by with a lot. And I'm all for it. If you can get away with it. Frank O'Hara could. And did.

I remember collaborating with Frank O'Hara. It was easy. Or so it seemed. Mostly they were cartoons. I would do the drawings first and then he would fill in the balloons instantly. On the spot. Sharp and funny and very frank.

I remember Frank O'Hara as somehow being very vulnerable. At the same time there was an air of confidence and superiority about him. This combination was electric.

I remember that Frank O'Hara loved martinis. Henry James. Westerns on T.V. Joe LeSueur's chili. W.H. Auden. Balanchine. And Greta Garbo. (Etc.)

I remember that Frank O'Hara could hardly talk about ballet without demonstrating it too.

I remember Frank O'Hara's walk. Light and sassy. With a slight twist and a slight bounce. With the top half of his body slightly thrust forward. Head back. It was a beautiful walk. Casual. Confident. "I don't care." And sometimes "I know you are looking."

I remember one very cold black winter night on the beach alone with Frank O'Hara. He ran into the ocean naked and it scared me to death.

I remember the day Frank O'Hara died. I tried to do a painting somehow especially for him (especially good) and it turned out awful.

Now I want to stop this "Frank O'Hara" stuff and tell you what Frank really means to me. Now. Personally.

I wrote in a diary not long ago that "If I have a hero it is Frank O'Hara." I do. And it is Frank. Because Frank really lived life. Which, as you know, is not so easy. You can get hurt that way. It's very time consuming. And, at least for me, it's hard to be that uninhibited. When Frank got mad at somebody he lost his temper. When Frank was unhappy he cried. If Frank loved you you knew it. Frank had a natural gift (I assume it was natural) of being able to *be* himself. Frank showed his feelings. Frank needed people and he needed for people to need him. (who doesn't?) But Frank let it be known. Frank admitted to being very human. Perhaps (I hope) he was even proud of it.

The most important thing I am still learning from Frank is to just do whatever you want to do and don't worry about it.

Frank had the most infuriating way of making everything sound so simple.

Thinking about Frank makes me think about myself. I am thinking now about how little I ask of people. How little I let people know that I need them. How not

demanding I am. I am thinking how Frank was just the opposite. He demanded a
lot of people. Emotionally. And in other ways too. I am thinking that perhaps being
"easy to be with" is actually being very selfish. I am thinking, once again, how
generous Frank O'Hara was.

(1968)

FIRST FROST

walk up to sunset pasture
autumn wonderland of milkweed floss
its spewing out frozen

in mid-free-fall
much as that summer stopped
fragments and remnants

returned to NYC
scared I'd wake up in DOA City
holocaust: no Frank O'Hara

audible chasm: no Frank O'Hara
snatches of his voice in certain intonations
blotting out process

no red leaves left
ritual: wrapped him in a rug
best dance we ever danced

song: on Dial-a-Poem
life two/thirds over ("grass" floss: frozen)
before I heard Frank sing

Kenward Elmslie

home with this one work of his. Later on I got to know him. John Latouche's interests were way ahead of their time—The Book of Changes, mescaline, magic, and he also moved with ease out of the Broadway arena into the world of the avantgarde, so it seemed natural for there to be a poetry reading in John's penthouse one night, featuring two young unknowns—John Ashbery and Frank O'Hara. I didn't know them at all, and I didn't know what to make of Frank. He read an incredible poem, "Easter," full of "fucks" and fecal rage. I hated it—the violence of the language scared me to death. Ashbery read a witty poem called "He" which could have evolved out of a Cole Porter "list" lyric, so I could understand *him*. It took me a while to pick up on their language. At a certain point, writing show lyrics just gave out for me. It was too constricting. I happened _____ _____ joint called the Five Spot around this time, and _____ _____ his plays, with Larry Rivers provid- _____ _____ _____ _____ went very inspiring—a kind _____ _____ generated by these _____ _____ ry at that point was _____ _____ ge corner that reeked _____ _____ erstand. And I felt a _____ _____ _____ e, understandable to a _____ _____ cal of Kenneth—we were _____ _____ shared houses in the summer. _____ _____ was published around then, and I _____ ed its comic sweep. I began to stop worrying about the size of the audience, or cultism. I was hooked by poetry. I got to know Frank O'Hara better subsequently. I don't think I was tempted to try to write like him, but I was drawn to him as a person.

W.L.: In all these interviews, people have seen Frank in different ways. How did you find him as a person?

ELMSLIE: I went through a series of phases. If we were at a party with lots of other people, it seemed safe to flirt with him, but I didn't dare flirt when we were alone. It was really fun flirting with him, and he flirted back. Then I had this idea of a Great Romance, more than a mere infatuation. He had the knack of making people feel they were really part of his life, and they *were*.

W.L.: Evidently this didn't extend to everyone. John Giorno says in his interview that he felt excluded by Frank, hostility by the New York School of Poets towards poets of a different tradition. Strong antipathy towards what William Burroughs was doing for instance. Even towards Andy Warhol's work.

ELMSLIE: That's true. But hostility doesn't quite ring true to me. Frank was hardly doctrinaire; one reason I liked him was because of his fantastic openness. He liked movies. He liked musicals. He took them seriously. He liked TV—his likes went out in all directions. He was totally unstuffy about different kinds of poetry, and very generous about other people's work.

W.L.: Different people have said these contradictory things. Isn't it possible that in his character these contradictions were there, this generosity, an instant ability to communicate and to make people feel at home, but also some of these negative aspects.

ELMSLIE: Sure. He could be very imposing, the Pope of Poetry. People would come to *him* to say hello, at a party. He could be very snooty, very arrogant, cold, and I once heard him hiss the word "hate" as I've never heard it hissed.

W.L.: I think that's what John was saying, that if he liked your work, or liked you, he could be very outgoing, but if there was an antipathy for some reason, he could be very cold.

ELMSLIE: Towards me, he was very—gallant. He was a veteran compared to me, he'd paid his dues, but he never let me feel that. He was very very supportive. That's why I mention his generosity of spirit—he wasn't bound up in his own work, as poets can be.

W.L.: You were saying you felt a warm attraction for him. What happened on this?

ELMSLIE: It was comic. He asked me to stay one night, and *nothing* happened. We were both very drunk, and fell asleep in mid-embrace. Then he came over to stay with me one night and we started to make out, then I suddenly thought, I'm not at the baths or something—it freaked me out that he was Frank. I had a romantic notion of grandeur between us, two poets taking off into an emotional stratosphere, and the sex part didn't fit into that, so, dumb-bell that I was, I pulled back. It's awfully hard for me to extend sex into friendship. I wasn't able to cross that line with Frank.

ELMSLIE: We_____ would-be actor for _____ the habit of writing _____ times I'd see one of _____ have changed, and _____ there: a memory _____ otherwise forgott_____

W.L.: You've be_____ work?

ELMSLIE: I think his wo_____ anyone's. His book *Three Po_____ poetry keeps on developing. I'_____ good friends, but at this late date, _____ with my own style pretty much.

W.L.: You met him when you first moved to New Y_____

ELMSLIE: Yeah, but we weren't friends, particularly. He was away in Paris for most of that Fifties period. But I remember one summer in the Hamptons—John Latouche was making a short movie of a play written by Jimmy Schuyler called *Presenting Jane Freilicher*. Frank and John and Jane played themselves, and Jimmy hovered, voyeuring. I got to know them a bit while this film was being made, but I was painfully shy —and they were unbelievably articulate, but not all that interested in outsiders. I used to get bug-eyed at Frank's sex adventure stories. He'd regale mixed company about his black postman, who'd climb up five flights to make out with Frank. Or the time he was blowing the guy in the subway who makes change—at which point the subway train arrived, and there were tons of people pouring past the booth, with Frank both trying to keep a low profile *and* give head. He'd tell these stories in front of Janice, Kenneth Koch's wife, and other women and straights, spelling out everything so it wasn't just shocking, it was hilarious. From my English father, I'd absorbed the notion that it doesn't matter what one does, as long as one is discreet about it, so as not to offend other people. Frank would have none of this.

W.L.: Would you like to talk about po_____ the past several years? You'_____

E_____

Torn fragments (by interviewee) of GAY SUN-SHINE interview with Kenward Elmslie (Summer/Fall, 1976)

wou_____ was the _____ then read it at nig_____ off 3 or 4 orchid sto_____ anything quite like_____ the painter de Chir_____ carry one along—ve_____ stories of mine, to w_____ level of hypnotice_____ would have the tru_____ life. It's a mix of _____ about, poems _____ endings snip_____ effect, it's a _____ narrator. _____

W.L.: Di_____ New York_____

*ELMSLIE_____ extremely m_____ I prefer it. I _____ because I don'_____ a different w_____ on sexual rap_____ experience, a_____ in the same b_____ likes to mix, _____ close friends _____ or painters, _____ Their sexu_____

from SEVEN YEARS OF WINTER

That winter I got to know hundreds of people, actors, actresses, writers, agents, lawyers and more But looking back, one face, this unusual, sensitive, blue-eyed, Ottoman-nosed face was the most enchanting discovery for me. The face belonged to a poet named Frank O'Hara.

I was introduced to O'Hara that summer when Hans and I had the North Wind Players and had occasionally had drinks and lunches with him. Our relationship was cordial but not close.

When we had the North Wind Players I was hanging around with Humphrey, a young coed with long blonde hair, whom I nicknamed Humphrey because of her Bogart smile, toothy and manly.

She and I were at a party given by cartoonist Steinberg. Bill was talking to O'Hara.

"Erje, come here and meet Frank O'Hara. Do you know him?"

"It's a pleasure, I know his work."

O'Hara gave me a glance which I didn't care for since it sounded like so what i f you know my poetry. After exchanging a few pleasantries, Humphrey dragged me to the dance floor.

In the fall, Hans brought some of his sculpture to the city to show to dealers. He needed a gallery. O'Hara came to Hilarion's one of those evenings where Hans privately exhibited his work. O'Hara and I had a jolly good time talking about subjects that varied from Warren Beatty. Turkish boy scouts to John Rechy's *City of Night*.

"I heard you published a book of your own."

"Yes, *The Harbor of Whales*."

"Where can I get it?"

"Hilarion has some here."

I autographed a copy and told him that I was just finishing another book, my first novel.

"What's the name?"

"I hope you won't be angry at me. It's called *The Crazy Green of Second Avenue*."

"Why should I be angry? It is a beautiful title."

"Well you have a book yourself called *Second Avenue*."

"Don't be silly."

Frank suggested that I mail a manuscript to Joe Le Sueur at Coward McCann. He also wanted to read it himself so that he could tell me what publisher would be suitable for the book.

He read the book in a few days and said that I should send it directly to Barney Rosset and include a note saying that Frank O'Hara suggested I do it and Rosset should call him about it.

I mentioned before that our relation was a cordial one till the winter of 1965 and 1966. This was because I respected Frank's poetry to the point of hero worship which made me fear him, but once I realized that Frank really liked my writing my nervousness with him faded out.

Frank O'Hara was an extremely extraordinary man and complicated. He was a machine-gunner with ideas and words and nasty whenever it pleased him. Yet he was a beautiful sentimental bastard and a prince among commoners.

We spent many nights in El Quijote closing the bar. I still can't forget the night when we were drinking one Martel after another with café expressos, abruptly

Frank cut short what I was saying and started talking of David Smith. I had never heard before a man who could describe a fellow artist so fully, making you think you knew David Smith all your life, played marbles with him, went to school with him, drank, suffered with him, shared the same women with him...

And when Frank cried at the death of David Smith, self-consciously letting his tears drop into the cognac, I did the same thing. That was the first and last time I saw Frank unable to walk from too much liquor. It was snowing out. I carried him to a taxi. I wanted to go with him and help him with the stairs of his building.

"Oh, those, those are nothing, Erje. I climb them down every morning. Besides our favorite young novelist should rest. We don't want him to end up in a hospital again, do we now?"

And there was the time when Jan Cremer, Frank and I had a supper together. Jan and I were involved with this big discussion about the novel. Frank was like our referee. Jan and I were doing our utmost to cheat each other with words. Both of us although loud were in the best of spirits. Soon around the table gathered some young girls from a visiting college. Neither Jan nor I gave a damn if there were thousands of them. This was a fight to impress Frank O'Hara, our mutual hero; we valued Frank's judgement as if it was life or death. Frank's back was turned to the girls, but when he noticed them he watched them curiously for a minute or two, got up from the table and said, "For heaven's sake, my dears, aren't you tired yet? Please come and sit with us. Oh, I insist."

There in that moment O'Hara made me very ashamed of myself. Here I was, who always claimed to be the great lover of women and didn't have manners for a simple act of courtesy, and O'Hara, a fag, was representing us like a man among men.

FRANK'S CHARM

There are lots of stories of Frank being loud and noisy (it was a New York style in the '50s). But could he be charming! Edwin, or maybe it was Rudy, once took me to a party at Frank's. When he welcomed us, he gave us such a smile, with such an open look ... at that moment, he was an angel. *I* felt like a million dollars.

I liked the way he walked. Once I saw him going up Second Avenue. An angel with sneakers.

Edmund Leites

FATE

In a room on West Tenth Street in June
Of nineteen fifty one, Frank O'Hara and I
And Larry Rivers (I actually do not remember
If Larry was there, but he would be there
Later, some winter night, on the stairway
Sitting waiting, "a demented telephone"
As Frank said in an article about him but then
On the stairs unhappy in a youthful manner, (much
Happened later), Frank, John Ashbery,
Jane Freilicher and I, and I
Had just come back from Europe for the first time.
I had a bottle of Irish whiskey I had
Bought in Shannon, where the plane stopped
And we drank it and I told
My friends about Europe, they'd never
Been there, how much I'd loved it, I
Was so happy to be there with them, and my
Europe, too, which I had, Greece, Italy, France,
Scandinavia, and England—imagine
Having all that the first time. The walls
Were white in that little apartment, so tiny
The rooms were so small but we all fitted into one
And talked, Frank so sure of his
Talent but didn't say it that way, I
Didn't know it till after he was
Dead just how sure he had been, and John
Unhappy and brilliant and silly and of them all my
First friend, we had met at Harvard they
Tended except Frank to pooh pooh
What I said about Europe and even
Frank was more interested but very polite
When sober I couldn't tell it but
Barely tended they tended to be much more
Interested in gossip such as
Who had been sleeping with whom and what
Was selling and going on whereat I
Was a little hurt but used to it my
Expectations from my friendships were
Absurd but that way I got so
Much out of them in fact it wasn't
Causal but the two ways at once I was
Never so happy with anyone

As I was with those friends
At that particular time on that day with
That bottle of Irish whiskey the time
Four in the afternoon or
Three in the afternoon or two or five
I don't know what and why do I think
That my being so happy is so urgent
And important? it seems some kind
Of evidence of the truth as if
I could go back and take it? or do
I just want to hold what
There is of it now? thinking says hold
Something now which is why
Despite me and liking me that
Afternoon who was sleeping with
Whom was best and
My happiness picking up
A glass Frank What was it like Kenny
Ah from my being vulnerable
Only sometimes I can see the vulnerable-
Ness in others I have ever known
Faults with them or on the telephone
The sexual adventures were different
Each person at work autobiography all
The time plowing forward if
There's no question of movement as there
Isn't no doubt of it may I not
I may find this moment minute
Extraordinary? I can do nothing
With it but write about it two
Hundred forty west
Tenth street, Jane's apartment,
Nineteen fifty-one or fifty two I
Can never remember yes it was
Later or much earlier
That Larry sat on the stairs
And John said Um hum and hum and hum I
Don't remember the words Frank said Uh hun
Jane said An han and Larry if he
Was there said Boobledyboop so always
Said Larry or almost and I said
Aix en Provence me new sense of
These that London Firenze Florence
Now Greece and un hun um hum an
Han boop Soon I was at Larry's

And he's proposing we take a
House in Eastham—what? for the
Summer where is that and
Already that afternoon was dissipated
Another begun many more of
Them but that was one
I remember I was in
A special position as if it
Were my birthday but
They were in fact as if my
Birthday or that is to say Who
Cares if he grows older if
He has friends like
These I mean who does not
Care? the celebration is the cause
Of the sorrow and not
The other way around. I also went
To Venice and to Vienna there were
Some people I drove there
With new sunshine Frank says
Let's go out Jane John Frank
And I (Larry was not there, I now
Remember) then mysteriously
Left

Kenneth Koch

FRANK O'HARA'S QUESTION
FROM "WRITERS AND ISSUES"
BY JOHN ASHBERY

 what sky
 out there in between the ailanthuses
 a 17th century prison an aardvark
 .a photograph of Mussolini and
 a personal letter from Isak Dinesen
 written after eating

 can be succeeded by a calm evaluation
of the "intense inane" that surrounds
him:

 it is cool
 I am high
 and happy
 as it turns
 on the earth
 tangles me
 in the air

and between these two passages (from
the long poem 'Biotherm') occurs a me-
diating line which might stand to charac-
terize all of Mr. O'Hara's art:

I am guarding it from mess and message.

 Ted Berrigan

Olson: *If there's any importance in this soliloquy in the theatre of time, it was written in 19— very soon, 1950, I should think. About 1950. I'm telling you, like poetry by Frank O'Hara or Jimmy Schuyler and that beautiful note on poets and painters by Mr. Allen. That's the most interesting note of all. Why are poets in this language in this point of time for the first time later than painters? This is an interesting question. It is the first time in the history of the language that has not been a very interesting time until like around 1950 it was very interesting time and Schuyler says this so marvellously in that anthology that note. Jimmy Schuyler—you know who I mean? A great guy. I never met him, but when I was singing today when Berkson wrote me about writing about Frank, beginning to come back to that crazy question . . . Frank was absolutely enamored of Marilyn Monroe and painting.*

Malanga: *You said dandy . . .*

Olson: *I said dandy, but I meant dandy in the great tradition of figures. If you talk in terms of his life and death I meant that his poetry could, Christ if there was any man who had done what those cheap people call campus martii. Campus martius. The Campus of Mars. Frank O'Hara was engaged on the campus martii. My first line to Bill—. Write the piece down. Let's get it down tonight. Beyond the——— idolized Enyalion, the Apollo, the perfect figure for today absolutely requires. In every respect in word in action and in person was hung up by Campus Martii. Which is the image of Mars as inherited to us as a military ROTC or aggressive or comparison figure which is Camp. And I know that Frank was writing at the very end in the poem to Berkson, which was published in the Lower Point type of—must be in English here like what magazine. Kelly anthology. Right. By Berkson. Right. The emotion beyond that problem is, God love us, that Frank didn't live to tell— like all of us we are only a—like the real thing attackers upon a forest like the future. In Frank we lost . . . Frank is one of those . . . Christ, if I wrote about the American Civil War I'd inscribe it to Frank O'Hara! The substance of my poem was the ner . . . right. But literally, I will never write a poem about the American Civil War and Frank in a sense like I said to him earlier, I always thought came from Baltimore. Cause that'm my highest controversy company of such elegance [LAUGHTER] Gerard and I do.*

Excerpt from THE PARIS REVIEW interview with Charles Olson
by Gerard Malanga (April, 1969)

[The following note by Charles Olson was relayed by George Butterick in 1977. Mr. Butterick had discovered it among Olson's papers at The University of Connecticut Library in an envelope addressed to me : "The envelope has been sealed, stamped, but never sent (there are about two dozen such among Olson's papers—including one to myself in which he says he's enclosing a check!)" The note was obviously meant for the "Homage" book which Joe LeSueur & I had begun to edit in 1967. Two postscripts on the envelope read: "P.S. 1/Bill:/I hope this makes it. Don't in any case use it unless it does, for you. It was the way it came out and it feels despite the occasion being in the same key, say at least to speak of him, for me. And that I would like to do. But your the judge." and "P.S. 2: I'll ship this along but if your deadline isn't as severe as you thought, push me a little—This developed a further idea for something which might also be useful if I can get it in some shape (Wednesday April 30th) O" —B.B.]

To remember Frank, whom I met only once. But that was good enough, both to hear him read and to end up having nowhere to go, quietly walking around the dead streets of Buffalo. The next morning I tried to reach him but he was all day at the Museum and in a Chinese restaurant with his host, and that was the end. Except that I believe it was Frank who was chiefly responsible that I was invited to read at Spoleto, the following summer—and himself didn't go.

Also, what came out that night was that he came, where I wld have expected Baltimore, from Worcester county! This seemed too much, that he shd join us old-fashion New England city-type poets instead of all that higher literature of both the immediate past here & abroad. (I don't mean this, like, analytically, I mean that I was gratified he came of our own general sociology. For he was *the* other poet for all of us to have lived out the rest of this century by, simply that his tone and pitch was to be the lyre of this too, he was so capable of footing the measure once his feet were on the way. (The long poem in fine print to Bill Berkson, he read that day, and I have seen in print since, so established his priority amongst us that it is lonely here, there is this palpable emptiness where he should have stood. I loved him very much so quickly I wish as I'm sure everyone else does who had ever known him that we hadn't lost him. It makes it all noticeably *less*, in particular by him.

Charles Olson
Gloucester, April 26th,
1969

REMEMBERING FRANK

I had just turned seventeen, a student of Daisy Aldan, poet and editor/ publisher of Folder Editions, in whose creative writing class poets Ruth Landshoff Yorck and Kenward Elmslie were invited to read their poems. I arranged with Kenward to interview him via correspondence for the school newspaper. Two months before being graduated from High school of Art and Design I received an invitation from Kenward who was giving what he referred to as a "Big Loyalty Day Party" on the eve of April 30, 1960 at his flat on 48 West 10th Street. Exposed for the first time to a gathering of New York poets whose names already familiar and whose work I was reading was overwhelming. I don't remember who actually introduced me to Frank at the party. He was standing in a corner with Bill Berkson whom I recognized from the photo of him in *The Beat Scene* anthology. Frank turned to introduce me to Bill.

I met Frank again in July of the same year in the lobby of the Living Theatre during the intermission to his play, "Awake in Spain." Willard Maas whom I met at Kenward's party made the introduction. Frank was propped up against a bare brick wall, his bright-red face contrasted against a faded blue Navy workshirt. He was wearing Indian mocassins. Intoxicated to the extent of almost falling over I can't be sure if he remembered that introduction.

I didn't see him again until April of the following year at Kenward's second "Big Loyalty Day Party." In 1961 and the years following I saw and spoke with Frank at parties, poetry readings, and other public events. In his company I sensed a brilliant mind at work, a scholar by instinct and training; but now I wonder if he always gave the world the best of which he was capable. I sense from reading his poems that he worked rapidly and with intense fervor and that he depended largely upon the fine rapture of his inspiration.

Frank could very well be considered our representative *man of letters*. His versatility and originality, his successful productions in many types of literature and his characteristic literary attitude towards his friends, his fellow poets and his public service as Assistant Curator for the Museum of Modern Art entitle him to this designation. He had a keen critical sense and definite critical principles and in one particular piece on Boris Pasternak, *About Zhivago and His Poems* (*Evergreen Review #7*, 1959), he set forth very succinctly his ideas concerning the poet: "the poet must first be a person, so that his writings make him a poet, not his acting the role."

In June of '66 Mary Might (a/k/a Mary Woronov) of Warhol's "Chelsea Girls" and I attended the opening of the Nakian exhibition at the Museum of Modern Art. Frank who had organized the exhibit was present. He invited Mary and me to a party he was giving in Nakian's honor at his studio loft. It was at this party that I spent my last time speaking with Frank.

There is no longer any question as to Frank's genius or of the elementary purity and goodness of his nature. All of him was his *being*.

(1969)

FRANK O'HARA: A PERSONAL MEMOIR

In the Fall of 1964 I moved from where my family lived in a house in Queens to 55th Street (between 8th and 9th Avenues) to a 1½ room apartment in the city. I had been writing, particularly writing poetry, for a number of years, but just having graduated from college and entering graduate school (something about the draft) I said to myself, more or less aloud "Okay, Ted. So you think you're a poet. Now you're gonna have to teach yourself how to write poetry." This was the task I set myself to at the same time I explored midtown, the center of the hub of the wheel of the engine in Manhattan.

It was about this time I started to think more and more of the poetry of Frank O'Hara. I remember reading some of his poems a few years back, but then I was more preoccupied in trying to figure out Charles Olson's essay on Projective Verse (his *own* verse left me flat) and John Ashbery's *Tennis Court Oath* (his poetry left me inspired but puzzled) than in paying attention to anything that didn't teach me something "about" poetry (I was big on Ezra Pound).

That fall getting used to living in the place I'd wanted to my whole life (for years I knew it was a matter of time until I went to live in the city—I felt *nothing* could possibly go wrong) I would take longer and longer walks around. On one of these walks, one evening, I walked into a slim, bare volume of a bookstore next to Carnegie Hall (it's now a cocktail lounge) and browsed through what they had in the way of books. In an almost empty rack next to the door there was a copy of *Audit/ Poetry* which was a whole issue devoted to the various works of Frank O'Hara (most of which I'd never seen before).

I'd earlier that year bought *Lunch Poems*, but even having read *it*, didn't pay much attention to it. I took the *Audit* home and sat down to read. "Personism: A Manifesto" so puzzled me that I said to myself "This is for me!" I started to pay attention to the poems.

Back in Queens while I was still living at home and going to school, my friend Lorenzo (who now lives and writes in Houston) had told me I ought to take a look at the poems of Frank O'Hara, they were really terrific, particularly "Why I Am Not a Painter" which was in *The New American Poetry: 1945-1960* anthology, that's what it was all about the New York School writing. I read and reread the poem, and some of the other poems, but except for a dopey and nasty marginal note I made about the probable sexuality of the poet (having nothing to do with anything but gossip) nothing sank in. This stupidity (which I later went back and burned out of existence) was a sexual way of saying "Give it up! I was a track star for Mineola Prep."

Back then we were (us budding poets) big on reading poems for a whole day— "You've gotta read such and such for a whole day all day at least!"—things like that—there not being other "distractions" in Queens—and then, having "subliminally" (a big word) absorbed and picked clean the poem and have it sink in, would sit down and write my own poem from same or inspiration from same.

When I got home from the walk with the *Audit*, and had my brain clove in half by lightning, I decided I would only read that year or so the poetry of Frank O'Hara, all other poetry would take a back seat. So I read and read and thought about and thought about. And went to school and came home and read a lot of stuff for school. And read some poems.

In all ways I was hanging ten. The summer just passed my mind opened up for the first time where I was aware what was going on; I'd fallen in love which would end nowhere disastrously in the fall I'm talking about (and took 3 years to get over); got in touch with my own dreams and ambitions—felt I would be a famous

poet and make a million dollars by the end of the year—and was teaching myself (furiously) how to write; and getting in touch with my own masculine and feminine strains sorting those out in relation to the social world around me, and what they had to do with sex and money.

For the first time differences came home to me that never meant too much before. I would take the No. 3 Convent Avenue bus up 5th Avenue (5th Avenue was 2-ways then) and would return, usually about 8:30 in the evening, down 5th Avenue, get off at 57th Street and walk west on 56th Street. I would, if I had some money, eat a hamburger or something, but most of the time I would walk past the expensive restaurants and their ventilators and look at the terrific-looking people (male and female) who were going somewhere expensive with a well-dressed older person, also terrific looking but old fart nevertheless.

Most of the time I would go home, read a book, write something, have a salami sandwich or a fig newton. My main form of entertainment and exercise was to walk around looking at things, using 57th Street as the spine of my walks and the avenues as limbs. As the poems of the Provencal poets were Ezra Pound's Baedeker to Provence, so Frank O'Hara's poems were my Michelin to Manhattan. The last thing I'd do every night would be to browse through one of Frank O'Hara's books and read a couple of poems. One of the amazing things about the poems was that they "took place" in places I was growing familiar with.

What is even more amazing after all these ten years is that the poems remain, improve, but most of the places (and many people) are gone. The Mayflower Shoppe in "Music" is now the GM Building; in "The Day Lady Died" the Golden Griffin on 59th Street and Madison is now lingerie, the Ziegfield Theater on 6th Avenue between 53rd and 54th or 54th or 55th (I don't remember exactly) is The Mill ("Have you been through the mill!") of Burlington Mills, the 5 Spot was closed for a long time and has recently reopened; in "Personal Poem" Birdland is long gone, LeRoi Jones is Imamu Amiri Baraka (and lives in Newark) and Lionel Trilling just died the other day following the buildings into oblivion.

After spending the academic years 1964-66 reading Frank O'Hara (we never met so I have a hard time saying "Frank") and falling in love with "love" with *Love Poems (Tentative Title)* and thinking "Having A Coke With You" and "You At The Pump (The History of North and South)" really great and being totally out of love and "it" in real life, I figured over the summer of 1966 I would really like to meet Frank in the fall—I liked his poems so much I wouldn't mind meeting *him*.

That summer Frank O'Hara was killed on Fire Island. I never made a million and no longer live midtown, finally settling downtown. I never completed any degree in graduate school (something about the draft) but write a lot of poems, do this and that. Right now the only things not in print by Frank O'Hara are the plays and letters (good things, but odds and ends to the poems), but soon to appear. I have no desire to meet another poet since, even if I secretly read the works of.

humidiFies
adjective pRonouns
Amoeba
acidulatiNg
abacK

heart-tO-heart
rec't
rancH
hudAida
Rb
Asbestos

*

hurtFully
Rolls
footmArk
reduciNg
negative feedbacK

kOlomna
hart's tongue
Ho chi minh
huelvA
fancieRs
eusebio frAncisco kino

John Cage

FO'H NOTES

The secret is that flamboyance *can* be so exact. (discrete?) And the word "discreet" can be used for something more precise than prudence if you move one of those e's to that end. The feeling that he must have "talked" to himself (in mind) a lot, practicing up for those brightening placements on the perfectly flowing (swaying?) page. "you go on your nerve" And he's not afraid to include all-out rhapsody so that you titter but not out of embarassment for his loss of possession. The lines can always be held entire. A pan-shot across gleaming NYC morning facades, which somehow stand for a completely different set of objects to be remembered, as in the mind of a mnemonist.

"naming things is only the intention/to make things"—*Memorial Day 1950*

"The value of the imagination to the writer consists in its ability to make words." —WCW, *Spring & All*

And just when you think it's all going giddy apart in a slightly slow sneeze "the light hardens."

"the clear architecture/of the nerves"—*Early Mondrian*

He was moved to (briefly?) inhabit certain points of the still world ("the eagerness of objects to/be what we are afraid to do/cannot help but move us"—*Interior (With Jane)*).

The way the nervous run-on haste of *Lady Died* slows (grows still) in the last lines without losing momentum.

It's after all all a matter of movement and the standing objects.

The dream of starting to speak and the words all coming to you for once in the right order, surprises. The times your mind slides helpless into a luscious crease of word generation. Recording in awe of what's arriving, new to you who are speaking, in mind, shapely mass of constructions without a sound. His poems are so silent for so much speech.
 "music must die but poetry is silent joy"—*Two Russian Exiles: An Ode*

It's invention any moment, and completed variations always. And it's odd all he can bring to graceful closure by suddenly seeming to stop before you're ready for it to. A slam of brakes with finesse. Shocking ease of stopping the car with the fingers.

A dance all made of and for elbows and fast
"is the room full of smoke? Shit
on the soup, let it burn. So it's back."
brought to calm run-off, pneumatic punchline
"You'll never be mentally sober."—*On Rachmaninoff's Birthday*, *"Quick!..."*

"the briars of the cadenza of dull things" (*Poem, "Now it is light"*) are in/of use
once more for the summoning. The placements in a Swingtime. Rhythms of the
rush with which things cross the bar-lines of memory. To make a poem *be* the very
slippery edge of forgettal.

The word "thing" in his lines often returned, each time lit by differing footlights.
Never a resting vaguery, "of its own a real right thing" (*To The Poem*).

He knows when to get off it (attractiveness) and bring in an orange (sardines).

The clear mess, never to clear up.

The way things go by him in his lines, to the side & away, just catching the edges of.
An inclusion of vectors inexplicable to syntax. The small things tangential and
instantly deflected in the going forward but not before they register. The mind is
moving, passing, and (even absently) collecting the while. However minute, the
bright included. A master of peripheral vision. "Everything that passes me I can see
only a little of, but I am always looking. And I see an awful lot sometimes."
—DeKooning, *What Abstract Art Means To Me*, 1951.

The conversational momentum to conjunct yet one thing more
"as space is disappearing and your singularity" —*Sleeping On The Wing*

"It takes writing such as unrelated passing on the street to rescue us for a design that
alone affords conversation."—WCW, *A Novelette*

The long lines that talk goes on. Continually full
impulse to speak. Given the stillness of writing.
To see speech in the heat of registration.
To watch and to catch the angles turning.
To allow the ending, for the time.

The feeling that states of other-being, object, strange thought sometimes speak in
his poems. "my theory being that an exact other is better than another one"—*The
Old Machinist*

The following constellation seems to reflect his wholeness, and will to choice:

"An atmosphere of supreme lucidity,
 humanism,
 the mere existence of emphasis,
 a rusted barge
 painted orange against the sea"
 —*In Memory of My Feelings*

His poems are "fair," as in weather that won't prevent you, as in an equal excitement at the various. "Hate is only one of many responses" Obsession only one of many darkenings. At the edges of an expanse very keen
 "that feelings are our facts"

"each in asserting beginning to be more of the opposite"—*Ode On Causality*

"the depth all in the ocean" (*Post The Lake Poets Ballad*), I've always liked that line. It's correct *and* mysterious.

"Khrushchev," near perfect in its closure.

The continuing feeling
we are subject to every thing
the subject of everything.

His poems, almost embarassingly these days (In Favor of One's Time), remind of the velocity of an inspiration, or is it aspiration, everything following in its arrangement outward until it's all exhausted. A definite bonus that he never knows when to stop.
 "The only way not to leave is to go"—*Let's Get Out*

"BARAKA RESPONDS TO QUESTION RE O'HARA
AS REVOLUTIONARY WRITER"

Question from young poet in audience: How does the work of Frank O'Hara stand up under this committee?

Imamu Amiri Baraka: Franco Harris?

Q: Yeah, you once had a personal relationship with him...

Baraka: Not the Pittsburgh Steeler?

Q: (*unintelligible*)

Baraka: Frank *O'Hara?* Oh, I thought you said Franco Harris, the Pittsburgh Steeler. No. I think Frank O'Hara's work stands up to what it was. I think Frank's great quality was that he rebelled against the dry academic bourgeois poetry that all of us came out to accept, that we were given, "this is great art." And Frank put that down, like many of us. But I think the question of putting it down, which, say, you know, petty bourgeois radical can do, "we put it down," like Beckett's plays— Beckett shows people standing in the garbage cans—they say, "Yeah, this society's ugly, it's corny, it's funny," you know, "it's excruciatingly boring..." But the difference between a petty bourgeois radical being sickened by society, and a revolutionary who actually wants to change it, I think is a qualitative difference, and I think that's the thing that we need to concern ourselves with and deal with.

(from Imamu Amiri Baraka reading at The New College, San Francisco, March 2, 1977; tape in The American Poetry Archives, San Francisco State University)

TO FRANK O'HARA

for Don Allen

And now the splendor of your work is here
so complete, even
"a note on the type"
yes, total, even the colophon

and now people you never met will meet
and talk about your work.
So witty, so sad,
so you: even your lines have

a broken nose. And in the crash
of certain chewed-up words
I see you again dive
into breakers! How you scared

us, no, dazzled us swimming
in an electric storm
which is what you were
more lives than a cat

dancing, you had a feline
grace, poised on the balls
of your feet ready
to dive and

all of it, your poems,
compressed into twenty years.
How you charmed, fumed,
blew smoke from your nostrils

like a race horse that
just won the race
steaming, eager to run
only you used words.

Stay up all night? Who wants to sleep?
It is not your voice I hear
it is your words I see
foam flecks and city girders

as once from a crosstown bus
I saw you waiting a cab in light rain
(drizzle) as once you
gave me a driving lesson and the radio

played *The Merry Widow*. It broke us up.
As once under the pie plate tree
(Paulonia)
it broke you up to read Sophie Tucker

—with the Times in a hammock—
had a gold tea service. "It's way out
on the nut," she said, "for service,
but it was my dream."

James Schuyler

POEM FOR FRANK O'HARA'S 50TH BIRTHDAY

Alec Guinness, Pernod, Frank O'Hara
and thou.
Birthdays go on forever,
 not so little boys.
Fifty years of solitude punctuated
by the sudden dissolution
of life forces.
 A cheap trick,
like leaving for Tunisia
without saying goodbye . .

 say goodbye Frank . .
Somehow thinking everyone
who's ever been to Tunisia
sensed they were going there.
 You were tricked
Mayakovsky
 yelling from his cloud
 "Run between the headlights Frank,
 between the headlights! . ."

The unresolved magnificence.
The want to conjure, the need to endure.
The endurance that pacifies,
the pause that refreshes,
 and it's time for lunch.
 No . .

Frank O'Hara as Peter Pan . .
 Oh pick *my* roof, Frank!
Hope springs eternal.
Time for a midnight snack.

Chaka Khan, Frank O'Hara, Pernod,
and thou.

The company we choose during the times
we know to be
the best of times.

 (Pay attention Ginzos,
 half the fun of poetry is sensibility,
 just like half the fun of life is sex.)

Bah.

The lesson of Frank O'Hara
16 through 21.

To assert *and* to seek.
To propel without fury.
To recoil without venom.
To make the best mistakes possible
under the circumstances
To admit nothing
except *that* humanness
required
 by *this* situation.

These situations.
The heralded potency of fleas,
the legendary acoustics of cathedrals.
Careening unto this certainty.
Demonology made simple,
or
we all make the same errors of faith
thinking them to be errors of judgement.

this horror———that phantom

Yell when it hurts *a lot*.

FOH who helps keep these inclinations
intact,
who helps me chase *my* demons
down the frozen food aisle
of the Briones Supermarket.

Frank O'Hara who never visited California.

A matter of knowing.
A matter of consequences.
A perfect symmetry
and the most illogical balance.

The contention.
The ethic.
The story that is never told on television
or to pilgrims.

Fear of territory, faith in language.

Thank you, Frank.

Jim Gustafson

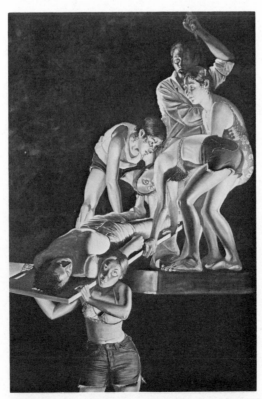

Alfred Leslie: ''The Killing Of Frank O'Hara 1966,''
1975. Oil on canvas.

WHITE CLOUD POEM

A chamber in the Chinese style.
A bed and on it two small pillows.
Behind the bed a Cormandel screen.
This was the first dream.

I dreamed Frank O'Hara joined me as I walked
to a poetry meeting. He was older and more
frail. He said, ''I won't be coming to these meetings
much longer.'' I took his hand, calling him ''my dear''.

We proceeded to our meeting
at ghost inn of Yuan Mein
beside ghost mountain of Tu Fur
not far from shining palace of Hu Sh'ien.

Everyone read poetry which was
tender, exciting, and immortal.

Barbara Guest

PASTORAL

Into the anus of the other the cock nudges
like a green thumb.
Patience overcomes cowardice and slowly
the sphincter opens like a petaled leicaflex
& the relaxation spreads over the general surroundings.

Some cows nuzzle down devotedly
against a tree trunk
and by the same stream without interruption
a long haired pointer is stalking dragonflies,
moving toward that sudden and wonderful appointment
to which flowers all that is left
behind.

The more one bears
the more fecund one becomes.
It is a beautiful afternoon in September,
the air has a harvest, carnival atmosphere,
Frank's dead in heaven, and everything else is right
here on earth.

 Stephen Rodefer

FRANK'S RUSSIA

In 1961 I stopped in New York to see JJ Mitchell, who had been a close friend at Harvard before I got drafted. He was staying at Noel Monod's old apartment behind Cartier's, and he said he wanted me to meet a friend who was coming for a drink that afternoon. The friend was Frank O'Hara. JJ had shown him some of the translations of Rimbaud that I had done while I was in the Army; a lot of them I had done for JJ. Frank liked them, JJ said, and wanted to meet me.

It turned out that Frank and I had met briefly in Cambridge in the spring of 1956. I had played Orpheus in a production of Cocteau's *Orphée* at the Poets' Theater; George Montgomery had translated it, and we'd all gone to George's apartment one afternoon to do publicity photographs. Frank had been there. That was my James Dean period, when I wasn't paying much attention to anyone I met, only making sure they paid attention to me; as a result I don't really remember meeting anybody. I told Frank that, and he laughed and said that's just what he had thought. (Orpheus wasn't too good, either, for just that reason.)

Frank said he liked my Rimbaud translations, which was an enormous encouragement, and over the next year or so he was in fact to make a number of suggestions about Rimbaud and about the poems. But it was when I told him that I was studying Russian literature at Harvard that he lit up. I mean that quite literally, too: Frank had a kind of reaction to things sometimes that made you think someone had thrown a switch somewhere. He would smile, his voice would get pitched even higher, and all his attention would be brought to bear in a bright stream on whatever it was. And if it was you, you felt wonderful about him. He began asking me about Russian poetry, and it turned out we had both taken courses from Renato Poggioli at Harvard. I told Frank about Poggioli's book *Poets of Russia* that had just come out. Then he asked me what Russian poets I liked, and why, and we started talking. I'd rarely talked that easily with anyone I'd just met, and it was exhilarating.

I could remember, in Cambridge, staring out of windows at the rain and the snow, and feeling Frank O'Hara as a kind of link between me and the Urals. His particular affinity for Russia —a Russia full of snow and tears—made sense to me. I've always imagined that most poets have, or make for themselves, another country, an imaginary home somewhere else, from whence all easy visions flow. Greece or even Rome for the pastorally minded, Paris in one way or another for anybody who writes well, sometimes misty Germany (romantic), Spain of the bullfights (butch), or Italy of the gardens and crumbling villas (not butch). But only Frank had Russia, and it was a Russia of his own, a snowy panorama, a landscape that extended from the Russian Tea Room on 57th street to Irkutsk "beyond the Urals." I think it was music and ballet that outlined its contours. It was a World of Art, in any case; perhaps at first it was the Russia that Diaghilev brought with him. But it included Russian poets, and so it was not just a matter of sensual surfaces, of Fabergé Easter eggs. It was extraordinarily something more— a world more profound, more important, more sustaining. Balanchine, Rachmaninoff, Scriabin, Mayakovsky and Pasternak were its monumental citizens, all imagined as gigantic statues standing in a silent fall of snow. It had some whimsical visions, but they were snowy ones too: Greta Garbo caught in the Revolution, and Jean-Pierre Aumont playing Rimsky-Korsakov in *The Song of Sheherazade*. Frank and I both agreed that our souls had been marked forever by that moment near the end of the film, when Aumont stomps through the snowdrifts into the colonnades of what I think, now that I've been there, was meant to be the Bolshoi Theater, and throws open his sable-lined overcoat to reveal himself in white tie and tails—no longer a naval officer, but a composer at last! Frank had spent two years in the Navy and I had spent two in the Army, and that was an image that sustained us both: everyone thinks you're a military man but it turns out you're really an artist. And an artist in the snow at that, close to tears or close to apotheosis—or close to an apotheosis in tears, which made sense to Frank. When snow falls in his poems it always falls like tears, or like the thought of them. Russia and its snow are accompanied by a sense of longing and regret everywhere in Frank's poems, although he was so *modern*, in Rimbaud's sense, that you didn't suspect that in him. It was a

nostalgia, really—perhaps the only one he had—and it was for a Russia beyond his experience. It provided him with a vast homeland—or more accurately, I suppose, it gave him a land to be an exile from. Time and space for exiles is always very subjective, a matter of what happens to *me*, rather than just a matter of what happens. Space may be separated—here is not there, that's the obvious fact of exile—but time becomes fused; it collapses into a mixture of perception and memory. Snow, like music, or like an endless *bourrée*, wipes away the traces of time, as it makes all space one: so in Frank's poem *Sudden Snow*, two girls in fur coats can wander out of Blok's poem *The Twelve* and fall down in the snow on First Avenue in 1960, instead of on the Nevsky Prospect all those years ago.

What I think attracted Frank to Russian art was its grand romantic, larger than life gestures. Hyperbole, on a personal level. The vastness of Rachmaninoff's imagination, of Scriabin's, of Mayakovsky's. And the link between them, the key to understanding it all, was Pasternak. Frank loved Pasternak's autobiographical prose *Safe Conduct*, and in it the link between Scriabin and Mayakovsky is presented very clearly as the passage from music to poetry. Why should Frank have loved Pasternak, have written so often about Pasternak, if not as a model, an example of a pianist who had given up the piano and become a poet, and who had then written down openly the way it had happened?

As far as I know, Frank knew Pasternak's writing from the New Directions volume first published in 1949 that contains *Safe Conduct*, some other prose pieces and some poems; he must also have known Yarmolinsky's *Treasury of Russian Verse*, and those few selections of Pasternak's published in England during the late forties and early fifties, as well as translations of other poems scattered in journals. It's curious to speculate how these English translations may have influenced Frank's own style. What has always struck me is that Russians describing Pasternak constantly remark traits that were Frank's as well; Ehrenburg says that Pasternak "liked being among people, was full of joy, and the poems of those years are full of joy too. To me he seemed fortunate, not only because he had been granted a great poetic gift but also because he knew how to make high poetry out of everyday details." And the Russian Formalist critic Osip Brik characterizes Frank's two favorite Russian poets in terms that might describe Frank: "Mayakovsky: experiments using polyphonic rhythm in poems of wide everyday and social range. Pasternak: application of dynamic syntax to a revolutionary task."

It's not too far-fetched to make these comparisons; Frank himself has already done it. His admiration and love of Mayakovsky and for Pasternak were an admission of some essential identity that Frank surely perceived. And whenever I teach Russian poetry, I almost always begin by reading four poems to my students: Mayakovsky's *Extraordinary Thing...* and Frank O'Hara's *True Account...*, and Pasternak's *Mein Liebchen, was willst du noch mehr* and Frank's *Variations* on it. It's part of a pattern in my mind, of people reading and writing, by which poetry was defined for me in some true and essential way: the thought of Frank O'Hara in Cambridge writing about Pasternak, of Pasternak writing about Mayakovsky, and of Mayakovsky dying, like Frank, before he had written all his poems. And my response to Frank's death was the same as Pasternak's to Mayakovsky's: "*Ja razrevelsja, kak mne davno xotelos.*"

"I burst into tears, as I had yearned to do for a long time."

Susan Friedland

CONVERSATION WITH BILL BERKSON AND JIM CARROLL (Excerpts)

S.F.: Frank O'Hara says about Pasternak that Pasternak understood that as theory nothing can survive. That's what kills Strelnikov: "rendered passive by his blind espousal of principles whose needful occasion has passed; Zhivago, passively withdrawn from action which his conscience cannot sanction, finds the art for which an occasion will continue to exist." I guess you'd have to say Frank O'Hara thought he found the art for which an occasion would continue to exist.

B.B.: Yeah, by making the occasion. That's where he was as big or bigger than anyone of his age. Because he took... the sun says to Frank "Now that you are making your own days, so to speak"—and Frank took that to be his occasion.

J.C.: That was like that great line in Allen's elegy that I was talking to Sue about, when he said: "someone uncontrolled by history would have to own heaven on earth as it is." Frank didn't have that heavy symbolic sense of personal history and politics in his work.

* * *

B.B.: I think he was really seeing, in a radical sense of it, how far he could go towards articulating a complete person, and all the facets of that person in the world, in his life, and then some... He says, "my vices which I created to be worldly and modern and with it," and those are parts of his complete person. He actually implies, "I *am* this person." But his poems do more than exemplify that person, of course.

.S.F: And you don't think that in any way he ever holds his intelligence at bay from experience? In other words, you put your faith in something other than your critical intelligence. You want to be a whole person but in a sense you're also cutting your critical part off, in the hope that something else is going to come through in the meantime.

J.C.: I don't think he ever did that, no. I think that there's not that much self-criticism in the poems, in an obvious sense. Like when he says I created these vices to be worldly and with it. You could think that in a way, but once you've read all the poems you see it's not that person. He's totally always with it and in those critical faculties but cutting right through them with the poems, with the language, cutting right through it, moving fast with the language and getting away from that.

B.B.: That kind of sharp intelligence can only be active, like a tool, something you use; although many people are intelligent and get used by it, it may not even be intelligence anymore but a case where intelligence has been derailed and freaked like a singing chipmunk, instead of being the thing to cut thru and see with. Frank would bring his intelligence to bear on things— the facts of the case, so to speak—and rough them up until they yielded what his feelings knew was there to be had. So he's working on reality that way, or he's working on the incidentals to make something real take place. Socially, too. Like socially he could carry on, and embarrass almost everybody, insult and disturb cozy cocktail parties; these social situations where nothing's happening finally, people going through the motions of this & that—and he would make something happen. People might cry. People might get angry or completely chagrined or caught unawares or variously horrified or glad or amused. And *then*, 4 in the morning or early the next day Frank would call up and say "I hope you didn't think I was *too* horrible, I just thought something ought to *happen!*"

* * *

S.F.: Jim, I know that you think you were strongly influenced by Frank O'Hara. Can you say why? Or how it seemed at the time?

J.C.: It's very hard for me... Well, first of all I saw something in him where I knew I could take his work... I mean, first of all, when I first read his work I wasn't very sophisticated in a literary sense, and what I saw in it, what made me really attracted to it, would maybe not be the same

things that attract me now—but they are basically. It was open and it could come right back to me and I could see where it was at in relationship to me. It was totally objective to me, whereas I would get bogged down with someone like Stevens. I would be very impressed but it wouldn't have the same weight to move me as . . . the literature would move me with Stevens whereas with Frank the saying itself would filter through myself. It would come back and filter through me whereas the other poems would stop in my intellect and I could admire that and see the beauty in it but I couldn't get the experience out of it like I could with Frank's poems. It was open for my own interpretation and I knew that that interpretation was going to be right, no matter what it was. With a lot of other poetry I was reading it wasn't that way. It came back through me. I guess I could answer it differently now, my take on it, but not as offhand. What did you feel, Bill, when you first read his poems? What was it that attracted you to his poetry?

B.B.: It was partly that. I didn't know *Lunch Poems* first, so . . .

J.C.: I knew those poems first. Not really, the poems I read first were the poems in the Don Allen anthology. So it was a sampling of all of them.

B.B.: Yeah, so there were those. First, *Meditations In An Emergency*. I first read that about 1959. How it impressed me I don't remember. I mean, I remember it did impress me, but how— I think that it was accessible. As Jim was talking about how it impressed him I was thinking, yeah, Frank O'Hara, if you put together *Love Poems* and *Lunch Poems* and the actual poem "Meditations In An Emergency" or even "Blocks," for instance, which was a big poem for me when I first heard it in Kenneth Koch's class. And since I was just coming out of adolescence, I was 18, and this poem was about childhood mostly . . . and clear to me, since it was not an idealization of those years like Yeats' "Among Schoolchildren . . ." Oh what I mean is, it occurred to me that Frank wrote poems that any bright boy would want to write, would see available to himself as a way of writing.

J.C.: Yeah.

B.B.: Because they are so accurate as to what it is to be personally walking alive anywhere and being in love and of all the rings of emotion there, and so much is included in it in terms of talk. It wasn't necessarily what scholastically you were *supposed* to say in poetry but it really was what you had to say.

J.C.: Without a literary background, I was impressed by the sense of music more than any other poetry. I can't explain how it's tied in with music or how it influenced me in that sense but it's a really heavy part of it. And then there's also the fact that it was really American in the sense that it was almost a street city type poetry. But it's not a street type poetry . . . certainly a city type poetry . .

B.B.: One thing that struck me was that he was right in New York where I was and where I was growing up, and he was writing of living in New York. And Frank's poems were like New York without tears or compunction. Almost all the standard poems about city living that I had read insisted upon the city as an emblem of modern degeneracy and how we all ought to be out swinging on the redwoods or something . . .

S.F.: In O'Hara's poems it was like a protagonist or hero.

B.B.: Yeah, like he says about Moscow in Pasternak. Yeah, it's like that. Because that is where he lives . . .

* * *

B.B.: As Jim says, music. On the surface, Frank's words were jumping all over the place. Every word was exciting as well as completely exact. Otherwise, most contemporary writing seemed very dreary to me. When I got to college I kept looking for who's writing anything *now*. I would look in magazines, and anthologies would appear, like The New Poets Of England And America which was the first one supposedly devoted to the "new." I looked to see who was born closest to me, it was, hmmm, OK, but it was very tired and hopeless in its tone. Then other things happened. Getting the chance to read Henry Miller's then banned-in-USA books was important then. And then Patchen, Kerouac, Ginsberg's first book, Evergreen Review, the Don Allen anthology

later… Before all that—and before taking Kenneth's New School workshop—I was beginning to think it wasn't possible to be a writer. Cause I figured these guys knew what they were doing, and they had studied the field and were probably trying to do something alive and true, but it came out very tired, so I thought maybe it's a horrible age and you can't do it…. But then, knowing Frank's poetry better, I saw the range of feelings he was admitting into his poems that no one had to had my experience allowed before, or if they had they weren't recognizable. And those feelings had the phrasing… they were seen through the telescope or microscope, sort of, manufactured by Frank O'Hara. Frank had that entrance. He gave me an entrance to my own feelings.

J.C.: That's exactly what I was just thinking, like a microscope. You were reading this literature, just reading it for school you know, and all of a sudden something came along that hit you with such more impact that other poetry that it was like, if you were going to be a writer, it was like you were working with a hammer and chisel all this time and then all of a sudden this poetry was like someone had just given you a computer. I mean it facilitated the whole thing so much that not only did it make me feel like I could handle and love literature but it made me feel that I was going to be a writer. It not only was going to make me more inspired about writing my next term paper, it was going to take over my whole life. I mean it was so much of a revolution to me… it made it easy to get right there to where you wanted it.

B.B.: Plus we were, anyone coming into it, Jim and me both, would have felt at the time, given the way we both got to know Frank's work: could you be a writer, was that a possibility for a life? Everybody else, all these teachers who were mainly teachers, thought it was great, they thought it was almost *too* great! their thought of it was too great. For Frank, however, you could see right away in his poems, it was the natural thing to do.

J.C.: It was the difference between that being alive and the other poetry being something to examine. You looked at this poetry and it walked right up to you.

S.F.: And you didn't feel that writing of the poems took over Frank O'Hara's life?

B.B.: Oh no, because… Jesus, no. He was living his life. So much so that that became… I didn't know too much about limitations when I was 18 or even 25 or 28… I didn't know that if one person can do a thing that didn't mean that anyone could do it likewise…

J.C.: I still don't know that.

B.B.: Yeah. Because I did get close to him and he was a model to me, and I drew a lot of mannerisms from him then and information, which stuck, and a lot of my standards are still based on that information he made me aware of… Now I get astonished by how people get tired, for example, or if I do… But he was maybe one of the original maniacs. Maniac in the sense of being somebody who's incredibly willful or lived on a sort of principle like, say, "what's so great about *sleep?*" Everybody, almost everybody I know who isn't completely insane seems so fragile today compared to what he was doing.

J.C.: Yeah. And the intelligence in it, that's what impressed me a lot at first… the intelligence was really appealing… the intelligence in these poems was the type of intelligence which you knew if you aspired towards, you could live your life very handily. At least that was the way it seemed to me when I was that age. It was an intelligence which was incredibly—Bill was talking about how it was a tool… he used it right, it was very adaptable and it had the weight to cover any kind of intellectual scrutiny which someone wanted to subject it to. But at the same time it had something else which was incredibly more important. So that appealed to me a lot—the fact that this poetry could make me live my life easier… obviously it was very selfish in a lot of ways. I was looking for a tool that could make me handle this very easily and I saw that this was it—this was the poetry that you check out if you want to get there fast. I thought I had it covered because I didn't know there was this whole school of other young poets who were writing like Frank O'Hara. It blew my mind when I started to go to readings, this series of readings at The New School, and every week there was some guy reading some new Frank O'Hara influenced poems. It was getting very depressing. It was a real break when it was Peter Orlofsky's turn to read. He never read as a matter of fact. He stormed in and went bananas and walked out.

1976

from FRANK O'HARA'S POEMS

[author's note] The following is an excerpt from the first chapter of a doctoral dissertation, Frank O'Hara's Poems. *What is dealt with in these first fifteen pages is, essentially, problems arising out of my own reading of the poems. The difficulties encountered were, I think, inherent ones, necessarily occurring in any serious reading of the text. I formulated these interpretive problems in this way: how to satisfactorily localise or 'fix' the narrative place of these poems, which seemed in intent and practice so clearly 'on the page,' neither confessional or self-pitying on the one hand, nor didactic or polemical on the other; and still to fully account for their clean intention to influence, deal with and sustain the relationship of reader to writer in terms which are of the narrator's own choosing—terms, moreover, which seemed basically subversive of the linguistic and ontological privileges of real readers. This finally led me, by the end of the dissertation, to this view: that the question of the meaning of these poems is finally a question of their ideological form and content and therefore must eventually be answered as a social/political dialectical question. What follows in the excerpt below looks forward to such a context in its tone, perhaps, but in content remains descriptive.*

If we read through the early poems of Frank O'Hara, we may feel as if we are looking at a kind of battle field after the battle is over and the belligerents gone on. Looking at the dead bodies, we may wonder who fought whom. Whose uniforms are these, and those over there? And why did they fight? If there is a story to be told, the corpses are not telling it.

But there is a story to be told. Very soon it becomes clear that everything has been arranged. Someone has gone to a lot of trouble to make sure that we see things in the right order, some things before other things, from this angle rather than from another, this in the foreground, this in the middle, this in the background. And then things change. We see things from another point of view. A formation of attack may seem on closer inspection and from another angle a defense formation. Things have been placed in certain positions by design, and by design we are given first this view, then that, then another and so on. And all around there is smoke, ensigns still in position, bits of torn flag still waving in the breeze. It seems a bit contrived, to say the very least. Someone, it appears, is going to a great deal of trouble to make sure we reach certain conclusions.

Let us review the bodies. In the first poem of Donald Allen's edition of *The Collected Poems of Frank O'Hara* there is a broken porcelain pony and "pink floored" roses, which have been set afire and reduced to ashes.[1] Then there is a speaker, and an unknown antagonist, identified only as 'you.' But who or what is being, or has been, killed is not altogether clear. What is clear is that someone is being put on notice. If you can kill, I can kill too:

> *First you took Arthur's porcelain*
> *pony from the mantel and! dashed*
> *it against the radiator! Oh it was*
>
> *vile! we were listening to Sibelius.*
> *And then with lighter fluid you wet*
> *each pretty pink floored rose, tossed*

your leonine head, set them on fire.
Laughing maniacally from the bath-
room. Talk about burning bushes! I,

who can cut with a word, was quite
amused. Upon reflection I am not.
Send me your head to soak in tallow!

You are no myth unless I choose to
speak. I breathed those ashes secretly.
Heroes alone destroy, as I destroy

you. Know now that I am the roses
and it is of them I choose to speak.

A scene of violence is being re-enacted; but it is a petulant violence, a violence of the doll-house. A porcelain figurine is smashed, a bouquet of pretty roses is set on fire. The corpses are doll corpses. Or else something is being 'acted out' whose meaning is not quite clear to us, something that seems to call for an 'explanation.' The title is ''How Roses Get Black.'' It is an ambiguous title: does 'how' mean 'an account of' something or 'an explanation' of something? Possibly it means both. The first part of the poem represents a miniature 'scene,' relates an action; the second part of the poem tells us what the scene means.

But the meaning presented is extremely problematic, for it involves us in a peculiar ability of certain pronouns to take first a linguistic, then an 'objective' referent. Pronouns and other words which are able to displace their meanings in this way have been called 'shifters.'[2] One of the difficulties in interpreting the poem is occasioned by the necessity of the reader's sorting out the several displacements of the 'shifter' 'I.'

The last stanza claims: 'I am the roses.' Fine. But if that is the case there is no more 'I' left to speak: the roses have already been burnt up, incinerated. How can the narrator say he chooses to speak, if the roses are already destroyed? The implication very clearly is that there are at least two 'I's: a grammatical construct and a real person. Or, to put it another way: the shifter 'I' may mean either a linguistic usage or a dead human being, and the problem is that they don't seem to coincide.

And the problem does not seem to be simply, or even at all, a problem of the 'nature of metaphor': how can you say ''A is B,'' does it really mean ''A is B'' or is it in fact an abbreviation for ''A is like B''? 'You' is a shifter too. The difficulty of words being able to change their meanings, seemingly at will (if metaphor has only heightened a general problem of words), seems in this poem absent, or only potential. The real problem is pronouns. 'I' is a shifter. But how can it be?

The other pronouns are not so important, for the time being at least. Except 'you.' This pronoun, like 'I,' seems to exist as a dilemma: it may be a construct or a corpse, but not both at the same time. ''You are no myth unless I choose to / speak.'' But the speaker *has* chosen to speak. The speaker is speaking the poem, and at the same time that he is relaying the dilemma, menacing the other with 'becoming a myth,' he has, by the end of the sentence, in fact already carried out his threat. Lest there be any illusions about what 'being a myth' means, the speaker makes it clear:

Heroes alone destroy, as I destroy
you.

'You' is therefore a shifter. Having been the very active, 'real' person figuring as principal in the scene presented by the first three paragraphs, the pronoun remains, while the myth is born and the person dies. Destruction (death of something real)

and myth arise at the same time: in the act of speech. Yet strictly speaking, since the narrator has been speaking all along, from the beginning of the poem, there never has been a time, in the poem, when the 'you' has not been both 'dead' and 'a myth.' How could he have been alive, even at the beginning, if it is speaking that kills him? Common sense will point out that there must have been a person who pre-dated the poem and upon whom the speaker revenges himself by the destruction that the speaking of the poem brings about, even if that person ceases to exist and becomes a myth in the course of the poem. Perhaps. Such an interpretation, however, presupposes that the words of the poem do not, strictly speaking, mean what they say. For what they say is

> You are no myth unless I choose to
> speak.

That is what they say. They do not say: You are no myth unless I choose to speak *of you*. The implication of the poem seems very strongly to be: speaking makes 'you' equivalent to a myth, or dead. To speak at all creates a dead person, a myth. 'You' can only exist from the beginning as a dead person. It is important to note, however, that the 'you' in question is a grammatical 'you.' Insofar as the 'you' has another, and existential function, it is left unspecified: 'you' is never tied down to a proper name, 'Larry,' 'Ashes,' 'Bill' or some other name.

It is the psychological and grammatical status of 'you' that is in question. The pronouns of this poem refer primarily to ideas of peson rather than to biological entities, or individuals. If then 'you' comes into being as 'dead,' so does 'I.' Or at least one 'I,' the 'I' who, equated with 'the roses' (''Know now that I am the roses'') and already incinerated before the poem begins, speaks as a dead person from the beginning of the poem. The difference between them is that 'I' is dead as a result of an original event, whereas the necessity of 'you' being dead is a logical linguistic one, coeval with speech itself. Emotionally the narrator feels that if he is 'dead,' it is because someone has killed him; there was a time when he was alive once, wasn't there? Who is that someone? If the murder has been a particularly linguistic one, involving the pronoun that speaks and knows that it speaks, perhaps it is a murder that can be 'circumvented' verbally: by defining the murderer as 'the-one-who-exists-by-not-existing.'

Yet such conclusions are vaguely unsatisfying, just as the poem itself may be felt to be somewhat unsatisfying, and perhaps 'preliminary.' There is a murder victim and there is a murderer. The victim claims that by using language, by speaking, he can make the murderer 'just as dead as I am': in fact more dead, because the murderer will be dead because it is his very nature to be dead. Why not name names? Proper names, that is. The speaker marks out his braggadocio and tendency to quick conclusions by referring to his enemy or enemies as 'you' rather than calling the enemy by his proper name. And one wonders why it is that the indictment isn't more circumstantial. Who is it that could have done such a deed? Isn't it a bit unheroic in one who seems to have such contempt for his enemy not even to tell us his name?

But there do seem to be clues. First of all, there is a great deal of ambiguity in the narrator's attitude toward his enemy. He claims to have been 'amused' by the other's pyrotechnics, and then, at the same time as he 'defines' him as dead, honors him as a myth (a 'mixed' honor, it is true, but an honor just the same). In the narrator's feelings about his enemy there is, evidently, no small degree of awe.

Then there are the 'burning bushes': ''Talk about burning bushes!'' Are the roses 'burning bushes'? The Biblical passage, from *Exodus* III: 2, is instructive:

> There the angel of the Lord appeared to him in the flame of a burning
> bush. Moses noticed that, although the bush was on fire, it was not
> being burnt up.

The words from the burning bush are the announcement of Moses' vocation. Through the words of the angel Moses comes to the knowledge of himself as he really is: the leader of his people, God's chosen instrument of communication with his community and the bearer of God's word, the Law. Moses' mission is to lead his people out of Egypt and to receive and proclaim the word.

But Frank O'Hara's roses burn up: Moses' bush does not. The voice speaking to Moses says, 'I am who am.'[3] Frank O'Hara's myth, on the other hand, is He-is-who-is-not. The reference to the burning bush will stir strong, though ambiguous, feelings in the reflective reader, feelings which must parallel those of O'Hara himself. For in this poem reflection is a two-edged sword: it creates the myth, but destroys the person. At first O'Hara is 'amused' by his adversary's antics, but: ''upon reflection I am not.'' 'Reflection' is thinking of course, but thinking that is aware of itself. Or, perhaps, thinking that is aware of 'self.' Perhaps the reader becomes uneasy at this point in the poem; the phrase has a rather disturbing 'secondary' meaning. It means, of course, that 'upon reflection' the narrator is not amused. But again, that is not what it says: what it says is, 'upon reflection I am not.' Which, if not 'what it really means' is nonetheless what it says. The reader may well be uneasy if he is a reflective reader: as he is reading the poem, he is reflecting. What does such a poem say about the nature of reading? What does reading do to one's 'self'? Disturbing reflections, but reflections that for the present seem only to lead us down a hall of mirrors.

Let us turn to another poem. Frank O'Hara has already told us *how* roses get black. In the poem ''To My Dead Father'' O'Hara gives us a variant on the theme:

> *Don't call to me father*
> *wherever you are I'm*
> *still your little son*
> *running through the dark*
>
> *I couldn't do what you*
> *say even if I could hear*
> *your roses no longer grow*
> *my heart's black as their*
>
> *bed their dainty thorns*
> *have become my face's*
> *troublesome stubble you*
> *must not think of flowers*
>
> *And do not frighten my*
> *blue eyes with hazel flecks*
> *or thicken my lips when*
> *I face my mirror don't ask*
>
> *that I be other than your*
> *strange son understanding*
> *minor miracles not death*
> *father I am alive! father*
>
> *forgive the roses and me*

<div align="center">(CP, <i>pp. 160-161</i>)</div>

Here also the narrator identifies his person with 'the roses': their thorns are his 'face's stubble.' Is the narrator 'dead' in this poem? It is true, ''your roses no longer grow'' and ''my heart's black as their / bed'', but there is no mysterious 'fire' this time, no lighter fluid, no burning bush. And if the narrator is 'dead,' he also claims very energetically: ''father I am alive!'' Given the striking similarity of themes

(identification with roses, with the color black, the state of being 'dead' and yet 'not dead' at the same time) and the fact that the narrator is 'the same' (the roses) in both cases, can we assume that the 'father' of this poem is the same as the 'you' of the earlier poem? Perhaps. But in that case, the second poem seems to have a distinct referent outside the poem, unlike the first poem.

If we go back to our initial comparison, the early poems of Frank O'Hara are like carefully constructed 'scenes,' in which the reader views a spectacle of carnage and destruction from different points of view. The observer views the bodies from varying angles and distances, drawing conclusions about the identity of the corpses, the nature of the conflict, etc. that are appropriate to that point of view; the points of view being somewhat like a series of snapshots he is being handed, one after another, by another person. Only the corpses turn out to be all members of the same family, but wearing different clothes in different photographs. The observer begins to wonder why there is so much contrivance. How can he tell who the 'real' victims are, and who the 'real' aggressors are, or if indeed there are 'real' victims and aggressors? There is even the possibility that the photographs may have been taken for only one reason: to show to him, and him alone. That possibility, and in fact the photographic metaphor on which it is based, will both, eventually, seem inadequate, as Frank O'Hara's poetry becomes more felt and human, and less familial.

On this basis, let us look at another 'photograph,' "Macaroni." A much later poem (1961) than "How Roses Get Black" and "To My Dead Father," "Macaroni" is, nevertheless, a valuable point of comparison with the earlier poems. Dealing with much the same material as the earlier poems, "Macaroni" at first glance appears to be a direct statement of something rather than a transcription or 'photograph' of it. The poem begins with the familiar themes of the death of a plant and a feeling of guilt:

> Voici la clématite *around the old door*
> *which I planted, watered, and let die*
> *as I have with so many cats, although* sans une claire-voie
> *and it seemed that the whole summer dipped*
> *when it withered, when the leaves did* . . .
> (CP, *p. 388*)

And this comes shortly to remind the poet of something:

> *I'll come tonight to talk about*
> *the old days when my father knocked me into the rose-bed*
> *thereby killing a half dozen of his prized rose plants*
> *yak, yak it's a wonderful life for the plants*

Isn't this the Event then? And doesn't this clear up the mystery of the 'rose' poems? Frank O'Hara's father once knocked him down and he fell into the rose bushes, which he then 'identified with,' because it was his father's fault they died; but which he felt a little guilty about just the same because it was his, Frank's, body which actually caused the damage to the roses. In other words this poem, "Macaroni," is the 'real-life' happening, while the other two, earlier poems, "How Roses Get Black" and "To My Dead Father" are, so to speak, 'poetic re-wordings,' the first being more distant and abstract, and the second being closer, more concrete, but both of them figurative where the third poem is literal.

Frank O'Hara's father may or may not have actually knocked him into a rose bush, and that may or may not have been the traumatic event of his life. The point is, even if it is a poem about an Event, and as literal as anyone may want, the poem is still the poem and the Event is still the Event. Words are not things: they

transcribe them. Frank O'Hara's last poem 'about' roses speaks the unspeakable: but it is not itself 'the unspeakable,' it speaks it. And so we are left where we were before. Like the previous poems this poem, also, is a 'transcription.' It is also a 'photograph.'

We have, therefore, not been given an Event after all, but simply a family name: Father. What, then, of the O'Hara poems that speak to us of 'Mother.' Those that give us a 'Child'? Are they any more likely to release an 'Event' behind the poem? Indeed, other O'Hara poems of a family past may appear to be even more strongly present to us as reworkings, in comparison with the poems that speak of a 'Father.'

For, indeed, if there is a group of remarkable photos in this family album that picture father and son in states of life-in-death and death-in-life, there are also other pictures, equally striking, and groups of pictures, that seem more to favor the mother's side: the mysteries of birth and early sexuality, the presence of nature. The pictures of birth and early sexuality, though pastoral by title, by locale and by excess of language, present nearly as dreary a picture of early family life as the father-and-son groupings: their subject matter is murder, the murder of a small child. The prose-poem "Oranges: 12 Pastorals" (June-August 1949) begins:

> *Black crows in the burnt mauve grass, as intimate as rotting rice, snot on a white linen field.*
> *Picture to yourselves Tess amidst the thorny hay, her new-born shredded by the ravenous cutter-bar, and there were only probably vague lavender flowers blooming in the next field.*
> *O pastures dotted with excremental discs, wheeling in inter-planetary green, your brown eyes stare down our innocence, the brim-stone odor of your stars sneers at our horoscope!*

> (CP, *p. 5*)

So birth is the source of it, the disaster. No sooner born than "shredded by the ravenous cutter-bar." And in the next field, flowers, lavender: the various hues of the color blue that are always so many temptations to non-existence, as Frank will soon explain to Bunny Lang in "A Letter to Bunny" (October 1950). And is disaster the universal intention of the cosmos? The stars stare down with eyes of excrement; they waft sneers of brimstone odor. Is the disaster so large? And then, shortly, the bovine mother drowns: "You see her floating by, the village Ophelia" (11. 9-10).

FOOTNOTES

1. Donald Allen, ed., *The Collected Poems of Frank O'Hara* (New York: Alfred A. Knopf, 1971). Abbreviated throughout, following citation of the poems, to "*CP*, p.__."

2. Roman Jakobson, "Shifters, Verbal Categories, and the Russian Verb," *Selected Writings* (The Hague: Mouton, 1962-71), pp. 130-147. Jakobson borrows the term from an earlier usage in Jesperson.

3. Or 'I am; that is who I am.' But O'Hara would have been more familiar with the traditional Catholic reading for *Exodus* III: 13, 'I am who am.'

ALL THE IMAGINATION CAN HOLD
(THE COLLECTED POEMS OF FRANK O'HARA)

Frank O'Hara's work has already influenced a generation of young poets; some of those who are not poets may find it hard to judge the importance of what he has done when critics so often mistake solemnity for seriousness, obscurity for profundity, and the expression of pain for intensity of feeling. O'Hara's poems are buoyant, exuberant, wild, personal, open in troubling and troublesome ways, sometimes humorous, often about seemingly ordinary or trivial things, and radically original in form. They are the result of an unfamiliar aesthetic assumption: that what is really there, in the poet's thoughts, fantasies, and feelings, is what is richest in possibility and worth the most attention. Beginning with whatever is there, if one's feelings are stirred by it, is the best way to get anywhere—

> *That's not a cross look it's a sign of life*
> *but I'm glad you care how I look at you . . .*

In a book of twenty or thirty poems, certain of Frank O'Hara's subjects (lunch, movies) could seem trivial and wilful because chosen at the expense of others; in this book of five hundred poems what strikes one is the breadth, sincerity, and exuberance of his concern for life. At first overwhelming, it is also liberating: by caring so much for so many things, he gives us back feelings of our own and permits us to respect them. Garbo and Aphrodite are connected, but an exclusivist Yeatsian poetry can say only that they are one (like Maude Gonne and Helen of Troy) or that one is a cheapened version of the other. Frank O'Hara's poetry gives us the freedom to respond to both—as we do anyway, but not so much before he showed us how.

The honest and immediacy of the poems are communicated in a verse which has seemingly learned plainness from Williams, variety from Pound, grandeur from Whitman, and music from all three; the result is a poetic line with more capability for drama, more flexibility, and more delicacy in rendering nuances of the speaking voice than any I know in modern poetry. It takes a whole poem to hear it right, but the conclusion of "Ballad" may give an idea:

> *you know that I don't want to know you*
> *because the palm stands in the window disgusted*
> *by being transplanted, she feels that she's been outraged and she has*
> *by well-wisher me, she well wishes that I leave her alone and my self alone*
> *but tampering*
> *where does it come from? childhood? it seems good*
> *because it brings back the that*
> *that which we wish that which we want*
> *that which a ferry can become can become a bicycle if it wants to get*
> *across the river*
> *and doesn't care how*
> *though you will remember a night*
> *where nothing happened*
> *and we both were simply that*
> *and we loved each other so*
> *and it was unusual*

In this poem, as in others, the movement seems determined by a musical line of feeling rather than by an intellectual working out or a preconceived form. It is as

if the poet were writing to his feelings, as one might write poetry while listening to Chopin, letting the melodic rise and fall of the sound determine what one says. Frank O'Hara did in fact write some of his poems while listening to music; the immediacy of the relationship of what is happening outside to what happens in the poem is characteristic.

Frank O'Hara wrote his poems quickly, unexpectedly stirred by something he was thinking or feeling, often when other people were around. The speed and accidental aspect of his writing are not carelessness but are essential to what the poems are about: the will to catch what is there while it is really there and still taking place—

> *I better hurry and finish this*
> *before your 3rd goes off the radio*
> *or I won't know what I'm feeling...*
> (*On Rachmaninoff's Birthday #158*)

There is a difference between a feeling seized rapidly, while it's happening, or while it's being created (for his poems create feelings as much as they expose them) and a feeling considered in any other way. In catching a feeling in the process of coming into being, or as it first explodes into a thousand refractions, one can hope to reveal some of the truth that lies hidden in our unconscious, in all the things we have known and felt but can't be aware of simultaneously. The form of Frank O'Hara's poetry is flexible and consistently experimental—flexible, to accomodate the poem to whatever is taking place; experimental, perhaps for a number of reasons, among them to help awaken, by strangeness of form, new perceptions while he is writing.

For all their use of chance and the unconscious, Frank O'Hara's poems are unlike Surrealist poetry in that they do not programmatically favor these forces (along with dreams and violence) over the intellectual and conscious. He must have felt the power and beauty of unconscious phenomena in surrealist poems, but what he does is to use this power and beauty to ennoble, complicate, and simplify waking actions. His poems are like atoms for peace rather than for war; he brings unusual powers to everyday activities. His inability, or unwillingness, to stay in the realm of dreams and super-powers, stated explicity at the end of "Sleeping on the Wing," is everywhere evident in his work.

> *And, swooping,*
> *you relinquish all that you have made your own,*
> *the kingdom of your self sailing, for you must awake*
> *and breathe your warmth in this beloved image*
> *whether it's dead or merely disappearing,*
> *as space is disappearing and your singularity.*

Of course it was not only the speed, spontaneity, and immediacy with which Frank O'Hara wrote which enabled him to write this poetry. It is a method of composition to surprise a confusion of riches—but the riches have to be there. Without them, poems, written this way can seem like surprise raids on empty buildings. Along with his brilliant intellect and his wide-ranging knowledge of music, dance, art, history, and philosophy, Frank O'Hara had an ability to fantasize himself to be almost anybody, anything, anytime, anywhere; and he also had an unusual gift for friendship and for love, for identifying himself with, and for transforming other people and their concerns. None of which detracted of course from his passionate concern about himself and his own life, and about all this he was thinking, meditating "in an emergency." It was always an emergency because one's life had to be experienced and reflected on at the same time, and that is just about

impossible. He does it in his poems. The richness of his perceptions gives the poems their characteristic dazzle:

> *kisses! kisses!*
> *fresher than the river that runs like a moon through girls*
> *.*
> *alfalfa blowing against sisters in a hanky of shade*
> (*Easter*)

> *What spanking opossums of sneaks are caressing the routes!*
> (*Second Avenue*)

The most ordinary things are presented with enough complexity to make them real—

> *an enormous party mesmerizing comers in the disgathering light*
> (*Joe's Jacket*)

and the most complex things are said as simply as possible:

> *it is all enormity and life it has protected me and kept me here on*
> *many occasions as a symbol does when the heart is full and risks no speech*
> *a precaution I loathe as the pheasant loathes the season and is preserved*
> *it will not be need, it will be just what it is and just what happens*
> (*Joe's Jacket*)

The richness and agility of his mind can be seen clearly in his images, which tend to be instantaneous, immediately changing into something else, as in the first stanza of "Sleeping on the Wing" or in these lines from a slightly earlier poem:

> *he is throwing*
> *up his arms in heavenly desperation, spacious Y of his*
> *tumultuous love-nerves flailing like a poinsettia in*
> *its own nailish storm against the glass door of the*
> *cumulus which is withholding her from these divine*
> *pastures she has filled with the flesh of men as stones!*
> (*Blocks*)

The effect can be a crowding and brightness which are "more than the ear can hold," as Frank O'Hara wrote of an orange bed in a painting by Willem DeKooning, and almost more than the imagination can hold, but not quite. One's feeling of being overwhelmed gives way to a happy awareness of expanded powers of perceiving and holding in mind.

The *Collected Poems* cover a period of eighteen years (1948-1966). They move in general from being experience-inspired outbursts of imaginative creation to being imaginative illuminations of ordinary experience. What we see at first is a brilliant talent finding and testing itself in art, music, literature, and history, as well as in relations with a few friends. There is an atmosphere of continual invention and excited experimentation with form. During the first years in New York (1952-1954), unhappiness and despair come into the poetry as they hadn't before, and with them a kind of toughness and defiance and the creation of rugged, hard, brilliant, surfacey kinds of poems ("Easter," "Hatred," "Invincibility," "Life on Earth," "Second Avenue") which in some ways resemble the big abstract expressionist canvasses Pollock, DeKooning, and others were painting at that time ("Easter" and "Second Avenue" seem to me among the wonders of contemporary poetry)—

> *My hands are Massimo Plaster, called "White Pin in the Arm of the*
> *Sea"*
> *and I'm blazoned and scorch like a fleet of windbells down the Pulaski*
> *Skyway,*
> *tabletops of Vienna carrying their bundles of cellophane to the laundry*
> *ear to the tongue, glistening semester of ardency, young-old*
> *daringnesses*
> *at the foot of the most substantial art product of our times*
> *the world; the jongleurs, fields of dizzyness....*
>
> <div align="right">(Second Avenue)</div>

Like many of the shorter poems, these long poems seem composed at high speed, as if they were attempts to catch an infinite succession of moments or the infinite expansions of one. They are all in one breath—or in a series of breaths, each held as long as possible. In the late fifties there is a different kind of long poem ("In Memory of My Feelings," "Ode to Michael Goldberg"), more introspective and directly autobiographical, more modulated in tone. Also of this period are many of what Frank O'Hara called his "I do this, I do that" poems, such as "The Day Lady Died," "Personal Poem," "A Step Away from Them." These are followed (1959-1961) by a number of wonderfully tender and delicate love poems—such as "Les Luths," "St. Paul and All That," "Poem: Hate is only one of many responses." He wrote about them, "everything is too comprehensible/these are my delicate and caressing poems" ("Avenue A"). In the sixties there is the amazing "Biotherm," countless days with all their thoughts and sensations jammed into one rapidly shifting and unstopping statement, and shorter poems like it, such as "Maundy Saturday" and "New Particles from the Sun."

The changing character of the poems, however, is less remarkable than the energy and the vision that are everywhere present in them. The *Collected Poems* shows these qualities better than a shorter volume could: the range of Frank O'Hara's enterprise as a poet is so important a part, finally, of his work's value. It is a great experience to read it all. I have known Frank O'Hara's work for about twenty years, and I had read a great many of the poems before. One reaction I had to this book, though, was astonishment. All those "moments," all the momentary enthusiasms and despairs which I had been moved by when I first read them, when they were here altogether made something I had never imagined. It is not all one great poem, but something in some ways better: a collection of created moments that illuminate a whole life. Historically, his work seems to me to represent the last stage in the adaptation of twentieth-century avant-garde sensibility to poetry about contemporary American experience. In its music and its language and in its conception of the relation of poetry to the rest of life, it is a poetry which has already changed poets and others, and which promises to go on moving and changing them for a long time to come.

<div align="right">(New Republic, 1972)</div>

ON FRANK O'HARA'S BIRTHDAY
(Interview with Ted Berrigan)

(*Note: This is one out of many conversations between the interviewer and Ted Berrigan on the subject of the poems of Frank O'Hara, distinguished in this case by the fact we had previously arranged to discuss the work for the purposes of this tape. All quotes are from memory, rather than a text: consequently there may be some slight inaccuracies. S.S.*)

Q; When did you first read works by Frank O'Hara, and what was your reaction to them, your response?

A: That's a good question, actually. I don't . . . it seems to me that I first read them in about 1959. Though the Don Allen anthology, which is where I first read them, came out presumably in 1960. Let's just say I read them in 59 and 60. The first one I remember reading is "Why I am not A Painter." I remember it because it's almost like the first poem I remember reading. Before that it was all music, or like Poe, whom I liked very much. I'd read Eliot and I'd read Conrad Aiken, I'd read lots of poetry but, I read something that was a piece of writing, a poem, that talked just the way I talked, I could understand it absolutely clearly, the way you understand a picture by looking at it. Or, let's say, more the way you understand a person when you see that person for the first time or talk to them for the first time, and you immediately know that person is for you. And whether anything ever happens in the future or not, it doesn't matter. You just understand. You know. And that's what happened to me with that poem. Later, having to teach school and so on, and also thinking about poetry alot before I ever got to teach school, I put that poem through alot of word by word analysis in my head to see if there was some way to understand it in terms of telling other people what it said. Because it's an enigmatic poem, see, and yes I discovered I could tell people what it said. I could paraphrase it or I could put it on the blackboard and point this section and that section and say this says this and this says this and in the end . . . this happens and this happens and in the end it turns around to show you that this is this and this is this and that's why Frank O'Hara, the author, the person speaking, is not a painter . . . he's a poet. That is because when he feels emotions, though they may totally have to do with colors, what comes out, what he deals with them (in) are words. Whereas the painter, even if he should start off with words, or start off with words in whatever he's feeling, in the end what he makes comes to be what you make a painting with: paint, parts of words, no words, or whatever. Cause he's a word . . . he's a person (O'Hara) who uses words to make the things that he makes. "Why I am not A Painter" and it begins "I am not a painter, I am a poet. Why?" It has little to do with . . . SARDINES . . . and in fact there's an off-reference to Grace Hartigan's series of paintings ORANGES but what he really . . . it's like you can't say like . . . it would be amusing to be able to say like Allen Ginsberg is a poet because he has a good character and Andrew Wyeth is a painter because he's a bad person, you know. But I mean, I'm afraid such things are not true or maybe they are true, but whether they're true or whether they're not true, they're irrelevant. And the reason the person talking in that poem is a poet and not a painter is when he wants to make something, that intrinsic human desire to make something that you can see in children, you see everywhere . . . he makes it with words and he makes it with words in the way you make poems with words rather than the way that you make novels or short stories or whatever. Poems are like, many poems are like "anti-short stories." Many of Frank's

poems are like anti-short stories... that is, they're not anti-short stories but they're *like* anti-short stories. They are short stories but the ingredients that are necessary to make something with words and have that something be a piece of prose that is a short story, if you're a poet, you don't do that... instead you make the poetry equivalent of that, which leaves out many of the necessary ingredients to a short story in prose and on the other hand throws in a few details that might particularly be irrelevant, (in) a short story.

Q: Okay, now "Why I am not A Painter" is... that's one of the "I do this I do that" poems, one of the "Lunch Poems..."

A: I don't think "Why I am not A Painter" *is* one of the "I do this I do that" poems, though it uses that structure... it has a preconceived... it's preconceived quite differently from an "I do this I do that" poem, that is, inside what he's writing is "I do this I do that"... "I drop in, I drink, we drink," and so on... but it's actually not a tracking poem where he's saying "I wake up in the morning, I have a drink, I read from this book, I read from that book, I see the dog out on the lawn..." and then into his head and having a thought.

Q: But, in any case, at the same time... I think the dates in the "Collected"... up to about 1957... he was mostly writing basically literary poems, with a much more "clotted," a much less colloquial language, which you presumably would have read at the same time...

A: No, no, no, no... both those things are not quite right. In the first place by up to 1957, you're saying something like *until* 1957, or until whatever year you want to say, he was generally writing a certain kind of poem... the kind that you just described as "literary" "clotted" sort of poem. But no, that's not so at all, in fact, if you read through the *Collected Poems* rather than the *Selected Poems*, which is a misleading book, you look through the *Collected Poems* you'll find... even looking back, into the two books which have just come out, the Found Poems and the Early Poems, you'll find that at any given time Frank was writing a number of different kinds of poems and like always, you know, once he got a really rolling start into being a poet, which he did by the time he'd gotten to Ann Arbor, which would have been 50, 51 or some such time as that... I'm not quite sure that he always... that he had central ambitions and he wrote "major" kinds of poems. Many of his models are impeccable models and he returned to them time and time again, Wyatt being one of them... he returned to a number of times. Bill Berkson has pointed this out, of at least one or two, in his piece in the (Poetry Project) Newsletter, that a particular poem of Wyatt's, one particular poem, will lead Frank to writing a number of different poems until he eventually comes up with a poem like "To The Harbormaster" and the other poems that he wrote, before he comes up with "To The Harbormaster" are good poems in themselves. And when he comes up to "To The Harbormaster" he's gotten the poem that he's going after, and that doesn't mean he was in the consciousness of going after something. He was always... you can find... Frank always had models and like uh he was very inspired by music, by painting, by whatever, by prose, by his own ideas. The way that he was inspired was generally the way... he was inspired in a particular way so that he was always attempting to be classical, formal, and... tradition is a different word than classical, I guess it is... classical, formal, traditional, and yet he has to get it right, and that's why he did so many of the same things a number of times, and also why every time they came out different, because when he was 26 he wasn't the same person he was when he was 28 or when he was 24 or when he was 32. And, you notice in his poems that generally he dropped... once he'd gotten everything that was real and that he had to be able to get, somehow, out of some particular kind of thing, he didn't do it anymore. Or he might do another little off-hand one, an amusing one... then he didn't do it anymore. Occasionally... generally he had to plug to get the traditional

version that was also fully his version, he had to plug to get it, he would have to do it six or seven times. And what you've gotten, fortunately, were at least four or five really terrific poems, quite different..

Q: And then one jewel...

A: Right, and then the one. Because he was doing that, and because he was going after a number of different kinds of things at once, the gaps inbetween coming to write different kinds of formal works in a way that he would have to write them, being a man who knew...who looked at de Kooning and listened to Stravinsky or whoever, you know, and gone to the ballet and all those other things, the four or five kinds of things he was nearly always trying to do at once, there were gaps, where little poems would slip through, riding in the beak of the penguin, and many of those poems are total gems. The little poems to about Berdie, Larry Rivers' mother-in-law...those are the poems, many of the early ones, the quiet, serene, little poems that were left out of the *Selected Poems,* that make it seem that Frank was almost like incredibly queeny, and shrill, and precocious, and much too fast, until he hit the right place. And then suddenly he was there. And it wasn't that way at all. He *was* queeny, and he *was* occasionally shrill, and he *was* very, very fast. But nobody is too fast who is just very fast, that's all. How many poets, I wonder, decided...I mean, deliberately made an attempt, because they were very fast people, to write poems that were not, to go against their natural grain, and there-fore like not turned out to be very good poets. Frank wasn't going to do it that way. He wrote poems just the way he was. So...I say this from from what seems to me be observation. And there are a good number of serene, slow, small poems, stately, beautiful poems. Actually there's a lot of quickness in them, but all the time, all along...those poems...the "I do this I do that" poems are very interesting because they contain marvelous control, and complete quickness...not fast at all...they can be slowed down at will, and he does slow them down at will. "The Day Lady Died" is a classic example, but perhaps an even better example would be "A Step Away From Them." Or "Getting Up Ahead of Someone (Sun)" which is like an almost... that's how to make an inconsequential poem be a little Chinese gem, like a master-piece.

Q: Well, see the thing that uh has always uh slightly confused me about his work is like the distinction between a poem like "Getting Up Ahead of Someone (Sun)" and a poem like "Easter" or a poem like "Second Avenue" in that uh in a certain way they seem to be the work of a different, of two completely different poets and is that merely...

A: He *wasn't* two completely different poets...

Q: ...well I used to think it was just Frank O'Hara at 25 and Frank O'Hara at 30...

A: Or you could think it was Bassho and Swinburne gone berserk. But no, no, Frank was a very conscious artist and the fact that he could dash off a masterpiece like "Adieu to Joan, Bonjour to Norman and Jean-Paul..." The fact that he could dash off a poem like "Adieu to Norman, Bonjour to Joan and Jean-Paul" was because he had written a certain number of those kind of poems, and he knew how to do it, and he did dash it off, we're given the note that he wrote it in a half-hour or forty-five minutes and it's a perfect, masterful little poem, and also has incredible in-depth things in it, like "Shall we continue" and like...it's not "shall we continue..."

Q: Shall I get the book?

A: Yeah, it is like "shall we continue" and "everything continues to be..." like "Jane Hazan continues to be Jane Freilicher, I think," like "is it possible to

continue? Yes, it's the only thing to do." "Shall we continue? Yes, because it's the only thing to do." "Is it possible?" "Samuel Beckett, René Char, Pierre Reverdy, it is possible, isn't it? I love Reverdy for saying yes, but I don't believe it." Now, I really think that's what Frank thought. I mean, that's not glib, that's not quick or clever, that's what he thought. It is not possible to continue...

Anselm Berrigan: Daddy, Daddy, Edmund, me and mommy are having the last of your Pepsi, your last Pepsi.

A: It is not possible to continue...I mean, he really believed that. It is not possible to continue, and the opposite of that is that it's impossible *not* to continue. But I mean, the poet who wrote "Second Avenue" postulated for himself the problem of writing a certain kind of poem, and that poem was to be...

Q: Without a memory of itself...

A: Yeah, that's a very good way to put it, that's a pretty literary phrase. I don't know if he postulated it in that way, I mean, like that's what he wants to...there was something he had to talk about and he generally felt like he knew what he had to say about it, but he hadn't ever said it. He had to figure out a way to talk about it, so that he could say it all, sort of enough times and in enough ways round and round and over and over until it was said, finally, for himself. Cause he knew what he believed and he had to say it, but he had to say it so that he had said it and could then stand on it: that's what he believed. And he did not believe in reflectiveness and its kind of darkness as something that made you have depth, and be real, and without it, therefore, you were shallow and unreal. But he believed that, on the contrary, that life, in the living of itself, fully aware and alert and fully as conscious as possible, with an eye almost to impulses to drift off into reflectiveness and fugue states of introversion and so on, that as being the enemy of reality, the enemy of being a real person. That if you stayed on top of...not on top of things in the sense of being in control, but if you stayed and didn't dance about as you went on all the time, that that was the way you were in touch with the real light *and* the real darkness. And he yearned for that real darkness, as opposed to the false, artificial, self-indulgent, and disgusting, filthy self-defiling darkness of indulgent reflection and introversion, which he and all of us are totally subject to, and he didn't believe in cultivating one's anguish like a garden, nor did he believe in carrying around a flag, wearing a patch saying "I am living a life of quiet desperation." He believed, as he indicated in the Franz Kline interview, that probably a life of noisy desperation was preferable to a life of quiet desperation, but he didn't knock the fact that everyone or anyone might be living a life of quiet desperation, but it was the interminable wallowing in that, to the state that it kept you half asleep all the time, made you a sleep walker. He was against the false darkness and therefore he yearned for the real darkness, though he was afraid of that, too. As anyone should be, afraid of the darkness. It's natural to be afraid of the dark. If it's a real dark, though, and you're caught in it, you might be able to understand something about what it is that comforts you in the dark, and what life is all about, and so on. I think he was very influenced by de Kooning in that, and I think...the poem "Second Avenue" was originally dedicated to...there was a series of dedications...at one time it was dedicated to Mayakovsky and another time to de Kooning and I think that he was possibly influenced by Mayakovsky's willingness to sort of talk to anything, talk to the elements, talk to anything in a very modern way, shout at them, or do anything. At the same time, to chest-thump or do almost anything...and at the same time, the way it was done in paint, I think, and particularly by de Kooning, that probably inspired that poem. It had to be a big mess, it had to have everything in it...in order to get the formal considerations organized, he had to get them organized in a way that he hoped would make the poem be what it had to be, and I think he *did* get them organized and he *did* make the poem be what it was, and it's very

complicated, very dense statement of where it's at. And it's this man talking who's saying that, that's all. It's not necessarily for you, or whatever, he's not being Shelley, like Shelley or someone, particularly, though there is the incredible idealism of Shelley in it, just to do that. He simply wanted to get it out, he had to get it out. And I think he did get it out, and he got it out at the pace . . . it could only be gotten out by him at his natural pace, cause he could only get out what he knew about it. And what he wanted to tell you was everything he knew about it, cause he wanted to tell you everything. As Jim Brodey said, "I've always wanted a hamburger with everything . . . a hamburger with everything . . . I've always wanted everything." He had to tell you everything, cause the place he was in, he felt like he knew everything, and therefore had to say it, that is why he had to say it, because he suddenly knew it. It took him a number of months to write and obviously he could have written it in a form that was less dense, he could have done all sorts of things to make it easier to read and so on, since he had a number of months to work on it, but actually he used those months to make it be faster and denser, and more difficult. But while I say that it's an incredibly complicated poem, it's not a complex poem. There are only about four things in it. About four themes. Sort of positive light and dark, and negative . . . positive dark and negative dark, positive light and negative light and then, how to make a circle out of that four, out of those four. And then the division of it into twos, and it's totally divided into twos all the time, and the twos keep coming up and then turning around, and then he chose to work with . . . it's called "Second Avenue" and "Second Avenue" is a particularly apt title for it, for many reasons, the difference between Second Avenue and First Avenue . . . I mean, that's one reason . . . I mean, First Avenue would mean, I suppose, the first way one might do things, and Second Avenue would be the second way, and then there's a second person pronoun and in that poem there's almost a Jacob wrestling with the Angel fight between the first person "I" and the second person "you," which change places a number of times. It's Miltonic, in that way, that poem's very Miltonic, and nobody has ever said, I think, that Milton was easy, and that poem is not easy. Many people, I think, including some of Frank's biggest admirers, John Ashbery is on record, even, as being somewhat dismayed by that poem. People that I know personally, haven't been able to make head nor tails of that poem, and it's only been recently that I went to the poem, because I generally agreed with them on it. And the reason I agreed with them was because it was so easy to take Frank's greatest, most wonderful, adorable poems and love those, and why bother with the difficult work. But I, one night I was just talking with a man who I admire very much, and who is very intelligent, and he was just saying this poem doesn't really work, I mean, I don't think it really works, and what do you make of it. And I heard myself agreeing with him, and I realized that I didn't agree with that, what I was saying . . . you see, what had happened with me talking with that fellow is the same thing that happens in the poem. That fellow had taken my "I" and put his on it and so I was now saying what he was saying and yet I had always been walking around, I would have said that any time. But that conflicted with my sense that, that isn't the way Frank thought his poetry is, so when I got home I got the poem and I studied it for like two nights, five or six hours each night, I mean I just went to it, line by line, and I looked to see what the pronouns were saying and what they were modifying, like when "you" was talking who was that "you," and when "I" was talking who was that "I," and I'd find a place where they switched, and then where they switched back, and I found that it was actually a battle. The first switch being a deliberate giving up . . . not giving up in the battle, giving up to say "alright, I *will* be you for awhile and you can be I." And then, a switch back saying "so, see . . ." And meanwhile, the constant thing of darkness is being discussed all the time, and then . . . it's being discussed all the time but what is being presented all the time is what occurs to you, what your senses, in the light, and what occurs to you, in your senses in the light in New York City is everything! Blasting you hitting

you banging you thumping you throwing you around and you're just reeling and that's set up as a polarity and opposite condition against the condition of like being in a dark room or one of those dark…one of the space chambers…weightless… sensory deprivation chambers, like at the bottom of the sea literally. And where is that? That's nowhere. That's absolutely nowhere. And though it has it's pleasures…It's not the first time Frank has discussed that sort of thing, nor was it to be the last. I mean, "Sleeping On The Wing," for example, compares to "Second Avenue" the way that Whitehead's *Modes of Thought* compares to *Process and Reality*. I mean, it's nice to think that you could read *Modes of Thought* by Whitehead and that you don't every have to read *Process and Reality*, and it's true, you don't. But I don't believe it's fair to say that Whitehead wrote *Process and Reality* and it was a failure but he wrote it in order to be able to write *Modes of Thought*. A particularly ridiculous idea. He wrote *Modes of Thought* for the amusement of it. He wrote *Process and Reality* for the amusement of it too, but a much more abrasive amusement, because when you are…Frank didn't write to figure things out, to figure things out, no, to say them.

* * * * *

In order for your poetry to be true, I guess you could say "it can't be like your life, it has to be like you." Or, you could say, it can't be like you, it has to be like your life. That might be…you could try either one, and see what that would work out. I lean to the second one, which makes me think the first one is probably true. It can't be like you, it has to be like your life, because you can't know what you're like, but you can know what your life is like. Any attempt by you to sum up what you're like is of necessity going to be a sentimentality, a piece of sentimentality. But to tell the world what *a life* is like, showing some life with an "a" in it, at the center and therefore the central character and therefore the hero, but a very funny kind of hero because not an epic hero, or not a tragic hero and not a romantic hero, not a proletarian hero, not an ordinary man hero, but not a put-down anti-non-hero, either. Rather, a human being, an "I" and that's what Frank did, of course, that's the thing he does that I am interested in so much and like so much, he creates a three-dimensional "I" when he uses I in his poems, a three-dimensional character, he's writing, literally, plays. They're these plays, sometimes very short, some of them are actually only like speeches from plays, be telling a story, and yet the person telling the story, as in "In Memory of My Feelings," the person telling the story, a series of stories, the overlapping stories, is still actually a character in the play in which he gets to do that and it's always at least three-dimensional. That's what I think is modern…important…certainly to other writers. That's what's real about his poetry and makes it be like the poetry of *our* times, I mean the poetry that best personifies our time.

(June 27, 1977)

O'Hara: "Mozart Chemisier" is a poem I wrote after visiting David Smith, the great American sculptor in his house in Bolton Landing; it's really called . . . the Mozart comes in because he was his favorite composer. [reads the poem]

Announcer: Frank O'Hara is the Assistant Curator of the Department of Painting and Sculpture at the Museum of Modern Art in New York. He is an art critic, a playwright and one of the wittiest of contemporary poets. He is also part of that circle of friends including John Ashbery and Kenneth Koch which is sometimes identified as the New York poets, probably because they all happen to live in New York.

Leslie's studio, New York City.

O'Hara: John and Kenneth and I and a number of other people later found that the only people who were interested in our poetry were painters or sculptors. You know, they were enthusiastic about the different ideas, and they were more inquisitive. They had no, being non-literary, they had no parti pris about academic standards, attitudes, and so on. So that you could say, "I don't like Yeats," and they would say, "I know just how you feel, I hate Picasso, too." That sort of thing—a much pleasanter atmosphere than the literary was providing at the time. Apart from the fact, of course, that the only people who were doing anything interesting were painters.

Announcer: One painter very much interested in contemporary poetry is Alfred Leslie, who happens to be a film maker as well as a painter. In his New York studio he shows Frank O'Hara some of his current work, the best known of which is probably this larger than life-size self-portrait. Leslie is one of the painters who collaborated with the New York poets in various theatrical productions. O'Hara and he are currently collaborating on a film.

O'Hara: Poets in New York always have had some kind of a relationship with the theater. When the Artist's Theater was started for instance, the whole point of it was to do plays of an avant-garde content, but have real artists do the sets rather than commercial designers.

Leslie: I had a very big problem when I'd work originally on the big ones.

O'Hara: The painters who collaborated with us, like Alfred and Larry Rivers and Grace Hartigan and Jane Freilicher, and Elaine de Kooning and Nell Blaine, they got the script and saw it as a theatrical event. It was not going to be made into something where you take it to Boston and adjust it and rewrite it, and it's really just the raw material for an experience. The painters that we worked with read the script, either liked it or didn't like it, either wanted to do it or didn't want to do it, but they saw it as a theatrical event already, which very few people in the theatre will do any more.

Leslie: You see here, you don't have a view down, so in order to paint these and have the whole sense of confrontation and frontability. Actually there are four positions of perspective. These are bigger, by the way, than life size. Look at the perspective you get.

O'Hara: The reason that I'm interested in movies is not a substitute for poetry, but who is making it. If Al is making it, then I am interested in the sense that I can understand what it is going to be, or that I know that it's at least going to be something interesting for me.

Announcer: One of the poems in Frank O'Hara's book *Meditations in an Emergency*, published in 1957 by Grove Press is titled, "To the Film Industry in Crisis," and in part the film script that O'Hara is writing with Alfred Leslie is derived from this poem.

O'Hara's loft, 791 Broadway, New York City.

Leslie: The main point is that it's nobody's business what anybody does when they're alone. And that these people are being intruded upon and if somebody else finds out what they're doing, that some way or another, they're criticized, they're condemned, that, and it is nobody's business. We've timed this now up to here—we have 3 minutes and 40 seconds. Now at the beginning of the film Dorothea starts making love to Miles, and then John is laying there, and is sort of talking about the Church and he is sort of . . . oh, yeah, then at one point, just about that time, John says, "Oh wait a minute. Let me sort of engage myself a little bit with Dorothea," and then he pulls Dorothea away from Miles, and then Miles gets rather cross! That's just about the time this is happening, and actually for the rest of the film Dorothea and John are making love, and Miles is addressing himself to Dorothea.

O'Hara: "How old was I when I realized that I wouldn't enjoy anything anymore? Anxiety is just another form of entertainment. Negroes are religious; I am religious; therefore I am a Negro. At least I am not white. We walked on and on hating each other, there on 14th street. The air was better in bed. Now my eyes hurt; I'm coughing and out of cigarettes. I looked at them on the corner of 23rd street and 7th avenue. I wanted to lie there and be run over. It will come anyway. We looked at the Chelsea Hotel. It seemed to be damaged, like everything else. Two nuns walked by looking like lady wrestlers. I thought of my childhood and my dirty underwear, my socks. Pollution isn't interesting; you can't even see it. I am a sight queen, I guess. If you can't see it, it isn't there, until it hits you—boom.

I wonder where the land of the orange tree really is. Not southern California, maybe Nome. Maybe Pittsburgh. Maybe Nagasaki. Maybe Nome. I'm going down there in the sweet polluted twilight if the sun ever goes down, and if they ever go away from my quiet walk along 14th street, 7th avenue and 23rd street. Who are they anyway? It's raining. It makes me feel sweaty like last night. I hate to feel sweaty. She doesn't feel anything about me or him. She just wants to be accommodating. We're all generalized like mannequins. It's nobody's business what people do when they are alone. Everybody is always intruding, but it never makes any difference anyway.''

Leslie: Yeah, terrific. It's going to be marvelous. I kept seeing the image and it was very, very exciting.

O'Hara: But then I want to add like, you know, because John does have these ambivalent feelings: ''She thinks she is some sort of a cornball Salome. I think she'd like to have my head.'' [phone rings]

Hello, Jim. How are you? You have an upset stomach? What did you do? You went to the Kansas City, I suppose. Yeah. This is a very peculiar situation because while I'm talking to you, I'm typing and also being *filmed* for educational TV. Can you imagine that? Yeah. Alfred Leslie is holding my hand while it's happening. It's known as performance. What? Yeah, all right! Flash and bolt. What does that mean? Flashing bolt, you mean. Oh, good. Flashing bolt. [Types] A flashing bolt. Is that art or what is it? I just laid it on to the paper.

Announcer: Frank O'Hara's most recent book is titled *Love Poems*, published by Tibor de Nagy Editions in New York. In 1959 O'Hara wrote this about his poetry: ''What is happening to me, allowing for lies and exaggerations which I try to avoid goes into my poems. I don't think my experiences are clarified or made beautiful for myself, or for anyone else. They are just there in whatever form I can find them.''

O'Hara: ''Physical Fantasy dedicated to the health of Allen Ginsberg'' . . . It depends on how angry you get as you go along and how dissatisfied . . . [reads ''Fantasy'' and then reads 2 more poems, ''The Day Lady Died'' and ''Song (Is it dirty? . . .)'']

This poem is one of the *Love Poems*. It's sort of like . . . I get the idea of Marianne Moore in a way because the title is part of the poem, and also it defines something but I don't know how. The poem is called, ''Having a Coke with You.'' [reads the poem]

* * *

Transcript of ''FRANK O'HARA: SECOND EDITION'' (a film based on USA: POETRY outtakes)

Scene I

Silent montage behind titles: Frank O'Hara and Alfred Lesie, New York City

SCENE II

O'Hara and Leslie interior shots, Leslie's studio, New York City

Leslie: . . . audience of intellectuals right from the word ''go'' and that's actually . . .

O'Hara: You know, John and I, when he was producing us, he would look at the

audience and say, "Well, Harold Rosenberg is here; Tom Hess is here, Mark Rothko just came in. It must be a hit (laughter)! Only it'd be a one night hit (laughter).

Leslie: Well I do remember, though, on one occasion, Jimmy Merrill's play, when John had the theater, remember he had that funny little theater?

O'Hara: You mean De Lys?

Leslie: No, it wasn't De Lys; it was the small theater out about 72nd Street so that you had to go out a back alley...

O'Hara: Oh yeah, and it was very funny, because it was called the Joker's Club or the Monkey Club or something like that.

Leslie: Oh that's right; and Gabby, I think was in it, when Jimmy wrote "The Bait," and in the first row, asleep, was Tenessee Williams, Dylan Thomas...

O'Hara: Yes, I remember...

Leslie: ...and Arthur Miller...

O'Hara: And also afterwards, when we went to that bar, Tennessee introduced me to Dylan Thomas and he said, "Those plays are shit." (Laughter) And he wouldn't come back after intermission. But that's, I suppose, that's the whole thing. That the painters really did. Elaine, for instance, did that marvelous set for Jimmy Schuyler...

Leslie: That was beautiful.

O'Hara: ...and absolutely at the last minute, you know, like she could do it in about five days or something like that; she suddenly got an idea and did it.

Leslie: But what happened? I don't understand why the whole thing...in a sense I do, and in another sense I don't; I mean, why the whole theater didn't survive...I guess what it was, that they were trying for a bigger audience and even though there was no money involved or anything, if they hadn't been willing to, they had to be willing rather to settle for, say, a couple of hundred people; like last year, when I put a concert on here for, or rather Jill put it on here, for Lucinda Childs. I mean, that's the kind of thing which I think in the end is probably the most direct and gives the most support to all of the work that's being done, rather than striking out for...or like the time that what's-his-name, Wynn Chamberlain, had the reading of Burroughs up in his studio and everytyhing.

O'Hara: That's another thing that happened, that there should be more of a certain kind of thing. When John Cage had his first concerts, or not his first, but you know, there was a limited audience, and it was bored and so forth, a lot of it. But everybody went because they had to know about it, whether they were bored or they weren't bored, they felt like it was important to know what John Cage thought, or did, or sounded like, which seems to be declining, in a certain sense. I mean, you said if everybody goes to "Marat/Sade" and everybody says the text is lousy, but it's interesting to see the people directed on the stage, and the way they're directed, which is nothing, that is, there's nothing to that kind of thing. If there is no content, let's say, and I'm not saying there isn't any content, but I mean if the audience doesn't get any content, then what difference does it make how much excitement you get by moving people around a stage and showing a bare ass when the guy gets out of the tub?

SCENE III

O'Hara and Leslie, interiors, O'Hara's apartment, New York City. Frank at desk with Al seated near him collaborate on a film dialogue. Frank types as they talk and

reads back certain sections. A construction by Joe Brainard that hangs above the desk is referred to.

Leslie: . . . the warmth of the bed, the sexuality of the scene, to play something against it all the time.

O'Hara: (typing) Oh shit. Alright. So, we say then it's raining, right? Let's say that it is.

Leslie: Yeah, to keep the whole thing full of those images, just sort of write it through, and then we'll play it together, we'll play it against the picture and see what it's like, see what it feels like.

O'Hara: Alright.

Leslie: In fact, if you, we can read it against the film on Tuesday night when we show it to Jerry; we'll bring this with us and you can try reading it to yourself while we're screening the film.

O'Hara: Well, just to time it, sort of.

Leslie: Well, not to time it, but to see . . . if you were reading it, while you were watching the film, then you'll be able to proximate in some way how the total sense of the two levels will work, so that you're reading . . .

O'Hara: But I want it to be against the movie . . .

Leslie: Yeah, I want the dialogue, the printed dialogue, should always be against what's happening that we're looking at, what we're looking at in the scene.

O'Hara: Now, we already got to Southern California, Nome, Pittsburgh, Nagasaki, pollution, so now it's raining . . . "It makes me feel sweaty like last night." Does he still like her? That's what I want to know.

Leslie: Does he still like her?

O'Hara: Yeah, because of the other guy taking her pants off.

Leslie: Yeah, I don't know if their relationship . . .

O'Hara: He thinks she's a big drag, right now.

Leslie: Oh, you think they're trying to get rid of her?

O'Hara: Momentarily. No, *he* might, John, the hero.

Leslie: I don't know that's important enough . . .

O'Hara: No, but it would be something you would think if . . .

Leslie: Actually, because when you read it, when we place what you write against the image, it's going to take on different contexts anyway, because those words might appear just at a point when John is paying an extraordinary amount of attention to Dorothea, or Dorothea is paying a lot of attention to Miles, or when Miles is laughing at the cameraman stepping in his kishkas.

O'Hara: But he's sort of a Puritan anyway, though, John . . . By now we're already in the bed, right?

Leslie: No, when this is on, when they're reading, they're in the bed the entire time.

O'Hara: And he's lying back and she is on top of him at this point.

Leslie: No, at this point . . .

O'Hara: Miles is sort of fooling around with her . . .

Leslie: Miles addresses himself to Dorothea, Dorothea addresses herself to John, John is always talking about his past. He's talked about the Catholic church, the nuns, the priests, and everything else. So that's what's going on after that first three minutes, and for the rest of the film.

O'Hara begins typing...

O'Hara: So what if she just feels that she wants to be pleasant to everybody . . . Dorothea?

Leslie: That's alright.

O'Hara: That is, she'll sort of screw someone but it doesn't mean too much to her.

Leslie: I don't think...

O'Hara: She doesn't mean, she doesn't do anything with these two people, in a way...

Leslie: I think the whole point is that it's not an issue of life or death who goes to bed with who—because it's nobody's business. I mean, that's one of the points of it. Nobody's damn business what anybody does when they're alone.

O'Hara: Okay, so they're all generalized types. OK, now I've got them to be mannikins like in a store window.

Leslie: Alright.

O'Hara: Yeah? OK.

Leslie: Well, they don't have to be mannikins...

O'Hara: Well, I mean in their attitude, not in their, not that they look like they, you know.

Leslie: Yeah, no, but I mean...

O'Hara: You can shove any three people in one bed and they'll do it anyway.

Leslie: Yeah, but instead...no. But my...one of the main...

O'Hara: That's our burden, our message......the editor (laughter). OK. Now what I have is: they're going down the street, he's thinking...I don't want to, let's not go through the whole thing.

Leslie: Well, just try reading the first two paragraphs and then, look at the thing of what's-his-name's, the sculpture, the combine, Yeah, because...

O'Hara: Well, that's where I got the idea for that line, you know; but what I do after they're in bed, you see; I get them to... "Dorothea cries a lot in the daytime, argues silently at night. I didn't enjoy it..." This is, you know, in reference to what you're watching, but now he's in the future, and it's the past. The film is the past according to his feelings.

Leslie: So actually what happens now is that the viewer is watching the film which is the viewer's present. They're reading the...

O'Hara: The future...

Leslie: They're reading the future which makes their present the past.

O'Hara: Um...No, I don't think we'd better get into that, or I'll never be able to write anything (laughter). He says, he says while he's rolling around in bed, "I didn't enjoy it. Miles pretended to. All she wants is attention," meaning Dorothea... "Going to bed with Dorothea is like going to bed with a nun. She's just a pal sexually"...